THE POWER
of
SACRED IMAGES

August 29 1998

For John and Buff,
Enjoy!

Gretchen B. Lewis

THE POWER of SACRED IMAGES

A GUIDE TO THE TREASURES OF EARLY CHRISTIAN ART

ELIZABETH BRUENING LEWIS

ORIGINAL DRAWINGS
BY STEVEN G. HELFFRICH

Christian Classics™

A DIVISION OF THOMAS MORE PUBLISHING

ALLEN, TEXAS

Cover design by Dennis Davidson

Cover art by Pin Yi Wu

Illustrations by Steven G. Helffrich

ACKNOWLEDGMENT
All Scripture quotations are from the King James Version.

Send all inquiries to:
CHRISTIAN CLASSICS
200 East Bethany Drive
Allen, Texas 75002-3804

Toll Free 800-888-3065
Fax 800-688-8356

Printed in the United States of America

Library of Congress data: Pending

ISBN 0-87061-208-5

1 2 3 4 5 00 99 98 97

FOR
Orme and all my family,
with thanks and love.

Contents

Introduction

After much thought and discussion, this book has been titled *The Power of Sacred Images: A Guide to the Treasures of Early Christian Art*. However, any guide presumes the existence of people who wish to explore something, and for myself, I imagine the explorers of early Christian art as being many and varied.

I think of someone with an interest in the emergence of early Christianity and consequently its visual expression, of someone else fascinated with history who does not subscribe to the theory that history should necessarily be confined to the evidence of the written word, and of still another sort, the humanist, who believes in studying the many areas of human development (historical, cultural, artistic)—not in isolation, but rather as part of a whole.

Yet though religious inquirer, historian, and humanist have all become an important part of my own thinking, the concept for this book actually originated with the Docents of the Phoenix Art Museum—volunteer researchers, lecturers, and tour guides who, for the most part, signed up for the program because of an avid interest in learning more about art. Some Docents go on to travel extensively,

while others extend their knowledge through books. But they are all adventurers, men and women not afraid to delve into unfamiliar territory, and so art enthusiasts and travelers must be added to the list. I hope this book will be of some service in giving them and others an introduction to early Christian art and symbolism, and to the world of events and ideas that gave rise to them.

Traces of early Christian art have been found throughout the lands incorporated into the Roman Empire, which at its apex stretched from the lowlands of Scotland to the sands of the Sahara, from the Rock of Gibraltar to the edges of Iran. It is a wonderful legacy, extremely rich and varied, one that could easily tempt a writer to drift far afield. To avoid such temptation, the works selected for this book are mostly from Italy, where the largest assortment of early Christian art still exists and can be seen.

Time presents less difficulty than geography. For reasons that will be considered in chapter 1, there was no Christian art before the third century A.D. On the other hand, the terminus to early Christian art is more problematical. Although the case can be made to continue the designation "early Christian" up through the eighth century or, conversely, to end it as early as the beginning of the fifth century, this book concludes with the fourth quarter of the sixth century, by which point in every aspect of human endeavor a new order is at hand. This is clearly reflected in Christian art.

The period thus encompassed is almost three exceedingly tumultuous centuries during which the changes—political, social, economic, and religious—were profound. That great, seemingly all-embracing political unit the Roman Empire was disintegrating

as the world we think of as medieval was gradually taking shape. The old economic and social order was inexorably slipping away. Paganism was not completely dead, but Christianity was quickly gaining the upper hand. The Church as an institution was emerging, while at the same time theologians and Church councils were gradually hammering out the basic doctrines of Christianity. And all this is reflected in early Christian art and in the symbolism that provides this art with its special power of communication.

Meanwhile, the story of early Christian art also has its own internal structure: the birth struggle, the effort to develop its own voice while using the artistic forms and symbols of a world with which it was in conflict, and the final maturation achieved by absorbing the artistic heritage of the ancient world and transforming it to its own ends. In the process, early Christian art established a basic working vocabulary that is still in use today. One can, of course, admire works of Christian art solely on the basis of their beauty, but this is to miss much of what they have to offer. Christian art has a message to impart, a message expressed through symbolism. And the foundation for its symbolic language was formulated during the early Christian period.

Thus, this period and its art offer much to all sorts of explorers. Further, as so often happens in the study of human endeavor, what is discovered about the past bears directly on the present. The art that developed during the early Christian period created a foundation for a large preponderance of the art of the Middle Ages, much of that of the Renaissance and Baroque, and indeed of contemporary Christian art. The past is not "past" in the sense of being over and

done with but is part of our collective present and—as such—continues to have influence.

So best wishes to the explorers of all sorts. It is hoped that they will take as much pleasure in the reading of this book as the author took in researching and writing it.

Elizabeth Bruening Lewis
Phoenix, Arizona

Note to the Reader

When a term that may not be familiar to the reader first appears, it is printed in **boldface** to indicate that it is found in the glossary (see pages 245–52). To aid the reader in putting together the art with other events, a time line has been included (see pages 14–15). For the reader's convenience, a list of frequently encountered symbols has also been appended (see pages 253–58). The person who is inspired to explore still further will find a list of suggested reading (see pages 259–64).

Meanwhile, speaking about "Christianity" is a potentially dangerous business since so many different kinds of Christian worship exist today. Therefore, when either Christianity or Christian belief are referred to in this book, the reference is to Christianity as it existed in the centuries under discussion.

Perhaps a still more dangerous snare for the contemporary writer is that of gender. As a woman, I am quite well aware of the problems posed by words such as *mankind.* However, when it has come to a choice between political correctness and smooth, readable prose, I have generally decided in favor of the latter. I hope the reader will indulge me in this and understand that *man* and *mankind* are used in their widest sense to include both male and female members of the human species. As for God, the early Christians, guided by phrases such as "our Father," tended to refer to the divine being as "he." Since this book is about them and their world, I shall, too.

	POLITICS	RELIGION	CHRISTIAN ART AND ARCHITECTURE	MISCELLANEOUS
50	Augustus (1st Roman emperor), 27 B.C.–A.D. 14	Crucifixion of Jesus		
100				Colosseum (Rome); Eruption of Mt. Vesuvius
150	The "good emperors," 96–180			Column of Trajan (Rome); Pantheon (Rome)
			Construction of Roman catacombs begun	
200			Beginnings of Christian Art	Sassanid dynasty (Persia); Plague, economic decline, constant pressure on frontiers
250		The beginnings of monasticism	House church at Dura Europos covered over	
	Diocletian, 284–305			
300	Constantine I, 306–37	The "Great Persecution"; Edict of Milan, 313; 1st ecumenical council, 325	Lateran (Rome); Old S. Peter's (Rome); S. Costanza (Rome)	Battle of the Milvian Bridge, 312

	POLITICS	RELIGION	CHRISTIAN ART AND ARCHITECTURE	MISCELLANEOUS
350		St. Ambrose, bishop of Milan, 374–97 2nd ecumenical council, 381 Pagan temples closed		Appearance of Huns
400	Theodosius I, 378–95 Honorius, 395–423		S. Lorenzo (Milan) S. Ambrogio (Milan) S. Paul's Outside the Walls (Rome)	Battle of Adrianople, 378
	Valentinian III, 425–55	3rd ecumenical council, 431	S. Pudenziana (Rome, apse mosaic) S. Sabina (Rome) S. Giovanni Evangelista (Ravenna) S. Maria Maggiore (Rome) Mausoleum of Galla Placidia (Ravenna)	Ravenna becomes de facto capital in West Visigothic sack of Rome, 410
450	Galla Placidia died, 450	4th ecumenical council, 451	Orthodox baptistery (Ravenna) decorated S. Stefano Rotondo (Rome) Spirito Santo (Ravenna) Arian baptistery (Ravenna)	Defeat of Huns, 451 Vandal sack of Rome, 455
	Deposition of last Roman Empire in West, 476			
500	Theodoric "king" in Italy, 493–526 Justinian I, 527–65		S. Apollinare Nuovo (Ravenna) Archiepiscopal Chapel (Ravenna) SS. Cosmas & Damian (Rome, apse mosaic) S. Vitale (Ravenna) S. Apollinare in Classe (Ravenna)	Mausoleum of Theodoric (Ravenna) Italian wars, 535–54 Byzantine capture of Ravenna, 540
550		5th ecumenical council, 553 Maximian, bishop of Revenna, 546–56 Agnellus, bishop of Ravenna, 557–70		Lombards enter Italy
600				The Hegira (beginning of religion of Islam), 622
650				

CHAPTER

1

To Be or Not to Be: The Beginning of Christian Art

Against All Odds

Gazing up at the Sistine Chapel ceiling, one stands in awe before Michelangelo's powerful vision of creation—a magnificent work which has justly impressed people through the ages. As the visitor cranes his neck into ungainly positions in order to study the panorama above or to imprint its beauty on the inner retina of memory, questions about meaning, technique, or even execution may come to mind. But probably few visitors, if any, ever stop to consider the miracle of this work being there at all.

Of course, we are well aware of the ravages of time—deterioration due to neglect; the havoc wrought by the overenthusiastic restorer; destruction caused by fire, flood, war, and, in the case of the Sistine Chapel ceiling, a leaky roof. But for the moment, the many hazards encountered by any work of art, the Sistine

Chapel ceiling included, *after* its completion are not the point. What is important is that Michelangelo would not have painted the ceiling in the first place, at least not in the way he did, had there not existed a tradition of representational Christian art, an art involving the depiction of plants, animals, and—above all—human figures in a manner sufficiently naturalistic so that they can be easily recognized as such.

Religious art does not have to be representational; it can be spiritual without telling Bible stories, depicting religious scenes, or doing any of the other things we tend to assume Christian art should do simply because we are used to seeing it done that way. To realize the possibilities in nonrepresentational religious art one need only look at selected works in the Islamic tradition in which the subject is an elegant and seemingly infinite conceit on the words of the Koran. Works such as these are profoundly religious; indeed, their subject matter—from the Islamic point of view—is quite literally the word of God, but they rely on calligraphy rather than on representation for their beauty and significance.

With a little imagination, one can conjure up various alternatives for the Sistine Chapel ceiling that would have rendered the space beautiful without resorting to representation: an abstract pattern either geometric or based on sensuous swirls, a dramatic architectural treatment, or, borrowing from Islamic art, the words of the Bible transformed into an elegant and semi-abstract design. Instead, the story of creation is told in rich detail with a host of figures, including God himself. And all this is possible because, from the beginning of the third century, Christianity had developed a tradition of representational art, one which had the most profound consequences for Western civilization. For more than a

Not all Islamic art, even all Islamic art created for specifically religious purposes, is entirely devoid of representation. But those works based solely on calligraphy (the words, of course, being those of the Koran) demonstrate how effective non-representational religious art can be.

millennium, from the fifth into the sixteenth century, the great preponderance of major European works of art sprang from this tradition. Yet, in the early days of the Church, the odds were quite good that there would be no representational Christian art at all.

By no means did the first Christians rush eagerly to embrace visual art, representational or otherwise. They had far weightier matters on their minds. The Second Coming was expected almost momentarily, certainly no time to be frittering away energies and resources on decoration. But when it became apparent that the final days were not yet upon them and that the Second Coming might be much further in the future than they had anticipated, visual art, most particularly art involving any sort of representation, was still eschewed—an attitude for which there were excellent reasons. Above all, had not God specifically forbidden the creation of graven images? It is not easy to ignore those chilling words in the twentieth chapter of Exodus:

> "I am the LORD thy God. . . . Thou shalt have no other gods before me. Thou shalt not make unto thee any graven image, or any likeness of any thing that is in heaven above, or that is in the earth beneath, or that is in the water under the earth: Thou shalt not bow down thyself to them, nor serve them: for I the LORD thy God am a jealous God." *Exodus 20:2–5*

At the same time there were other factors militating against representational art of a less profound but very practical and immediate nature. The Roman Empire was highly visually oriented, and much of its art was bound to be both offensive and threatening to

the Christians—particularly images of the pagan gods and goddesses and those of the emperor. It takes very little imagination to understand why the former were abhorrent; their pagan subject matter alone was enough to make them repellent. Furthermore, how was a Christian supposed to keep his mind on spiritual matters while gazing at the voluptuous breasts of a half-naked Venus? Or, similarly, how could his wife be expected to keep her thoughts pure while confronting the graphic and three-dimensional depiction of a most well-endowed young male? But, when pagan images were also treated as idols, more than a Christian's morals were in danger. Christians who would not perform public sacrifice to the traditional gods of the Roman Empire and/or do obeisance before the image of the emperor, making the latter equally suspect in Christian eyes, might be condemned to the most agonizing sort of death.

Thus, between the biblical injunction against graven images and strong negative associations with many of the artistic products of the Roman world, it is clearly a wonder we have any representational Christian art at all. Yet slowly, perhaps even reluctantly, such art came into being, probably about the beginning of the third century. This foray into visual art, and representational art at that, was not an obvious move nor one seemingly preordained by what had gone before. It had the most profound implications. As one scholar has remarked, "The passage from thought to representation involves a leap from one plane to another, and that leap contains an element of the infinite."[1] Had that leap not been made, we would not have the Sistine Chapel ceiling, most of the windows of Chartres Cathedral, or, and more to the point in the present study, the dazzling **mosaics** of fifth- and sixth-century Ravenna.

The Secret of Dura Europos

How and why did such a leap of imagination occur when there were so many factors weighing against it? By the beginning of the third century, an increasing number of converts were being drawn from the pagan sphere. For these new Christians, the pull of images must have been powerful; life without them would have seemed very bleak indeed. As has been suggested, the ancient world, particularly in its final flowering in the Roman Empire, was strongly visually oriented. Images exercised an almost irresistible attraction, and not just for those who were raised in the pagan tradition. Exactly how irresistible was not clear until archaeologists began to excavate Dura Europos, a small Syrian town on the western bank of the Euphrates River.

Dura Europos was founded by Macedonian Greeks about 300 B.C. and was captured by Parthians (a seminomadic Iranian people) in the second century A.D. Not long after that, with the expanding power of Rome, it became part of its empire. But the tide of Rome, having reached the flood, began to ebb. In A.D. 256 (some say 257), Dura fell to the Sassanids, an Iranian people from southwestern Persia (present-day Iran) who had supplanted the Parthians. The Sassanids, however, did not remain long; they soon abandoned the town, which subsequently disappeared in the sands of time. There it remained, a secret treasure trove of third-century life and art, left virtually undisturbed for almost seventeen centuries.

After the First World War, British soldiers in the area uncovered traces of the town, a discovery that immediately awakened scholarly interest. When archaeologists began to probe the site, they soon

realized that they had in Dura a veritable time capsule; having carefully removed sand and rubble, its twentieth-century excavators could quite literally step back into the third century A.D. And there some surprises awaited them.

But "surprise" probably does not really do justice to the situation. The excavation of Dura Europos coincidentally provided one of those historical upsets which change our entire way of looking at a period—historical upsets which demonstrate that knowing the past is no mere matter of memorizing dull, fixed dates and facts, and that our knowledge of history is as prey to rude shocks as are our expectations for the future. Digging uncovered (among other buildings) a Jewish synagogue and a Christian complex, the two having been partially covered by defenders trying to strengthen the city walls in preparation for the Sassanid attack of 256. Both locations yielded monumental (large-scale) representational art, but it was the **murals** in the synagogue that were truly unexpected.

The Old Testament, in which the prohibition against images is so clearly stated, is, of course, the very foundation of Judaism. However, scholars knew that the Jews had not always scrupulously observed the prohibition against graven images and had long hypothesized the existence of illustrated copies of the Old Testament produced in Hellenistic Alexandria. But such illustrations would have been discrete and small-scale. Nothing had quite prepared the scholars for the discovery of the large, vivid panels decorating the walls of the synagogue at Dura Europos.

Executed in **tempera** (and now in the National Museum in Damascus), these detailed and richly colored murals portray important incidents in the history of the chosen people and their covenant with

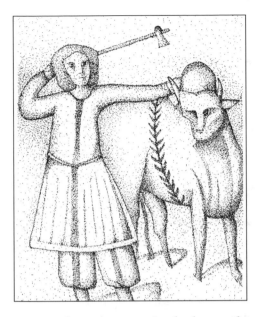

Figure 1.1:
Treasures of Dura Europos: In spite of the strict prohibition against images in Exodus (20:2–5), the lure of images was so strong in the Roman world that at least one third-century A.D. Jewish congregation decorated the walls of its synagogue with large-scale representational art such as that seen here. (Drawing inspired by a detail of *The Consecration of the Tabernacle and Its Priests*, a mural from the assembly hall of the synagogue at Dura Europos, 245–56 A.D. Now in the National Museum, Damascus.)

God. For example, one particularly striking panel (roughly five feet by eight feet) depicts *The Consecration of the Tabernacle and Its Priests*. Aaron (identified with Greek letters), priests, and animals are all present, as well as the Temple itself, the Torah, and other objects of religious significance (see Figure 1.1). Though movement is more or less lacking and size is determined by importance rather than actual physical relationships, the figures (both human and animal) are unambiguous. Certainly no one seeing such a work could ever again question the fact that at least some third-century Jews countenanced large-scale representational art.

The Christian discoveries at Dura were somewhat less dramatic, but still quite interesting in their own right. The Christian complex is an example of the "house churches" known to exist before the legalization of Christianity but of which little evidence remains. It was created by converting a private residence for Christian use, probably around

The very early Christians may have had some structures built as churches, but this was rare. Generally they met in apartments such as those in the apartment buildings of Rome, in large spaces in private homes, or in a house converted to their use.

The first part of the mass was instructional. After it was completed, the cate-chumens, those studying Christianity but not yet baptized, repaired to a point at which they could hear but not see the eucharistic service itself with the blessing of the bread and wine.

231–32. Discretion was the order of the day; nothing would have distinguished the complex from surrounding buildings. A passerby glancing in from the end of the alley on which it was located would have thought it was just one more modest home built around a central courtyard, the typical domestic plan in the area. As a matter of fact, though not a great deal had been changed, some internal walls had been removed to provide the sort of spaces needed by the Christians: an assembly hall (about sixteen feet by forty-three feet), next to it a smaller room perhaps used for catechumens (who, from that location, could hear but not see the mass of the faithful), and a still smaller room (about ten feet by twenty-one feet), which presumably served as a baptistery.

The baptistery (today reconstructed at the Yale University Art Gallery) has been of particular interest to scholars because its walls, like those of the synagogue, were once covered with paintings. Though these murals have not been treated kindly by time, and some have disappeared altogether, enough of them remains to get some idea of the decorative program. The subject matter is drawn from both the Old and New Testaments with scenes having baptismal significance playing an understandably important role.

Christ and the woman of Samaria at the well is one such scene. It will be remembered that Jesus, traveling from Jerusalem to Galilee by way of the highlands of Samaria, stopped at Jacob's Well for a rest. A Samaritan woman came along to draw water and was much surprised when Jesus, a Jew, asked her for a drink, since the Jews and the Samaritans had many bones of contention between them. She must have been even more puzzled when Jesus told her:

"Whosoever drinketh of this water shall thirst again: But whosoever drinketh of the water that I shall give him shall never thirst; but the water that I shall give him shall be in him a well of water springing up into everlasting life." *John 4:13–14*

However, these words would have presented no mystery to the Christian congregation at Dura. They would have recognized the use of water as a spiritual metaphor, not only a refreshment for the soul but a link to life everlasting. Virtually any reference to water served to suggest baptism to the early Christians, but the scene at Jacob's Well was particularly well suited for a baptistery since the person baptized was believed to die to sin and emerge reborn to spiritual (and hence eternal) life.

A scene such as this one of Christ and the woman of Samaria at the well is thus in itself clearly appropriate for a baptistery, but since it is only one of a number of scenes with which this room is decorated, it should also be considered within the overall context of the baptistery's artistic program. Above the baptismal font, or **piscina,** Adam and Eve, ashamed in their nakedness, stand beside the Tree of Knowledge— a clear reminder of the origin of sin and the human predicament. But as man has sinned, so too can he be saved, an idea expressed by the presence of the Good Shepherd with his flock. For the early Christians, the Good Shepherd was the most poignant of all symbols of divine love and care, the man who would leave his ninety-nine sheep to find the one that has strayed, the lost sheep being, of course, the sinner who is brought back into the fold. The Shepherd is also Christ himself, and through baptism, the Christian,

Jesus (*Joshua* in Hebrew) has been called by many names that emphasize different aspects of his mission. *Joshua* reflects the salvation of God and grace. *Immanuel* means that God is with this man. Both the appellations *Messiah* and *the Christ* refer to the anointed of the Lord. *Son of Man* points to his role as judge; *Savior* (*Soter* in Greek) or *Redemptor* recalls his mission to redeem man from original sin. The *Word* refers to the opening lines in the gospel of John: "In the beginning was the Word, and the Word was with God, and the Word was God" (John 1:1) and refers to the divine nature of Christ. For simplicity's sake, we shall use the terms *Jesus* and *Christ* interchangeably.

In the early Church, adult baptism was the rule rather than the exception, though infant baptism was indeed practiced. (The Christian writer Tertullian, in his work *On Baptism* [c. 200], denounces this recent innovation.) Originally the sacrament of baptism could be performed by pouring water over the person being baptized or by total immersion to emphasize that the person being baptized died to sin and was reborn to spiritual life (even as Christ himself died and was resurrected). Hence, the need for a small pool—or piscina as it is often called.

cleansed of sin, becomes part of Christ's flock, one of the sheep to whom his protection is promised.

Thus, these three scenes (which by no means exhaust those that can still be recognized on the walls of the Dura baptistery) taken together express more than the sum of their parts. Man has sinned (Adam and Eve), but Christ (the Good Shepherd) has come with the promise of salvation, salvation that is available through the life-giving water of baptism (Christ and the Samaritan woman at the well).

Though most scholars today agree that Christian art begins with the third century, the murals in the Dura baptistery are the earliest examples of Christian art that can be securely dated; we know that they must have been executed after the conversion of the house to Christian worship around 232 and prior to the strengthening of the city walls for the Sassanid attack in 256. The execution is simple, even somewhat primitive, but a small group of Christians in a frontier town would have had limited access to skilled artists. However, the impressive thing about the murals is the evidence they give us of how quickly, within four or five decades at the most, the Christians had developed a complex visual language, one capable of expressing in concrete form ideas as abstract as sin and salvation.

A New Language Is Born

What makes certain art Christian? Three things spring immediately to mind. First, there is context. It stands to reason that art used to embellish a Christian baptistery or a Christian burial place is in some way Christian even if it is purely decorative.

Second, there is content or subject matter, in our case specific scenes taken from the New as well as the Old Testament, the former being within the exclusive province of the Christians. And finally, there is the message—for, as in the case of the Dura baptistery, Christian art (except in the rare instances in which it is purely decorative) had something to say and deliberately went about saying it as clearly as possible.

On the other hand, in the early years of Christian art, how a scene was portrayed does not distinguish it as being Christian, since the Christians simply utilized for their own purposes the styles of art they found around them. There is nothing unusual about the materials the Christians chose either, or how they handled them. Tempera, **fresco,** stone carving for **sarcophagi**—all of these were originally used in exactly the same fashion as they were by non-Christians, and in fact we have no way of knowing if the artisans actually employed in producing Christian works were even Christians. In terms of this period beginning in the third century, there is only one notable difference in the choice of media between Christian and non-Christian art: the Christians (with a few exceptions) tended to avoid **sculpture in the round,** so very popular in classical art, undoubtedly as being too physical and too reminiscent of popular images of pagan gods and goddesses.

Hippolytus of Rome, writing in about 215, allowed that artists could become catechumens if they did not make idols.

The early Christians had quite a talent for making use of what they found around them. Nowhere is this more evident than in the numerous images that, by virtue of their skill for adoption and adaption, they "baptized" and brought into the Christian fold. The peacock, whose flesh was believed by the ancient world to be incorruptible, became a symbol of immortality. A crown, the classic emblem

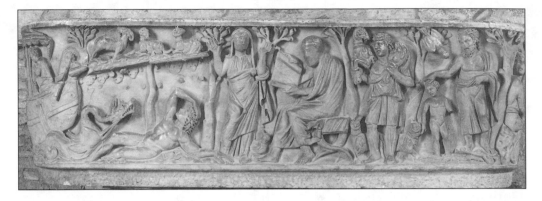

Figure 1.2:
Early Christian Symbols: From the outset Christian art sought to develop a language of images that could be readily grasped throughout the far-flung Christian community. Here we have (left to right): (a) Jonah and the big fish, (b) the orant, a personification of the soul of the deceased in prayer, (c) the true philosopher, either Christ himself or the philosopher who found the true philosophy, i.e., Christianity, (d) Christ as the Good Shepherd who would lay down his life for his flock, and (e) the baptism of Christ in the Jordan. (Marble sarcophagus, c. 270, now in Santa Maria Antiqua, Rome; photo courtesy of the Deutsches Archäologisches Institut, Rome.)

of victory, served to designate the martyr who, through martyrdom, had triumphed over death and achieved eternal reward, the athlete's palm of victory being used in a similar fashion. An anchor suggested hope. The Egyptian ankh, or life sign, could be seen as the cross. The gentle dove spoke of peace, as well as recalling the dove that brought Noah the olive branch (another classic symbol of peace), thus demonstrating that God had made peace with man (see Figure 2.4). Also the dove became the symbol of the Holy Spirit, the third member of the Holy Trinity. Victories, those winged female symbols of triumph, were transformed into angels.

The Good Shepherd, the most beloved of all early Christian images (see Figure 1.2), was based on the familiar pagan representation of a man bringing his offering to the altar. In time the pagan image, by our period referred to as the "Ram Bearer," had developed connotations of philanthropy and loving care, associations clearly compatible with the Christian understanding of the Good Shepherd, or Christ, as the one whose love was so great that he would willingly lay down his life for his sheep. The Greek demigod Orpheus, another shepherd who guarded his flock, also served as a Christ symbol and

is found in the Roman catacombs with his flock in what can only be called "green pastures" (thus recalling the Twenty-third Psalm).

Christ appeared in still other human guises in early Christian art. A third-century mosaic in the necropolis under Saint Peter's in Rome portrays Christ as the sun god Helios driving his heavenly chariot through the sky. On early sarcophagi we also find Christ depicted as a philosopher—a familiar image in the classical world—a bearded man whose chest was bare or covered with a tunic, usually draped over one shoulder (see Figure 1.2). He is sometimes seated on a stool and is often reading, the true philosopher who is privy to the wisdom of the ages.

As Christian art developed, Christ was often designated by the **cruciform nimbus,** a halo with a cross inscribed in it. The halo, or **nimbus** as it is more properly called, was occasionally used in the non-Christian art of the Roman world to denote power and dignity. The Christians used the nimbus to indicate holiness, but in time the need was found to distinguish the all-important figure of Christ from other holy personages, a problem that was resolved by the use of the nimbus with a cross inscribed in it. The cruciform nimbus is only used for Christ or, more rarely, for the other members of the Trinity.

Meanwhile, the Christians even incorporated the Dionysiac imagery, though the god **Dionysus** was associated with debauchery and ribald behavior. The **vintage feast** (the grape harvest), a delightful and ever-popular theme in classical art, became a particular favorite and one that the Christians endowed with profound religious significance. The harvest of the grapes and the making of wine brought to mind the wine of the eucharist and, hence, the blood of

The philosopher has also been interpreted by scholars as the follower of the true philosophy of Christ. In time, the seated philosopher with his roll, later his book, became the prototype for human, as opposed to symbolic, representations of the evangelists popular from late early Christian art through the art of the early Middle Ages.

29

Christ, whereas Christ's comparison of himself to the vine and his people to the branches added yet another dimension.

Though the vintage feast rarely, if ever, appears in contemporary Christian art, another early image, that of the fish, has never lost its appeal. As a symbol, the fish long predates Christianity. The pagans had the "Divine Fish," a concept originating in the eastern Mediterranean region. As the one creature to survive the flood unaided, the fish became a religious food for the Jews. For the Christians, the fish symbolized both Christianity and Christ, although the recognition of the acronym "fish" in the Greek phrase "Jesus Christ, Son of God, Savior" may well have been after the fact. (The first letters of these words written in Greek spell *icthus,* the Greek word for fish.)

The fish has a prominent role in the New Testament. Jesus promised to make the apostles fishers of men, and he revealed his power to Simon Peter by having the apostle cast his net, in which he had caught nothing all night, only to have it filled to the breaking point. Fish were multiplied along with loaves to feed the huge crowd gathered to hear Jesus preaching, and the multiplication of the loaves and fishes was, in turn, considered a **prefiguration** (something that happens before something else of the same type and points toward it) of the Last Supper and, hence, the eucharist. As the people in the great crowd had their physical hunger alleviated by the bread and fish, so all Christians would be spiritually fed by holy communion. The fish also represented the soul cleansed by the waters of baptism and was thus associated with the two major sacraments (baptism and the eucharist) recognized by the early Christians.

Examples such as these give us some indication of how this art gradually built up its own repertoire, and in a very real sense its own vocabulary. But the Christian artists were not given carte blanche and could not use just anything that came to mind. They had to make sure that the images they employed were comprehensible to other Christians and that they used them in a way that would express ideas consonant with the evolving doctrines of Christianity. Today we are familiar with artists developing their own, often highly personal, symbolism. But Christian symbolism was not, and could not be, the special product of any one artist or even a particular group of artists. It had to speak to, and for, an entire religion. Fumbling attempts might be made and rejected, occasionally an unsatisfactory byroad might be followed only to be abandoned later, and local idioms were bound to crop up, but, overall, Christian symbolism had to be clear and consistent, a message to be seen and understood throughout the Christian world.

This last consideration is not insignificant—for although early Christian art was by no means devoid of decorative intent, the message it was designed to convey far outweighed any aesthetic considerations. This is an important point to be made about early Christian art, even with regard to those works that number among the most beautiful ever created: beauty was desired and striven for (after all, this was a way of honoring God), but the message was always paramount. Thus, no matter how much one appreciates the aesthetics of these works, unless one is able to read their meaning, which is conveyed through symbolism, one has missed much of what they have to offer.

Dormice for Dinner

With Christians trying to focus their gaze on the world to come (the "City of God" as Saint Augustine would call it), there would seem to be little need to describe the earthly political unit in which they lived (Saint Augustine's "City of this Earth," or the Roman Empire). But this is not the case. Not only would a great many ideas and ways of doing things associated with the Roman Empire be absorbed into the emerging Christian Church, in the not too distant future, the fate of Church and empire were to become closely, almost indissolubly, linked.

Figure 1.3:
The Roman Empire at Its Height, C. A.D. 117

The Roman Empire has fascinated people over the centuries, particularly rulers from Charlemagne to Napoleon who attempted to emulate it. But even ordinary people with no intention of trying to establish an empire of their own have looked back with awe at the accomplishment of the Romans. Above all, the empire was enormous, stretching as it did from England to Egypt, from the Caspian Sea to the Atlantic

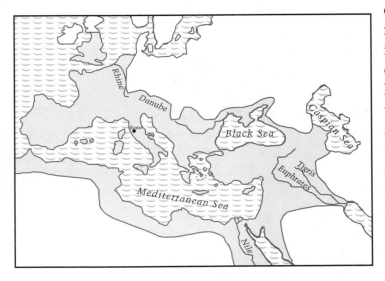

(see Figure 1.3). Although it failed to encompass the entire known world, the Roman eagle had spread its wings over just about everything that counted. Of course, traders were aware of peoples living beyond the Persians who periodically threatened the empire's

eastern border. (One very early Christian, Pantaenus of Alexandria, is even credited with a missionary journey to India.) Africa below the Sahara was not entirely unvisited, and there were always new waves of barbarians from the north and northeast to contend with. But the Mediterranean was a Roman lake, and all the peoples whose lives were touched by it, as well as many who lived beyond its immediate influence, were part of a single political unit.

Although by today's standards a population that peaked at somewhat more than 80 million (and some estimates are as low as 50 million) may not seem like much, it was extremely impressive for its time. For the first two centuries of its existence—that is, from 27 B.C. to A.D. 180—the Roman Empire was generally well run in spite of some flagrant conflicts among the rulers themselves. Of supreme importance to its inhabitants, the empire provided peace within its borders. No longer would a farmer return to his fields to find his ripening harvest trampled by soldiers, a shopkeeper watch helplessly as his entire livelihood (and quite likely his wife and daughters as well) were swept away by an invading army, or a merchant discover that the ship carrying his goods had been snatched by pirates. In a world in which war had long been endemic, it was not altogether a tragedy to find oneself forcibly taken into the Roman fold. (Or maybe not even forcibly; a few rulers—recognizing the inevitable and hoping to make the transition easier for themselves and their successors—avoided conflict by bequeathing their lands to Rome.) All this was of the greatest importance for Christianity because peace within the borders of the empire and comparative ease of communications made it possible for the new religion to spread quickly.

The first Roman emperor, Augustus, died in A.D. 14. Although his rule may have brought "the enjoyable gift of peace" (the words of the Roman historian Tacitus, who was by no means uncritical of Augustus) to the lands ruled by Rome, it was the better part of a century before this peace made itself felt at the imperial level. Life at the top was marred by palace intrigue, murder, madness, sadism, and debauchery—Caligula and Nero being perhaps the two most notorious emperors from this period. To give some indication of the temper of the times, three out of four of the immediate successors of Augustus died violently (two murders, one suicide), and the whole house of cards collapsed in A.D. 69 in a scramble for the monarchy known as "The Year of the Four Emperors."

But just when it seemed that things could not get any worse, they actually began to get much better. The brief reign of Nerva (96–98) signaled the beginning of a new state of affairs; the reign of Trajan (98–117) inaugurated more than eighty years of orderly succession and competent rule. The eighteenth-century English historian Edward Gibbon, author of *The Decline and Fall of the Roman Empire*, thought that the Roman Empire of the second century provided a bit of heaven on earth:

> In the second century of the Christian era, the Empire of Rome comprehended the fairest part of the earth, and the most civilized portion of mankind. The frontiers of that extensive monarchy were guarded by ancient renown and disciplined valour. The gentle but powerful influence of laws and manners had gradually cemented the union of the provinces. Their peaceful

inhabitants enjoyed and abused the advantages of wealth and luxury. The image of a free constitution was preserved with decent reverence: the Roman senate appeared to possess the sovereign authority, and devolved on the emperors all the executive powers of government. During a happy period (A.D. 98–180) of more than fourscore years, the public administration was conducted by the virtue and abilities of Nerva, Trajan, Hadrian, and the two Antonines.[2]

However, this was a period of ephemeral perfection, after which, according to Gibbon, the Roman Empire went to hell in a handbasket for almost thirteen centuries. Quite an extended decline, but then the Roman Empire had, in Gibbon's eyes, reached a breathtaking summit from which there was a long way to fall.

Historians have suggested a wide variety of causes for the decline of the Roman Empire. Although many factors were undoubtedly at play, it is easy enough to see that from the outset the empire had at least one fatal flaw: the problem of succession. There existed no provision for an orderly succession, and when an emperor died, chaos (such as in The Year of the Four Emperors) could easily ensue. During the period Gibbon cites as the empire's finest hour, and here few would disagree with him, this problem was solved by the judicious selection and grooming of a successor by the reigning emperor. These "good emperors," as history has called them, were all capable generals and administrators. Trajan chose his fellow Spaniard Hadrian. Hadrian in turn selected Antonius Pius and let it be known that he wished Marcus Aurelius to follow him. Undoubtedly things

worked so well because these men did not have sons of their own at hand to contest the adoption and eventual succession of a rival. Marcus Aurelius, familiar to those with an interest in philosophy through his *Meditations,* was not so fortunate. All of his philosophy could not shore him up against domestic influences. He died in 180, leaving not a carefully selected and trained successor but his cruel, half-mad son Commodus to rule as emperor. Under such a master, the Roman Empire began to slide quickly from the best of times into what was surely the worst.

Up until the death of Marcus Aurelius, the problems and vicissitudes at the seat of power did not make a great deal of difference to most of the people in the empire. Their daily lives were, by and large, unaffected by the imperial succession with its incumbent difficulties. Even the expansion of the empire had little direct impact on them (except insofar as that expansion brought in new sources of revenue, the loss of which, when this expansion ceased, had to be made up by evermore crushing taxation at home). For the most part, these years of the *Pax Romana* (the Roman peace) were good ones, a time when wars were fought on or beyond the borders and life within the empire was marred only by a few minor plagues and one major natural catastrophe, the eruption of Mount Vesuvius (A.D. 79). To paint a picture of life throughout the Roman Empire at this time would be a momentous task, as even a quick glance at the extent of the empire and its diversity indicates. But a few words may help to give some idea of the type of lifestyle generally current in the world through which Christianity was spreading so rapidly.

The majority of the people in the Roman Empire followed the traditional trades of the Mediterranean,

such as farming, fishing, tending olive orchards and vineyards (one thinks of the popularity of the vintage feast), raising livestock, and so forth. Land was the essential element, but the sea was important as well and generated numerous trades of its own: shipbuilder, sea captain, and provisioner, to name but a few. There were also urban professionals such as traders, doctors, barbers, bakers, street vendors, shopkeepers, merchants, and artisans. On the intellectual/artistic side one finds teachers, writers, poets, sculptors, potters, painters, builders, musicians, and actors. Slaves could fit in almost anywhere, for they ranged from the simple agricultural worker to the highly educated professional. Soldiers, prostitutes, government officials—the none-too-surprising list could be extended considerably. In other words, if you eliminate jobs and professions created by the special conditions of modern life and current technology, you have a good idea of what people in the first two centuries of our era did to earn a living.

In the Roman catacombs are representations of a gravedigger, a vegetable vendor, a medical lecturer, and other such indications of the ordinary life at that time.

One's lifestyle depended to some extent on where one lived (the conditions in England hardly being those in Egypt), but far more on one's economic circumstances. In Rome itself, a person of meager means would most likely live in one small dark room in an apartment building (such a building being, in theory, no more than seventy feet high as decreed by Augustus for reasons of safety) and cook over an open stove (a hazardous enterprise) or buy from street stalls. Such a person would dodge traffic in the narrow, congested streets during the day, enjoy the public entertainment of the "circuses" whenever the opportunity arose, and lie awake at night as the heavy supply wagons, forbidden to the city by day, rumbled by.

The upper-middle-class family, on the other hand, might have a very nice house indeed. Typically one would enter into an atrium, a rectangular room with a roof open over a cistern to catch the rain water, with smaller rooms around it. At the far end there might be a reception room between the atrium and the garden, the latter being a point of focus and pride located at the rear of the house, far removed from the hustle and bustle of the street. It was planted with artistry and loving care, perhaps provided with a small pond or fountain, and filled with as much statuary as the family could afford. The garden, like the atrium, was surrounded by smaller rooms. These rooms, both those around the atrium and those around the garden at the back, might reach great heights of elegance, with mosaic floors and walls painted with scenes giving color and life to the otherwise dark cubicles. Such murals can still be seen at Pompeii and Herculaneum, preserved for many centuries by the ash and lava that engulfed them during the eruption of Mount Vesuvius. Inside as well as out, the family would add whatever knick-knacks were within its means.

But as land grew more expensive, especially in a city such as Rome, private homes became a rarity and even the upper middle classes turned to apartment houses, though far more luxurious than those of their poorer neighbors. "Garden houses" like those that have been uncovered in the Roman port of Ostia offered considerably bigger units, open space, large windows, and shallow balconies (which usually served to protect the window below them rather than provide more living space). Sometimes the entire first floor was given over to a grand apartment, with more modest accommodations above.

Rich or poor, light and heat presented a major problem. Oil lamps provided only a modest glow; the window coverings, used to keep out the cold, also kept out the light (window glass did not come into general use, even among the wealthy, until the time of Augustus);[3] and braziers must barely have taken the chill out of the air on a cold, wet, winter day. However, in one way, Rome and some of the other cities like it were far, far ahead of anything known in the West until almost our own century—they had an abundant supply of fresh water. By Trajan's time, Rome had eight aqueducts (at one point there were as many as nineteen) providing 200 million gallons a day for drinking, scrubbing, and, most especially, for the great public bathing establishments, as well as for some private ones of a very impressive size. On the other hand, sewage removal must have left a lot to be desired. Sewage with a million people, to say nothing of animals, within something less than eight square miles, presented no small problem. Rome itself boasted public latrines and a drainage system, but people on the upper floors of the apartment buildings were as likely as those in the Middle Ages to empty their chamber pots from a window rather than lug them to a cess trench nearby or the pit provided in the basement.

By the third century, the "bread" of the famous "bread and circuses" was just that, baked loaves rather than simple grains, which the poor had no satisfactory way of preparing. The poor supplemented their diet of bread when possible with olives, beans, figs, and cheese, or perhaps an occasional piece of meat, most likely pork, or fish from a street vendor. By necessity no epicures, they drank water rather than wine and were glad enough if their stomachs were full.

Like everything else, food depended to some extent on where you were in the empire and even more on how much money you had to spend. Until poor husbandry strips the rest of the hillsides bare, and humans succeed in completely polluting the water, the Mediterranean region will, as it has throughout recorded times, provide a healthy and varied diet. The problems under the Roman Empire lay in producing enough food for both farm and city, and particularly in getting it to where it was most needed. The much-praised Roman roads on which Caesar could travel eight hundred miles in eight days were troop roads. Supplies could be transported relatively quickly and inexpensively only by water. Long-distance land transport for foodstuffs did not become viable until the advent of the railroad. Before then people in a landlocked location rarely ate anything that came from more than thirty miles away. As early as the second century A.D., the physician Galen recognized and lamented the effects of malnutrition, which was largely the result of inefficient farming techniques and transportation systems.

At the other end of the scale, the wealthy who lived where they could take advantage of water transport seemed to think that the further away something came from, the better it must taste. Of necessity Indonesia supplied spices and India pepper, whereas the true gourmet preferred oysters to come from Britain, ham from Gaul, pomegranates from Libya, pickles from Spain, and fish quite likely from his own well-stocked pond or, if not, at the least from a special spot on the Tiber. Although, from our point of view, heavy sauces may have marred or even completely destroyed natural flavors, people appreciated freshness whether it could be tasted or not.

The upper-middle-class housewife, whose budget would not stretch to the luxuries of the rich, could at least raise dormice in large terra cotta jars (with holes in the sides for air and a spiral ramp leading up to a feeding tray), a dormouse fattened up on nuts being considered a special delicacy by her family. Dormice or oysters, ham, fish or a special cheese—all would be served with the best wine, quite likely from the Jura, on the finest tableware the family could afford, glassware (replacing bronzeware) becoming increasingly popular in the second, third, and fourth centuries. But one sight familiar on today's tables would have been absent—forks. These handy utensils would not appear for many centuries.

Food, shelter, and clothing, or at least some sort of covering—these are the eternal necessities. We know less on the subject of clothing than we know about housing and nourishment, but, as usual, wealth was the key. From the short, bright, undoubtedly cheap clothing worn by the prostitutes sitting on benches outside the brothels, to the Roman senator's voluminous wool toga and his wife's *stola* (a long dress with plenty of fabric, familiar from the statuary of the time), the range would have been great. During the period under consideration, the long-sleeved tunic of such fine fabric as silk or muslin increasingly became the choice of society women, whereas men's attire gradually came to reflect a refined version of barbarian custom, short tunics rather than voluminous drapery. Women of wealth enjoyed makeup, elaborate hair styles, and fine jewelry—refinements that have a very familiar ring.

In fact, the world of the Roman Empire (minus products that reflect recent technological innovations) seems not such an unfamiliar place. To the

person of our own time, life in the year A.D. 1000 would have appeared far stranger than life in the large cities of the Roman Empire in the second century, though life in the countryside could be primitive indeed. Urbanization (although the Roman world remained overwhelmingly rural, especially in the West), taxation, bureaucracy—all things that affect our own daily lives—affected those of Roman citizens. But with the third century, the empire was to suffer cataclysmic upheavals, after which it would never again be quite the same.

Notes

1. Pierre du Bourguet, S.J., *Early Christian Painting*, trans. Simon Watson Taylor (New York: Viking Press, 1966), p. 5. Elsewhere du Bourguet comments, "Truism though it may be, it remains a fact that without early Christian art there could not have been a Byzantine art, a Western Christian art, or indeed a Christian art of any kind. It contains in embryo all the Christian art of the future." (Pierre du Bourguet, S.J., *Early Christian Art*, trans. Thomas Burton [New York: William Morrow & Company, 1971], p. 15.)

2. Edward Gibbon, *The Decline and Fall of the Roman Empire*, vol. 1: 100 A.D.–395 A.D. (New York: The Modern Library, n.d.), p. 1.

3. Although glass making may extend back more than two thousand years before the birth of Christ, the earliest blown glass probably dates to the first century B.C. But the use of glass expanded greatly during the period of the Roman Empire, and the Christians were to expand still further the artistic possibilities of this medium.

CHAPTER

2

Christian Art before the Legalization of Christianity

The Catacombs

On a Sunday afternoon at the end of the fourth century, some Roman schoolboys decided to explore one of the catacombs beyond the city walls. Even looking back over more than a millennium and a half, one can easily imagine the boys cautiously penetrating the subterranean gloom and daring each other to go ever farther down the dark, mysterious passages filled with the graves of the dead; there probably was a bit of shoving and pushing—nothing suggests that young boys were any different then than now—and a little nervous laughter to show each other that they weren't *really* afraid. But, underneath their surface bravado, they must have been properly awed by the necropolis through which they made their way.

Figure 2.1:
The Catacombs: The Roman catacombs were, and are, dark, claustrophobic, and uninviting. But the art with which the wealthier Christians began to decorate the burial places of their loved ones is a glowing reminder of the Christians' love and their faith in God.

A little more than two centuries before, professional gravediggers known as *fossores* had begun creating mazes from tufa, a soft stone of volcanic ash and sand that is not too difficult to excavate but hardens on contact with air. Some catacombs may have started with an abandoned quarry which had once provided the Romans with *pozzolana,* a noncohesive tufa mixed with lime to make mortar. But a quarry would have been only the beginning, since catacombs tended to grow quite rapidly.

From the outset, the Christian population of Rome increased rapidly, with an estimated forty thousand Christians in Rome by the middle of the third century. The Church considered it its duty to bury all Christians, including those who were indigent. Cremation was not acceptable, an attitude that may have been influenced as much by the customs of the time as by the Christian belief in bodily resurrection. No one ever implied that martyrs whose bodies were devoured by wild beasts or whose remains were thrown to the four winds would fail to enjoy everything that a more conventionally buried Christian could hope for in the life to come.

By law, burials could not take place within the city itself, but even land outside the walls of Rome was expensive. (Although Christianity was prohibited, the land that the Christians used for burials *was* legally acquired and duly paid for.) Considering the number of bodies to be accommodated, every effort had to be made to make the fullest possible use of a location. Although surface graves undoubtedly

existed, excavations beneath the ground—though arduous—were made practical in the environs of Rome by the character of the tufa. This allowed a vast number of Christians to be buried within a single cemetery. It was a practical solution, having the additional benefit of making it possible for many bodies to be crowded around the remains of a martyr. And if one needed a religious rationale, one could always recall the rock-hewn tomb in which Joseph of Arimathea·had placed the body of Jesus.

The approach to the construction of the Roman catacombs seems to have been flexible, although there was probably some general overall plan. When needed, a new passageway might be struck off in almost any direction where the soil was suitable (although usually at right angles to the original gallery)—good *fossores* being engineers of sorts, as well as sturdy fellows. Eventually steps led to different levels superimposed one upon another, from the oldest down to the most recent. In theory, a catacomb could go as deep as conditions made practical, but it never transgressed the boundaries of the plot of ground as inscribed on the portal of the cemetery. The inscription gave the width of the frontage and how far back the plot extended from that line. These dimensions were respected, even below the surface.

Between the difficulties of the construction and the constraints of space, the available space was used as efficiently as possible. Those adventuresome schoolboys would have traversed galleries or corridors scarcely a yard wide lined on either side with horizontal layers of niches, known to archaeologists as *loculi*, for the burial of the dead (see Figure 2.1). Graves, referred to as *formae*, were also set in the

Inhumation was the common practice in Rome by the second century A.D., and it was the Jewish custom as well. Archaeologists have discovered Jewish catacombs in Rome that date from the same period as the Christian catacombs. Whether the Christians were influenced by the Jews, or vice versa, is not known. There is the possibility that both Christian and Jewish catacombs were merely a response to the problem of using burial land as efficiently as possible.

floor. Many of the dead buried in the galleries were people of limited means whose bodies, had it not been for the generosity of other Christians, would have been tossed into common burial pits and covered with lime. As it was, the bodies were wrapped in a shroud before being placed in a niche or floor grave either alone or with another body, presumably that of another family member. The grave was then closed with a slab of stone, a piece of marble, or plaster inset with tiles.

From time to time, the schoolboys would have encountered more elegant burial spots known as *arcosolia* (semicircular recesses found both in the galleries and in the burial chambers) or *cubicula* (small rooms) opening off of the galleries. These *cubicula* were the final resting places of members of wealthier families. Here, as in the galleries, one finds *loculi* and *formae* but also bodies housed in sarcophagi of stone or lead. The *cubicula* were large enough to serve as gathering places for the friends and relatives of the deceased when the traditional meal was held in his or her honor a month after the death, then annually—very lively meals, as it happened, which gained additional conviviality with every cupful of wine. (As the Church grew more straitlaced, these celebrations were considered a bit too convivial and were eventually prohibited, at least in their original form.) But even the *cubicula*, though more spacious and better appointed than the catacombs as a whole, were, and are, essentially dark and claustrophobic, as noted later by one of the boys in his account of their adventures.

The reality of the Roman catacombs was quite different from the romantic nineteenth-century picture of white-garbed Christians wandering about

the catacombs in profound conversation (two or more abreast—although, as has been stated, the galleries are only about a yard wide). Clothes would not have remained white long under the circumstances, as certain late fourth-century Roman matrons undoubtedly discovered when their disheveled sons reached home. And only an extremely lively imagination, one blind to practical considerations, could conceive of a Christian community living secretly underground during the era of persecution. In the first place, the fact that these catacombs were Christian burial spots was no secret since, as has been mentioned, the land under which the catacombs were excavated was owned legally. Scholars may dispute the particulars of these acquisitions, but Rome was a society governed by law, and there was simply no way that any piece of ground could be taken over without a set legal procedure being followed. Then there would have been the difficulty of provisioning a large number of people without everyone in the city knowing about it. And finally, something that could never be mentioned in polite society during the Victorian era, any such community actually living in the catacombs would have been faced with the tremendous problem of human waste.

As it was, a few Christians may have sought refuge in the catacombs for very brief periods of time, but that was about it. Services were not held there regularly, and there are no really large rooms that date from before the legalization of Christianity in 313. In addition, one must consider the logistical difficulties of getting a good many people in and out of these underground mazes. However, this is not to say that the catacombs were only visited for burials. From very early on, the graves of the martyrs

attracted the pious, and mass was sometimes said there. Commemorative meals were held in honor of the dead; in the *cubicula*, seats were sometimes cut into the rock probably for this purpose. However, there were accommodations for such gatherings above ground as well, and a place with plenty of light and fresh air would surely have been preferred by many. Since only the wealthy could afford embalming, the air of the catacombs must have left a good deal to be desired. But darkness is the overwhelming impression created by the catacombs even today. Occasional light shafts *(luminaria* or *lucernaria)*, used for hauling up excavated material, must have let in some light and air. Yet neither then nor now are the catacombs a place one would wish to spend a great deal of time.

Many people assume that the term *catacomb* automatically implies the Roman catacombs, but actually there are catacombs (underground cemeteries) scattered throughout the Mediterranean area. (For our purposes, *catacomb* will be used here to denote the Roman catacombs unless otherwise noted.) Even the designation *catacomb* is something of a misnomer since the name comes from a specific geographical description that applied to only one locality. The Latin *ad catacumbas* simply means "at the place of the declivity" or, more probably in this case, at the ravine that excavations have revealed. This site, some two miles beyond the Aurelian walls on the Via Appia Antica where one now finds the Church of Saint Sebastian, was not even the first of its type. But it attracted special attention because it was associated with Saints Peter and Paul, and, consequently, was kept open for pilgrims until about the ninth century, long after other such burial spots

had been closed and forgotten. In this way, its name became generic.

Begun in the middle of the second century A.D., the catacombs were already beginning to fall into disuse by the time the schoolboys decided to explore them two centuries later. Burials ceased altogether in the fifth century, and when the last catacomb was closed in the ninth century, they were for all intents and purposes "lost" until the end of the sixteenth century. Scientific exploration had to wait until the nineteenth century, the point at which the general public became informed about their existence. It has been estimated that before the abandonment of the catacombs, *fossores* had carved out some 550 miles of passageways, about four-fifths created after the legalization of Christianity, which means that the fourth century, until decline set in, must have been a very busy time indeed for catacomb building.

The reasons for the gradual abandonment of the catacombs are not difficult to find. The population of Rome had begun to decline, a process that was to be accelerated by the barbarian rampages in the fifth and following centuries, and with it land values had dropped significantly. Meanwhile, both life and property were increasingly insecure, especially beyond the city's walls. People preferred—and with the fall in land values could afford—surface burial in or around the great cemetery churches which sprang up closer to Rome to interment in the more isolated, and hence vulnerable, catacombs. Yet eventually even these churches and their environs were no longer secure, and in the early seventh century, the remains of many martyrs (twenty-eight wagon loads) were transferred ("translated") to the Pantheon within the city walls. In the eighth century, as conditions

deteriorated further, even more relics were brought to safety within the walls until the last catacomb was closed in the ninth century.

But what a magnificent legacy was left to be rediscovered nearer our own time: those hundreds of miles of galleries, and uncounted *cubicula* and *arcosolia*—of interest not only for their historical value but because they held a large part of the extant Christian art predating the legalization of Christianity.

The Persecutions

If the reality of the catacombs bears little resemblance to the romantic image of the nineteenth century, the persecutions themselves (linked so closely in the popular mind with the catacombs), though neither as constant nor as widespread as commonly believed, were otherwise all that is claimed. The evolution of anti-Christian sentiment and the attitude of the Roman government toward the Christians are a fascinating story in themselves. But what is significant for present purposes is that, just as Christian art was coming into being at the beginning of the third century, a Christian could be tortured, even put to death, simply for admitting to be a Christian. If a person accused of being a Christian would not demonstrate loyalty to the empire by worshiping idols (images of the Roman gods or the emperor, emphasis varying somewhat depending on time and place), death was likely to take place under the most gruesome circumstances.

Originally, churches (i.e., local congregations) made every effort to keep records of those members

who had given up their lives for the faith. Many of these records were lost during the Middle Ages, but a few unquestionably historical documents remain. Among the most memorable of these is the account of the martyrdom of Perpetua, Felicity, and their four male companions, written in part by Perpetua and one of the men, and completed anonymously after their deaths at Carthage in 203. It serves as an actual example of what some Christians had to face and the grim reality that overshadowed early Christian lives. Such accounts of early martyrdom provide the backdrop against which early Christian art was created.

Perpetua was a young woman from a good family, quite possibly a widow, living in Carthage with her small child. Perpetua, Felicity (a slave girl nearing the end of her pregnancy), and four male companions were placed under house arrest, at which point the two women and three of the men—all catechumens, only the fourth man having been baptized—received the sacrament of baptism. Soon thereafter, they were transferred to the common jail, where Felicity endured a difficult labor and the jeers of one of the jailers as she gave birth to a little girl. (The baby was immediately adopted by another Christian, and Perpetua's child, about whom she was extremely concerned, was taken home.)

The six Christians were condemned to death by wild animals—a leopard, a bear, a boar, and a wild cow. These, however, failed to complete the job, and the survivors had to be dispatched by a sword thrust in the throat. The first thrust failed to kill Perpetua, who, though in unspeakable pain, guided the sword herself for its second and fatal blow.

That a devout Christian might be called upon at any time to endure the "most exquisite torments" for

his or her faith can be seen all too clearly in the fate of Perpetua, Felicity, and their companions. In this is a certain grim irony because, though Christians met death because of religious conviction, they were being persecuted for political rather than religious reasons. Sometimes, such as under Nero, persecution was simply indiscriminate and sadistic, but usually it had a more logical basis. The Roman officials assumed (for the most part correctly) that any person enjoying the benefits of the Roman Empire would gladly express loyalty to the empire by doing homage before the traditional gods of Rome and/or before the image of the emperor. The emperor, in particular, represented the might of Rome, a symbol of unity in an empire inhabited by people with different cultures, traditions, and languages. Furthermore, he was god, or at least a god-in-training, for in the early days of the empire only a particularly megalomaniac ruler insisted on being worshiped as a god while still alive. Generally speaking, there was no opposition to any of this. In fact, quite the opposite. New gods and new religions were readily accepted. One even gets the sense of an attitude of the-more-the-merrier, a feeling on the part of most people that no possible source of divine help should be neglected—most people, that is, except for the Jews and the Christians.

The Jews had sufficient political clout, at least until the disastrous Jewish uprising of A.D. 69, and inspired enough fear of armed resistance that in their case the issue was rarely pushed—except by Caligula (one of those megalomaniac emperors who could not wait to die to become a god), and then it was the emperor, not the Jews, who backed down. But the Christians were another matter entirely. The sect, or

> On earth the emperor might have the benefit of a divine spirit, but the transition to full divinity came only with death. It was in this context that Vespasian on his deathbed is supposed to have said, "Oh dear, I think I'm about to become a god."

religion, or whatever it might be—there was definite confusion on the part of the officials as to the proper classification for Christianity—was growing too rapidly to be ignored. To add to this, they were a strange, suspicious group that might well be guilty of the incest, atheism, cannibalism, sexual immorality, and other atrocities that were imputed to them. After all, what good could one say about people who talked about "eating flesh" and "drinking blood"? But the greatest fears arose from doubts about their loyalty to the empire. And the empire could ill afford to tolerate a large, subversive group in its midst since, after the best of times as described by Gibbon, the worst of times quickly followed. The empire was fighting for its continued existence.

The Worst of Times

This time of troubles is sometimes referred to as the third century, though we should see it as the period between the onset of the rule of Commodus, that unworthy son of the philosopher-emperor Marcus Aurelius, in 180, and the accession of Diocletian in 284. Commodus quickly patched up an inadequate peace on the Danube rather than fight to a decisive conclusion the war in which his father had been engaged. This left major problems in that region, with which his successors would have to deal. The young man himself had no interest in the affairs of the empire, his one passion in life being gladiator contests. But no matter how uncaring and ineffectual a ruler he might have been, Commodus did not create the difficulties that were to wrack the Roman Empire for more than a century; his weak and incompetent

rule merely gave long-existing problems the opportunity to develop unfettered.

The most obvious cause of the miseries of this period was the problem of succession. Unfortunately, the army soon became particularly adept at practicing a trick it had learned from the imperial guard and the Senate, that of making and unmaking emperors. Since each successive emperor plied the troops with rewards, it was clearly in their interest to make these lucrative transitions occur as frequently as possible. (One particularly cynical emperor with a clear view of this situation advised his sons to enrich the soldiers and forget about everything else.) Emperors were dispatched with such regularity that the worst stretch of this chaotic time, the half-century between 235 and 285, saw roughly twenty-six emperors (some of whom could be more accurately described as "pretenders"), only one of whom died a natural death.

Even as chaos reigned at the center, barbarians subjected the northern and northeastern peripheries of the empire to increasing pressure (see Figure 2.2). People who know this period only through school texts, which generally pass over it in a couple of sentences, sometimes have the impression that Rome was peacefully ruling the world when the barbarians (rude and coarse or strong and virtuous—depending on who is telling the tale) swept in to destroy Roman civilization, thus inaugurating the Middle Ages, a giant step backward in every respect, most especially in that of personal hygiene. As a matter of fact, barbarians had been around all along. A good Roman could still shudder at the thought of that unfortunate experience with the Gauls in 390 B.C. when barbarian invaders briefly held all the Roman

lands except the Capitol, whose inhabitants were fortuitously warned of the enemy's nocturnal approach by the honking of their geese.

But, familiar though it was, the barbarian problem was one that was not and could not be resolved on any permanent basis. The Roman Empire never succeeded in establishing an easily defensible line across the entire northern frontier, although some of its efforts were certainly impressive. By the second half of the second century A.D., barbarian pressure from the north was steadily increasing, and then, to make matters still worse, some of the barbarians, the Germans in particular, had managed to learn a great deal about warfare from their encounters with the empire. Also, while the northern and northeastern frontiers remained the most vulnerable to barbarian pressure, it should be remembered that there were always tribes from the Sahara probing at the empire's underbelly.

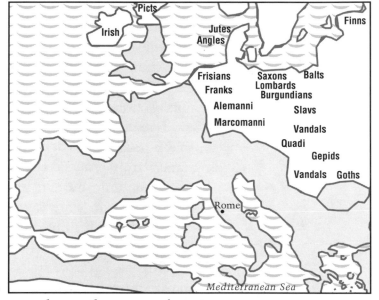

Figure 2.2:
Pressures on the Roman Frontiers, mid–third century A.D.

Nor were all Rome's enemies barbarians. The Persian Empire, revitalized under the Sassanids (A.D. 226), broke from the confines of today's Iran and pressed hard against the Roman Empire's eastern flank. It was in this period, mid–third century, that the Sassanids captured Dura Europos. They also captured a Roman emperor (Valerian), capturing a

Roman emperor being at the time unheard-of. And the problem of the Persians, like that of the restless barbarians, was not about to go away. In fact, the Persians were to remain a threat until they were finally defeated by a Byzantine emperor in the first half of the seventh century, only to be immediately replaced by a still more formidable foe—the Arabs.

All these wars were prolonged and expensive; worse still, they were defensive, not offensive as in the days when new conquests brought with them great amounts of booty and new lands to exploit. The economy of the Roman Empire could in no way cope with the strain. It had failed to develop and expand to the extent that it might have, and reliance on vast amounts of cheap labor had discouraged the sort of technological developments that might have proved valuable, especially now when war, plague, and a falling birthrate sharply reduced the empire's population.

The economic burden fell particularly hard on the rural poor, who were taxed both on their person and on their land. Inheritance taxes were more progressive, and although these were only levied on Roman citizens, a decree in 212 conferred this status on almost all freeborn males in the empire. Revenue was also raised by means such as the sale of monopolies, customs taxes, manumissions (slaves given or buying their freedom), and special levies. But the unpleasant fact remained that the treasury was being depleted far faster than it could be replenished. Expenses, both bureaucratic and military, were on the rise, while the income of the empire remained about the same or perhaps even declined. Nor was that the only monetary problem. There was not a sufficient amount of bullion to produce the coinage necessary, no token money such as our paper dollars

being used at the time. Many precious metals had been converted into nonproductive ends such as jewelry. Thus the coinage was necessarily adulterated, resulting in disastrous inflation.

Even the well-to-do of the cities could not escape economic pressures. Inspired by pride and intercity rivalries, the upper classes had in the past contributed heavily to the improvement of their cities and to the amusement of the citizens, thus setting a standard that could no longer be met. Some civic positions carried with them the obligation to provide games for the populace, an expense which fewer and fewer wished to bear. And, as the imperial situation became increasingly desperate, these formerly prosperous citizens found themselves in an ever-tightening vise. If the tax revenues fell short for the district, as happened with increasing frequency, the members of the town councils had to make up the difference. Since no one wished to be faced with such a drain on personal capital, municipal office, at one time eagerly sought, had to be made compulsory.

Once things began to go seriously wrong, they seemed to go wrong in every way. Plague struck. Crops failed. Fields were abandoned. Small farmers, caught between the low yield of played-out land and strangling taxation, abandoned the land, often for a life of crime. Law and order broke down, and town and country alike were victims of looting, not only by barbarians but also by Roman soldiers. At the same time both towns and country were also subjected to heavy imperial requisitions, creating more poverty and causing an ever-downward spiral.

The situation was grim: internal dissension and chaos, growing external pressure from barbarians and Persians, an economic system falling apart, crushing

The plague of Cyprian (so called because Cyprian, bishop of Carthage, described its symptoms: vomiting, diarrhea, an ulcerated throat, and putrefaction of the hands and feet) harried the empire in the middle of the third century, spreading from Egypt to Scotland. Deaths outnumbered survivals among those afflicted. Outbreaks of this plague continued for sixteen years.

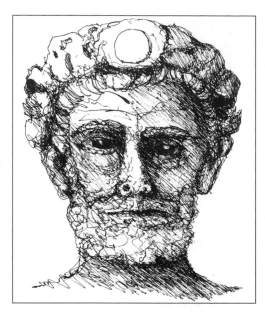

Figure 2.3:
Diocletian: The emperor Diocletian completely reorganized a disintegrating empire and revised its administration. Although an active military man himself, Diocletian surrounded the imperial power with the formality and ceremony heretofore associated with an Eastern despot. The emperor was now treated as a being far above ordinary mortals, an awe-inspiring, semi-divine monarch with unbounded authority over his subjects. (Drawing inspired by a contemporary sculpture of Diocletian now in the Archeological Museum, Istanbul.)

taxation and constant requisitions, citizens no longer willing or even able to play their role in the scheme of things. How long could any political system endure under such circumstances, especially one that had never had any compelling basis for unity?

It must have seemed that the empire was at its end when in 284 Diocletian, a native of Dalmatia on the Adriatic coast of what was until recently Yugoslavia, seized power. This tough, determined general, who had already proved his worth on the ever-troublesome Danube border, can be credited with saving the empire. Contemporary likenesses (see Figure 2.3) show us a man with a forehead furrowed above thick brows and knowing eyes, an ordinary rather squat nose, and lips set between a mustache and a short, curly beard. The face is that of a hardened soldier of the frontier, a man who has seen it all and has endured. Here, we sense, is someone who not only coped in the past but would continue to do so in the future, who would set things straight—not out of any exalted idealism or for any theoretical reasons, but because of a truly Roman belief in organization and order. One can easily imagine him saying, "Enough of the present nonsense. We are going to put things right; we are going to get this empire *organized,* and it's going to *stay* that way."

The first step was to solve the problem of the imperial succession. It was quite apparent to everyone that the empire had to have an emperor.

The only other possible contender for imperial rule, the Senate, had lost its starch centuries ago, although it had never completely withered away. Every now and then it would foment an uprising or put forward an emperor, an octogenarian of its own ranks whenever possible, but there was not the slightest indication that the Senate could ever again rise to be the powerful ruling body it had been in the days before Augustus or (more realistically) before Julius Caesar. An imperial monarchy was the only viable alternative. But, if the Roman Empire was not to collapse entirely, the constant battles for the imperial succession would have to cease. Diocletian decreed that the emperor would co-opt his own successor as in the days of the "good emperors." As *caesar*, the heir apparent would serve under the emperor, or *augustus* (plural *augusti*), learn his trade, and be ready to take over when the old emperor retired—yes, retired, for Diocletian believed that the head of state should bow out gracefully before he became incapable of fulfilling his responsibilities.

The old soldier went still further. Stubborn Gauls in Britain, fierce Germans on the Danube, Persians poised to strike at the rich province of Syria—the empire was too vast and there were too many threats from too many quarters for one man, even with the aid of the best and most willing of caesars, to cope with them all. Though, in theory, the imperial power remained one, for practical purposes there needed to be two representatives of that power, two emperors, or augusti, one in the East and one in the West, each with his caesar, to manage the Roman Empire and to protect it from its numerous enemies. Thus the Tetrarchy (the rule of four) was born and with it an order that recognized the new realities.

Meanwhile, Rome, too far from the frontiers, was abandoned as the seat of government, although it retained its prestige. Milan became the most important administrative center in the West and later the home of some very impressive examples of early Christian art and architecture. Nicomedia (today's Izmit in Turkey) was similarly important in the East until it was displaced in the fourth century by Constantinople.

In the same spirit of organization, the old, often unwieldy provinces were superseded by a system of prefectures (large units governed by a prefect), which were, in turn, broken down into smaller units known as dioceses (each of these being governed by a vicar). The provinces themselves were reduced to even smaller and more numerous units at the bottom of the scale, several provinces making up one diocese. A pyramid was thus created: province, diocese, prefecture, and—at the pinnacle—the emperor (be he in fact one or two), *dominus et deus*, lord and god, the supreme autocrat and the sole source of law.

During the troubled times from which the empire was only just emerging, soldiers had been raised to fill positions of civil importance, a system that made it all the easier for the military to control the administration. Realizing this, Diocletian completely separated the civilian and military aspects of the government, greatly enhancing the size and strength of the former. The job of the civil service was, henceforth, to administer the empire and to collect the taxes. The job of the military was to protect it. And, while he was at it, the emperor reorganized the military as well, giving it a new sense of pride and purpose.

The reforms of Diocletian having the most impact on the future were economic. Here he recognized and

solidified changes that had already occurred. When Diocletian came to power, the farmer was already being tied irrevocably to the soil. Not a slave, the *colonus* (who would emerge as the serf of later centuries) could, nonetheless, not leave the parcel of land on which he found himself. His person was theoretically free, and neither he nor his family could be bought or sold. But what he did with his life was no choice of his. From birth until death he stayed with the land (which he did not own, but which could not be taken from him), tilling it as best he could, seeing too many of the fruits of his labors taken by those (the state, the army, and later the lord of his area) whose job it was to protect him. His sons must, by law, follow in his footsteps; his daughters must marry others of his kind.

By the same token, other situations also became hereditary. The shoemaker's son was expected to become a shoemaker and his daughter to marry another shoemaker, and the same for the butcher, the baker, and the candlestick maker. Hereditary guilds emerged and were encouraged. Thus by the end of the third century, many conditions regarded as an essential part of the Middle Ages were already in existence.

The upper classes were similarly regimented. A person was expected to stay in the class into which he was born, serf or senator. And the upper classes were often no better off than the lower. The once well-to-do citizens of the provincial towns, whom last we met being forced to make up the difference between the taxes due and the taxes collected, were eventually frozen in their position of service.

Taxation was reorganized and made more efficient. Obligations owed to the state became more

clearly defined and inescapable. More and more, the state relied on requisitions in kind, a clear indication of the trend that would dominate Europe in subsequent centuries. Naturally Diocletian also made a stab at stabilizing the currency and at price fixing, but with limited success.

Thus, having revamped the political, social, and economic life of the empire, to say nothing of the bureaucracy and the military, Diocletian turned toward the end of his reign to religion. Undoubtedly he wanted to use the state religion as a unifying force in the reorganized empire, and the Christians, with their unwillingness to express their loyalty in the accepted manner, clearly did not fit into the scheme of things. Perhaps there were also more specific motives connected with the persecution that Diocletian inaugurated just two years before he retired, but, if so, these are unclear. We have no idea why Diocletian waited so long to address religion, exactly why he came down as hard as he did on the Christians (except that Diocletian would do anything he did with great thoroughness), or precisely what set off the "Great Persecution" of 303, so called because it was more intense and far-reaching than any of its predecessors. But the Great Persecution, dreadful though it was, was like the final blast of a great storm, and (although there were scattered instances of persecution in the early fourth century) not even the last pagan emperor would openly persecute Christians in the future. Henceforth, persecution would take the form of reprehensible acts either by Christians against Jews or, with unhappy frequency, by Christians against other Christians whom they deemed heretics.

An Art of Faith, Hope, and Charity

Against this somber background of an empire in imminent danger of collapse and the ever-present specter of religious persecution, the Christian art that predates the legalization of Christianity by the emperor Constantine in 313 glows with the internal radiance of faith, hope, and love. With the major exception of the murals from the Dura baptistery, this art is overwhelmingly funerary—though whether this represents the actual situation or is merely the result of the vicissitudes of time, it is impossible to say. Yet it touches on death only peripherally and then with a quiet confidence in that which lies beyond. Throughout it is a celebration of the miraculous saving power of God.

As the Roman world offered much that could be fitted to the needs of early Christian art, so, too, did Judaism. Although it is impossible to assess to what extent Christian borrowings might have been visual, the importance of the Old Testament as a literary source is without question. Initially (again, with the exception of murals in the baptistery of Dura Europos) images seem to have been drawn preponderantly from the Old Testament, not a surprising state of affairs since the text was long familiar, whereas the canonical (official) version of the New Testament had not even been formulated when early Christian images were first created. Furthermore, images drawn from the Old Testament had much to recommend them. They would have been reassuring both to the Jewish convert, who would have been encouraged by the familiarity of the subject matter, and to the pagan, brought up among religions that traced their origins back into the mists of time and

It was not until about the end of the fourth century that a list of canonical books of the New Testament came to be universally recognized in the West.

for whom Christianity itself, without the foundation of Judaism, would have been an embarrassingly recent development. But perhaps even more to the point, the Old Testament is filled with numerous and dramatic examples of the saving power of God, exactly the message early Christian art sought to convey.

It has also been suggested that the subjects chosen were inspired by a prayer recited on behalf of someone either dead or dying. This prayer implores the Lord to deliver the soul of the dead or dying person as Noah was delivered from the deluge, Daniel from the lions' den, Susanna from her false accusers, and so forth. The parallels between the prayer and the subjects most often illustrated in the art from this early period are striking. Unfortunately, however, there is no evidence that this prayer was said as early as the third century.

Among the earliest Christian representations, we find Moses striking the rock from which water gushes forth to quench the thirst of the wandering Israelites, Noah floating in what looks like a box through the raging waters of the flood (see Figure 2.4), and flames licking menacingly around the legs of the three Hebrews consigned to the fiery furnace (see Figure 2.5). All these are telling examples of God's ability and willingness to save those who have

Figure 2.4:
Noah in the Ark: Scenes that demonstrate the saving power of God were particularly popular in early Christian art. It was hoped that as God had saved Noah from the waters of the flood, the three Hebrews from the fiery furnace, and Jonah from the great fish, so would God protect and care for those who put their faith in him not only in this world but most especially in the next. (Drawing inspired by a third-century wall painting in the catacomb of Saint Peter and Saint Marcellinus, Rome.)

faith, but some of these images had additional significance for those who first looked at them. The fact that King Nebuchadnezzar had condemned the three Hebrews because of their failure to worship idols would have been duly noted by contemporary Christians, themselves in danger of suffering torture and death for the same reason. Similarly, representations of Daniel between quiescent lions were understandably popular at a time when the cry *Christiani ad leones* (Christians to the lions) was no metaphor.

Figure 2.5:
The Three Hebrews in the Fiery Furnace: The three Hebrews had special significance for the early Christians since the young men had been consigned to the furnace by King Nebuchadnezzar because of their refusal to worship idols, a crime for which early Christians, too, suffered torture and death.
(Drawing inspired by a third-century wall painting in the catacomb of Priscilla, Rome.)

Other images frequently encountered are Adam and Eve ashamedly covering their nakedness (the recognition of sin, but balanced at Dura, it will be remembered, by an image of salvation), Susanna approached by the two elders who are about to molest her (and against whose accusations her innocence will be proved), and Jonah with the big fish.

The adventures of Jonah were an exceedingly popular subject for representation in early Christian art, not at all surprisingly, since the story of Jonah provides both another dramatic example of the saving power of God and a direct link between the Old and New Testaments. The analogy between the time spent by Jonah in the fish belly and that by Jesus in the tomb would not have been missed by the early Christians with their sharp eye for examples of prefiguration, that is, when an event appears to

Figure 2.6:
Jonah Cast Out from the Great Fish: Images such as Noah in the ark (Figure 2.4) and the three Hebrews in the fiery furnace (Figure 2.5) use a pared-down form to suggest an extended story. Here Jonah being cast out from the great fish is enough to recall all of Jonah's adventures. Such an image is referred to as an **abbreviated representation.** When an image has more action and a greater number of figures, it is called a **narrative image.** Both abbreviated and narrative images are important throughout early Christian art, although narrative images do not really seem to have come into their own until after the legalization of Christianity.
(*Jonah Cast Up.* Marble, 40.6 x 21.6 x 37.6 cm. Eastern Mediterranean, probably Asia Minor, Early Christian, ca. 260–75. © The Cleveland Museum of Art, John L. Severance Fund, 65.238.)

foreshadow what is to come. (Another way to express this same recognition of parallels is by the use of the term **typology.** Jonah, having endured experiences like those that Jesus would suffer, was considered a "type" of Jesus, and thus closely associated with him.)

On seeing a Jonah image, the Christian would have called to mind the words that the evangelist Matthew assigns to Jesus:

"An evil and adulterous generation seeketh after a sign; and there shall no sign be given

to it, but the sign of the prophet [Jonah]: For as [Jonah] was three days and three nights in the whale's belly; so shall the Son of man be three days and three nights in the heart of the earth." *Matthew 12:39–40*

Images of Jonah abound in third-century art. In the catacomb of Saint Peter and Saint Marcellinus, one of two sailors in a small boat heaves the naked Jonah over the side and into the waiting jaws (they can be described no other way) of a large, long-eared sea beast (see Figure 4.6). On the side of a third-century marble sarcophagus in Santa Maria Antiqua, Rome (a church which is unfortunately not open to the public), Jonah lies exhausted before the great fish (see Figure 1.2). A pair of small marble statues (Eastern Mediterranean, second half of the third century) now in the Cleveland Museum of Art depicts two stages of Jonah's ordeal. In the first, only Jonah's legs and feet are visible, extending upward from the jaw of the sea beast that swallows him. In the second, Jonah, a muscular, bearded man of middle years with arms upraised, emerges from the beast's mouth (see Figure 2.6). The hero is triumphant, but it is the sea beast who really steals the show. It has a good-sized snout, pointed ears, appendages that look like wings, two front paws for balance, and a long, curvaceous tail.

Meanwhile, in spite of the popularity of images drawn from the Old Testament, the New Testament was by no means neglected; we have already seen the use of a scene such as the meeting of Jesus with the woman of Samaria at the well. Incidents from the gospels relating to Christ's life and selected miracles were popular, particularly those miracles that

Early Christian thought and art depended on the foundation of the Old Testament and on a reading of the Old Testament that drew special attention to the ways in which it fore-shadowed the New Testament. For Jewish converts this was important because they revered the Old Testament as the word of God; if the New Testament had not been seen as harmonizing with it, then the whole system of Christian belief would have been on shaky, if not untenable, ground. Gentile converts valued a religion with a well-established provenance. If Christianity could not find its origins in the mythical past, as did so many of the pagan religions, it could do even better by calling on the great historical past of Judaism.

complement the message of deliverance so eloquently conveyed through Old Testament examples. The raising of Lazarus is one such miracle. Further, the time spent by Lazarus in the tomb, like that spent by Jonah in the belly of the fish, obviously prefigures the entombment of Christ and his resurrection. (The mystic concordance between Testaments was also seen as existing within the New Testament itself.) This scene appears often, as in the upper tier of mosaics at Sant' Apollinare Nuovo (Ravenna), where one finds a very large Jesus reaching out toward the much smaller, mummylike figure of Lazarus encased in a roughly suggested tomb (see Figure 7.1).

Such disparity of size is not unique, size often being used to establish importance, again a technique well known to the ancient world. A more puzzling example of disparity of size is found in scenes of Christ's baptism in the Jordan, such as that seen on the side of the marble sarcophagus in Santa Maria Antiqua (see Figure 1.2). In these cases, it is Jesus who is the smaller figure, appearing, at most, to be a prepubescent boy, although he is described as being a grown man at the time of his baptism. The explanation, however, is really quite simple; an unbaptized person was considered an *infans* no matter what his or her age since the person did not truly come of age until receiving this sacrament.

Nor is the pre-Constantinian Christian repertoire limited to the sacraments and inspiration of the Bible. For instance, in the catacombs we find numerous birds, including a parrot in the catacomb of Domitilla, nude **putti** (baby cherubs), at least one *fossor*, and an olive picker, as well as representations of other jobs and professions previously mentioned. We even find mythological subjects such as the

Figure 2.7:
The Orant: The orant symbolizes the soul of the deceased in prayer. This calm, untroubled image—an expression of the Christian's unwavering faith in God—is as close to death as one comes in the earliest Christian art. (Drawing inspired by an image on the marble sarcophagus, c. 270, in Santa Maria Antiqua, Rome.)

labors of Hercules, and historical subjects such as the death of Cleopatra.

But perhaps the most popular image of all from this early period is the **orant,** the soul of the deceased in prayer—a concept expressed by a figure standing frontally with both hands raised (see Figure 2.7). The orant is thought to be a purely Christian creation, although the gesture itself had antecedents in both the Jewish and gentile worlds. (Aeneas is described as praying in this position, his palms raised toward the

stars, in Virgil's *Aeneid*.) This pose is also common to other figures in the art of the time, such as Noah, the three Hebrews in the fiery furnace, Daniel and Susanna—all of whom pray for deliverance.

One scholar has seen the orant as "first of all a symbol of faith. Hope had its symbol in the anchor, love (agape) in the Lord's Supper, and if we do not find the symbol of faith in the orant, there is no other place we can look for it."[1] Even more significantly, the calm, untroubled image of the orant is as close to death as we really get in pre-Constantinian art. Once again, the earliest Christian art celebrates the saving power of God; in spite of the difficulties, secular as well as religious, of the tumultuous third century in which it came to birth, this art does not lament the trials and tribulations of this world, and in it even death itself has no sting.

Notes

1. Walter Lowrie, *Art in the Early Church*, rev. ed. (New York: W. W. Norton, 1969), p. 46.

CHAPTER

3

Constantine
and Christianity

The Triumph of Constantine

In 305 Diocletian abdicated, an unprecedented move for a Roman emperor, and retired to the great palace that he had built for himself on the Adriatic coast of the Balkans. (When barbarian pressure mounted in the seventh century, the people sought refuge in this enormous fortified edifice, from which grew the city of Split.) The old emperor insisted that his imperial colleague, Maximian, follow suit and the two caesars, Constantius Chlorus in the West and Galerius in the East, were raised to the imperial rank, two new caesars then being selected. For one moment, and one moment only, things seemed to go according to Diocletian's plan.

Unfortunately, however, Diocletian's orderly arrangement for succession neglected to take into

account human nature. In his system, sons could not succeed their fathers, but understandably the young men themselves did not see things this way. Viewed from the perspective of history, the man to keep an eye on was Constantius's son Constantine, who was at the moment left out in the cold as Constantius dutifully accepted for his caesar the man chosen for him by his co-emperor, Galerius.

There are several versions of what happened next. As the favored story has it, the perhaps thirty-two-year-old Constantine (the year of his birth is still disputed), then at the court of Galerius at Nicomedia (Izmit) on the Asiatic side of the Bosporus, surreptitiously decamped in the dead of night and made a wild dash west to join his father. Traveling at top speed and taking care to hamstring the extra horses at the first few imperial outposts so that no imperial messenger could impede his progress, he arrived safely at his father's camp in Gaul. After a brief campaign, the two men retired to Britain, where Constantius Chlorus, who had not been well, died in July of 306. (It is thought that Constantine's knowledge of his father's deteriorating health may have been an important factor in precipitating the son's hasty journey westward.)

In spite of their history of making and unmaking emperors, the army believed, at least in theory, in heredity. Besides this the young army officer, son of their late leader, undoubtedly gave clear evidence of his force of character and ability to command. Thus it is no surprise that the army of Britain hailed Constantine as emperor. It comes as even less of a surprise that a dogfight almost immediately broke out among those who, like Constantine, were considered, or considered themselves, to be emperors. In

308 as many as six men claimed to be emperors, and the bad old days of the third century seemed to be back. But this was to reckon without Constantine. After a few tumultuous years, Constantine met Maxentius, the last of his opponents in the West, at the battle of the Milvian Bridge (which crossed the Tiber north of Rome) on October 28, 312.

Again there are several versions of what happened, but in short it would seem that before the crucial battle Constantine either had a vision of a bright cross accompanied by the injunction that *in hoc signo vinces*, that is, "in this sign you will conquer" (or at least some version of this sentiment), or he had a dream in which he was enjoined to put the Greek letters *chi* (X) and *rho* (P), the first two letters of the name of Christ in Greek, on the shields of his soldiers. One thing is certain: Constantine won a resounding victory. Maxentius had taken a position in front of the bridge, which was supported by pontoons (Maxentius had destroyed the real bridge and erected the makeshift one in its place). When he and his troops retreated in haste, the pontoons collapsed and Maxentius and many of his followers were drowned in the Tiber. (Not surprisingly, images of Moses and the Israelites crossing the Red Sea, and of the unfortunate Egyptians being engulfed by its waters, gained popularity after the battle of the Milvian Bridge and Constantine's subsequent favoring of Christianity.)

The vision/dream Constantine had experienced prior to the battle was assumed to be a sign from the Christian God, and when Constantine won the battle, he took his victory as an indication of God's power. Henceforth the **chi-rho,** with the *rho* centered in the *chi,* formed the basis of the **labarum,** the

imperial standard adopted by Constantine. When understood as a symbol of the cross, it continues to play a part in Christian symbolism to this day.

The Man Constantine

The accession of Constantine I, or Constantine the Great, had enormous consequences for Christianity. Power, prestige, riches—all of these came suddenly and in abundant measure to a sect whose founder had preached simplicity, humility, and love. But Constantine did not, as is often popularly assumed, make Christianity the official religion of the empire or outlaw other religions. The famous Edict of Milan in 313 simply gave freedom of religious choice to all people of the empire. Nor was it the first such edict of religious toleration, for earlier the emperor Galerius had pronounced the Christians free to live as Christians and insisted that this order be promulgated in the West as well as the East. Nonetheless, it was Constantine's edict that marks the real and lasting change. Except for a brief spurt of anti-Christian legislation under Constantine's eastern colleague, Licinius (whom Constantine deposed in 324), Christians were from this point on free to practice their religion, a right not even revoked later in the fourth century by the last pagan emperor.

What sort of person was this Constantine? We know that he came from humble origins, born in the Balkans, or more specifically the area until recently known as Yugoslavia.

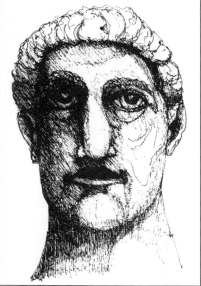

Figure 3.1:
Constantine: The emperor Constantine is perhaps best remembered for his legalization of Christianity. He did not, however, outlaw other religions or even have himself baptized until on his deathbed. Nevertheless, his active patronage of the Church had enormous implications for Christianity and its art. (Drawing inspired by a contemporary sculpture of Constantine, now in the Museo dei Conservatori, Rome.)

His mother, Helena, was the daughter of an inn-keeper. His father was a rising young military man, probably from a peasant family. Constantine's best-known portrait, the so-called *Colossal Head of Constantine* now in the Museo dei Conservatori, Rome, shows a man with huge brooding eyes staring into the distance, a rather lumpy nose, a small mouth, and a rounded chin (see Figure 3.1). He looks like both a visionary and a man of action, all quite true, although one can hardly stop there. Like so many other men who have changed the world, Constantine was a person of great physical drive and superior mental energies. He was a highly effective general and an impressive administrator, as demonstrated by his successful implementation of Diocletian's military and economic reforms and development of the civil service. His energy and intelligence in administering the empire shored it up sufficiently for it to continue to exist in its traditional form for almost a century, while the "new Rome" (Constantinople, which he established on the Bosporus) gave the Roman Empire, albeit in a much altered form, over a millennium more of life. Yet this man of so many talents and abilities was also egotistical, selfish, a show-off, and an altogether ruthless person with a quick temper and a steadfast determination to have his own way.

Constantine engendered tremendous loyalty in his troops, who tended to associate their loyalty with him as a person rather than with the more abstract notion of empire, and when it suited him he could charm. Most of his legislation suggests that he was generally a humane ruler who sincerely wanted the best for all the inhabitants of "his" empire (and he did think of the Roman Empire as his personal possession). Yet this is the same man who had his

Constantine's father, Constantius Chlorus, was forced to divorce Helena for political reasons, and she disappeared from history for over thirty years. During her son's reign she returned as a powerful woman and a devoted Christian. The woman Constantius Chlorus took as his second wife was Theodora, adopted daughter of Maximian, Diocletian's co-augustus. Ironically enough, Constantine, too, had to set aside his first wife (Minervina) because of politics to remarry a better-connected woman. This second wife of Constantine was none other than Fausta, daughter of Maximian and sister of the Maxentius who met his end in the waters of the Tiber as a result of his defeat by Constantine at the battle of the Milvian Bridge.

eldest and highly promising son, Crispus, executed, ordered the execution of the innocent son of his former co-emperor and brother-in-law, Licinius (who had also met his death at Constantine's command), and probably arranged to have his second wife, Fausta, scalded to death in her bath. Was Crispus (the offspring of Constantine's first marriage) having an illicit affair with his stepmother? Did she accuse him of indiscretion and then go on to commit other indiscretions of her own? Was treason afoot? We really have no idea. We do not even know with absolute certainty that Fausta's death can be attributed to Constantine. But in the case of the two young men there can be no question that the responsibility lies with the emperor, and we have nothing to show that he had sufficient justification for his actions.

Vain, egotistical, ruthless, cruel; humane, dedicated, determined, and efficient—the good and the bad were closely commingled, but for better or worse Constantine was certainly an entity and no small shadow passing quickly across the broad plain of history. While even the most energetic and astute ruler can vitiate his own efforts if his aims are conflicting or unclear, this, too, was never a problem with Constantine. He was, as far as one human being can be, relentlessly focused. All of his reforms, all of his actions, all of his policies were concentrated on one goal—a peaceful, unified empire. This, plus his own egotism, explains much about his approach toward Christianity.

Although not as yet a baptized Christian, Constantine had effectively thrown his lot in with Christianity at the Milvian Bridge. But to Constantine's disgust, he quickly found that the Church was not the unified body he had assumed it to be. An immediate

source of dissension arose in Africa and centered around those who, during the persecutions of Diocletian, had given up sacred texts to be burned or in other ways betrayed the Church, most commonly by offering, or getting someone else in their place to offer, pagan sacrifice. Could these traitors ever again be received into the Christian community? The more humane and compromising view held that, with proper penance, reconciliation could eventually be achieved; the rigorous viewpoint utterly rejected such a compromise.

From the outset, Constantine's attitude was made abundantly clear: the Christian Church, like the empire itself, must be unified at all costs. When his initial attempts at mediation failed, the emperor called a council of bishops at Arles (314). When even this measure did not succeed in restoring the unity Constantine demanded, he went so far as to send troops in to occupy the churches of the losing faction, the rigorists, known to history as the **Donatists.** Force, as is usual in religious matters, proved counterproductive and the controversy was to far outlive Constantine and his dynasty. But in spite of the inconclusive nature of his first foray into ecclesiastical dispute, the emperor was not discouraged from taking a more active role in another, and even more significant, religious controversy.

The great religious controversy of Constantine's reign—one that was to have tremendous political consequences for the future—concerned the nature of Christ and his relationship to God the Father. Was Christ, though divine, of somewhat lower rank than the Father—in effect, a lesser God created by the Father—or was Christ of the same substance as the Father and co-eternal with him? The faction known to history as the **Arians** maintained the former position,

which was strongly contested by others in the Church. When the debate raged so hotly that it threatened to tear the Church apart and even lead to civil war, Constantine called the first general Church council, known as an ecumenical council, to meet in Nicaea in 325.

The emperor himself greeted the assembled bishops with great pomp and circumstance. (Constantine loved a good show complete with all the proper staging and costumes.) He does not seem to have cared overly much about the theological issue; in fact, the key phrases were far less controversial in Latin, his accustomed tongue, than in Greek, the language of the great preponderance of bishops present. But he cared very much indeed about unity. Constantine told the bishops that he considered any dissension in the Church as formidable as a battle, and this from a military man who took battles very seriously. In the emperor's eyes, a split in the Church was just about as bad as that most abhorrent of all specters, civil war, and in fact, Arianism had threatened to cause exactly that. The goal of the council, and here Constantine's words were quite unambiguous, was to be peace and unity. And one can well imagine him following this pronouncement with a dour look that said "or else."

The outcome of this first ecumenical council was to pronounce the Son co-substantial with the Father, to condemn Arianism, and to resolve numerous other issues such as the date of Easter—henceforth to be celebrated on the Sunday after the first full moon following the spring equinox (March 21).[1] On the face of it, this was a tidy ending, but only on the face of it, because Arianism was by no means dead and was to continue to be a divisive element throughout the early Christian period.

Meanwhile, Constantine's involvement with, and encouragement of, Christianity was not limited to Church councils. Contributions, tax advantages, and prestige were conferred upon the now burgeoning Church—very practical benefits to which must be added the less tangible, but no less important, benefit of imperial favor. A religion in the ancient world was viewed from the perspective of the worldly rewards it brought its adherents (no matter how much the founder might have protested that his kingdom was not of this world), and Constantine, moving from success to success, became evermore committed to the religion that he saw as indissolubly linked with his good fortune. But for all his commitment to and support of Christianity, the emperor himself was not baptized until the end of his life.

Adult baptism following a period of instruction was the general rule, not the exception, in the early Church (though infant baptism did exist). Perhaps Constantine, ever mindful of the political ramifications of his actions, did not want to break definitively with paganism, still a viable force. But above all, an egocentric like Constantine would never have overlooked the well-being of his own soul. At this point only the sacraments of baptism and the eucharist had taken deep root. Baptism washed away all sins and made a person fit to receive the eucharist, but what happened if one strayed after the cleansing waters of baptism had done their work? (This, of course, was a major issue in the Donatist controversy; could the baptized sinful ever be forgiven?) Though something of a sexual prude for most of his life (the emperor has been accused, whether justly or not, of active homosexuality in his old age), Constantine must have realized that there were many other areas in which it

was all too easy to stain one's immortal soul. Certainly having one's son put to death for whatever reason was a highly questionable act, to say nothing of the others whose deaths could be attributed to the emperor— his brother-in-law Licinius as well as Licinius's son, friends whose executions Constantine had ordered (a rash of these followed the death of Constantine's son Crispus), and even those he killed in battle. Thus, perhaps for complex reasons, Constantine waited until the last moment to receive the sacrament and, fortune favoring him once again, was duly baptized on his deathbed.

In the meantime, as has been suggested, the lack of baptism in no way hindered Constantine's active participation in the furthering of Christianity. The emperor was quite sure that he had been chosen by God to rule the world, and to provide God's Church with the aid and direction that it obviously so sorely needed. Constantine even went so far as to inform a gathering of bishops that, whereas they had received their office in the traditional manner through the Church, he, Constantine, had been made a bishop by God. Such intense involvement with the Church understandably made itself felt in many areas, including the development of Christian art, architecture, and symbolism.

Constantine and Christian Architecture

Until Christianity became legal, Christians had usually met in simple, unobtrusive gathering places: a large room in a private home or apartment, a converted residence such as that at Dura Europos, and even in a bath such as the one donated for this

purpose by Senator Pudens in Rome, later the site of Santa Pudenziana. (One must remember that the baths of the rich, like public baths, could be quite large places, rather like today's health clubs.) Though there may well have existed a few structures actually built with Christian worship in mind, the very early Church had no real tradition of architecture, and most certainly nothing with the sort of grandeur Constantine would have envisioned. As the emperor saw it, any religion with which he had associated himself needed large imposing structures, something that spoke clearly to the world of its, and hence his, importance.

As soon as Constantine had established himself emperor in the West by his victory at the Milvian Bridge, he immediately addressed himself to this problem. Having donated the palace of the Lateran for the use of the bishop of Rome, he selected an adjoining piece of land (the site of the barracks of the House Guard, which the emperor ordered razed) on which to build the cathedral of Rome, the *mater ecclesiarum* (the Mother of Churches), the Lateran.

This first monumental Christian structure was begun perhaps as early as 313. Though Vandals, fires, earthquakes, and rebuilding have all done their work, we can still form some idea of the original, indeed an impressive structure though not as large as what was to follow. The floor plan was basically a rectangle with the long sides on the north and south, the entrance on the east end, and the altar on the west. (A church facing west in this fashion is said to be "occidented.") At this time the priest faced the congregation and thus toward the rising sun, which was probably the reason for this arrangement. Later churches were "oriented," that is, this order was reversed and the **sanctuary** with the altar was placed

The palace of the Lateran, residence of the popes until the papacy decamped for Avignon in the fourteenth century, had once belonged to a senator named Plautius Lateranus. It was confiscated by Nero and added to the imperial holdings. Constantine acquired control through his second wife, Fausta, daughter of the emperor Maximian. At Fausta's untimely death (or murder) Constantine gave the palace to the papacy. The basilica of the Lateran was erected nearby. In this location it, like the other major churches associated with Constantine, was tactfully removed from the pagan center of Rome.

81

at the east end. But as the priest now turned around to lead the congregation rather than face them, he still faced the rising sun. In either case, the rectangular shape of such churches helped to focus attention on the altar and hence on the celebration of the sacrament of the eucharist.

Down the center of the church running east and west was a wide **nave** with two aisles on either side separated from the nave by **colonnades** and from each other by **arcades.** The space enclosed by nave and aisles together was about 250 feet by 180 feet, large enough to have accommodated several thousand worshipers. Or the congregation could crowd into the four aisles to clear the nave for the great processions of the clergy, which would proceed down it and into the sanctuary. The sanctuary, extending westward and capable of holding at least two hundred members of the clergy, culminated in a semicircular **apse** covered by a **half-dome.**

Things had certainly changed since a priest celebrated mass amid fifty or perhaps sixty of his people in the modest environs of a Dura Europos. With Constantine everything became more formal, and the imperial made itself felt in many ways, some subtle and some not so subtle. The divine was no longer associated primarily with the humble figure of the Good Shepherd but with God the Emperor of Heaven, Constantine being God's vicar on earth. Liturgy, as befitted such an outlook, became more formal and ritualistic. The clergy, in a sense the court of the Almighty, were now separated from the congregation, inhabiting the special, and in theory more spiritual, space of the sanctuary, a separation emphasized by the architecture, which made the sanctuary clearly a distinct unit.

Size and, as we shall see, grandeur had become the order of the day. The only understated thing about churches such as the Lateran was the outside, generally of unadorned brick (at the Lateran the brick was used as facing for concrete masonry walls) with at most some plaster and a little decoration on the **facade.** The gabled roofs were made of wood (ceilings being either open timber or coffered). But inside the overall impression was one of unbridled magnificence. One literally stepped from the plain, everyday, mundane world into the glorious, glowing world of the spiritual, vibrant with light and color.

At the Lateran, natural light entered through **clerestory** windows, as well as through additional windows in the double aisles on either side of the nave. This natural light was augmented by the light from chandeliers—five in the sanctuary, forty-five in the nave, and sixty-five in the aisles—and from the candles placed in some sixty candlesticks of silver or gold. The light was reflected from stately columns of yellow-, red-, and green-flecked marble and from walls resplendent with marble facing or lustrous mosaics. Gold shimmered in the half-dome of the apse, and the floor was probably a dense mosaic carpet. The furnishings were equally sumptuous, including seven altars of gold (six were probably offering tables), hangings of the finest silks and brocades, and altar cloths sewn with a medley of sparkling jewels.

In Old Saint Peter's (another Constantinian foundation, begun between 319 and 322, and razed in the Renaissance to make way for the church we know today), the transition from the everyday, material world to the spiritual world was made even clearer. The pilgrim proceeded from the Tiber River up a street flanked with tombs (the church was built

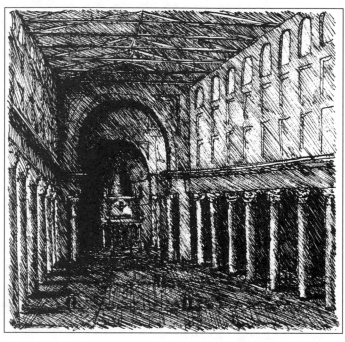

Figure 3.2:
Old Saint Peter's, Rome (a. elevation; b. floor plan): The Christians adapted architectural forms available in the Roman world to their own needs. The long, rectangular shape of a church such as Old Saint Peter's helped to focus the attention of the worshipers on the altar at the far end. The nave, or center aisle, also served to showcase formal processions of the clergy. (Drawings based on medieval descriptions and archaeological reconstructions.)

in a cemetery), over a slight rise, and through an entrance gate into an open courtyard surrounded by a portico. In the center of the courtyard, or **atrium,** stood a fountain, which would have reminded the visiting Christian of the waters of baptism that represented cleansing and the opening of the doors of spiritual life. From the atrium the pilgrim passed through a **narthex,** or porch, and into the church itself, overwhelming in size and splendor (see Figure 3.2a).

Though dwarfed by the present edifice, Old Saint Peter's was impressively large for its time, some 391 feet by 208 feet with the walls of the central nave rising to 105 feet, the peak of the gabled timber roof being still higher. On either side of the nave were two aisles. Saint Peter's, like the Lateran, was occidented, the building culminating on the west in the half-circle of the apse, a visual terminus to the nave. But in Saint Peter's a large transverse hall running north and south and known as a **transept** (see Figure 3.2b)

separated the nave from the apse and terminated the side aisles. The height of the transept was lower than that of the nave, and the transept extended beyond the outer walls of the aisles, thus giving the church a distinctive T-shaped floor plan.

This unusual (at least for the time) configuration helped Saint Peter's fulfill two distinct functions. The first was that of a **martyrium,** that is, a church dedicated to a martyr and usually built over his or her tomb. It was no accident that this church was located in a graveyard (the excavation for the foundations on the sloping site having required a significant feat of engineering) because it was constructed directly over the tomb of Saint Peter. The church was designed so that the tomb lay just below the line dividing the transept from the apse. The tomb, possibly encased with bronze, was set off by a canopy known as a **baldachino** well above floor level and supported by twisted columns of porphyry decorated with vinelike ornaments. A bronze railing allowed the visitor to gaze down at the sacred site without coming too close to it.

The transept accommodated the huge crowds that came to venerate the remains of the saint. It also provided room for the clergy (usually accommodated in an extended sanctuary) during services, for Saint Peter's functioned not only as a martyrium but as a church for regular Sunday mass. This versatile building had yet a third use, though in this case the transept played no special role. It served as a funeral banqueting hall and as a covered graveyard, its floors being carpeted with the graves of those who wished to "crowd around" the apostle. Inspired by the same reasoning, the wealthy built tombs abutting the outer walls, including a large imperial tomb at the south end of the transept.

Upon entering Saint Peter's, the visitor was met with a forest of columns in green, red, yellow, and gray, separating the great nave from the double aisles on either side and the aisles from each other. (These columns and their capitals were **spolia,** that is, they had been reused from some earlier building, but were no less elegant for being so.) Instinctively the visitor's eyes would have traveled down the nave colonnade to the huge **triumphal arch** at the far end. Such arches, reminiscent of those that Roman emperors customarily erected to celebrate their victories, rapidly became a standard feature of early Christian churches, where they focus attention on the altar before the sanctuary. On the triumphal arch at Saint Peter's, Constantine, with his usual modesty, had inscribed, "Because under Your leadership the world arose triumphant to the skies, Constantine, likewise victor, has founded this hall in Your honor."

Quite naturally the church was decorated in a way to reflect well on its benefactor. Frescos covered the walls, gold mosaic glowed in the apse, and lavish furnishings included a great cross of solid gold, a silver-gilt altar inset with four hundred precious stones, and a jeweled tabernacle with a gold dove above to house the sacrament. Seemingly countless candles filled candlesticks of silver and gold, and silver candelabra hung high above. (The **cornices,** ledges above the nave colonnade, were protected by a railing and served as catwalks for the lighters to reach the candelabra.)

Today Old Saint Peter's is gone and the Lateran has been altered out of all recognition. However, the traveler to Rome can still get some idea of the buildings of Constantine's time by visiting Saint Paul's Outside the Walls, which, although begun

(c. 385) nearly half a century after the emperor's death, was inspired by Old Saint Peter's. Although Saint Paul's was almost entirely rebuilt after a tragic fire in 1823, modern scholarship suggests that the overall proportions of today's church are much the same as the original building (the nave being 319 feet long and 80 feet wide, a space equaled by the double aisles on either side). The psychological impact must surely be similar. Even now, accustomed as we are to structures on a large scale, the visitor feels very small amid such vastness. The rich sheen of marble, the rhythmic march of columns down the nave, and the impression of a great space subtly illuminated by subdued light filtering in from high clerestory windows all give one a sense of enormous size and grandeur. How much more impressive such an edifice must have seemed to pilgrims coming from north of the Alps, most of whom, before their visit to the Holy City, had known only the most rudimentary structures except those encountered in a few Roman towns, even these being incredibly modest by comparison.

But if so much could be achieved so quickly, where did Constantine's architects get their ideas? Certainly not from pagan temples, where the emphasis was usually on the outside and which did not as a rule provide a large enclosed area in which to congregate. Although in connection with anything to do with early Christianity we usually look to the vast and rich repository of Judaism, in this case it would seem likely that both Christians for their churches and Jews for their synagogues took advantage of a common architectural tradition of the Roman world—the **basilica.** The term comes from the Greek word meaning "kingly" or "royal," but in general usage the word simply implied a large hall, royal only

because of its size. The Romans used basilicas as courtrooms, markets, meeting halls, and for all sorts of public business. In form, a basilica was a rectangular building, usually entered from one of the long sides. Inside there would be a nave with clerestory windows, an aisle or perhaps two around the nave, and an apse at each of the short ends. The walls were masonry and the structure was commonly topped by a gabled roof of wood. The Christians modified this building plan by putting the entrance on one of the short sides and an apse, before which stood the altar, on the short side opposite. The new arrangement focused attention on the altar, and the resulting longitudinal space lent itself to processions of the clergy.

Churches of this "hall" type were, and are, referred to as basilicas. They were practical and popular and were built from an early date throughout the Roman Empire. But the basilica was by no means the only type of church; circular, octagonal, and even **quatrefoil** forms were tried. Though centralized structures were built for general worship, they were more commonly used for one of three purposes: as a martyrium, a memorial church for a martyr; a **mausoleum,** the burial place of a member of the imperial family or someone else of high rank; or a baptistery, at this time usually a freestanding structure. The first two types (the martyrium and the mausoleum) had their origins in the classical world, where a centralized, often round building was used for the burial place of, or a place associated with, a hero.

Baptisteries, on the other hand, were often, though by no means always, octagonal—a peculiarly appropriate form since the number eight had special significance for the Christians.[2] According to the gospels, Christ arose from the dead on the first day of

the week, but to later Christians this seemed too mundane a description for a day of such importance, so they began to refer to it as the "eighth" day, eight thus becoming the number associated with rebirth or resurrection. The person being baptized was seen as dying to sin and being born to new life just as Christ had died and been resurrected, so having this sacrament performed in an eight-sided building served to reinforce its significance. Nor would this have passed unnoticed by all but a few since the Christians were very sensitive to number symbolism. Number was, after all, thought to be the measure of all things, and in and of themselves numbers were seen as having symbolic meaning. For example, three was the number of the Trinity and so represented things spiritual, whereas four was the number associated with this earth—the four elements, the four directions, the four gospels. And to multiply three by four, the spiritual by the earthly, is to get twelve, the number Saint Augustine would thus associate with the universal Church as symbolized by the twelve apostles.

Constantine and Christian Symbolism

Constantine, with the tremendous power he wielded and his favorable treatment of Christianity, influenced both the attitude toward images and those chosen. Though nothing Constantine did could affect in the slightest the injunction against images in the Old Testament, representational art in general became less threatening once people were no longer expected to do homage before "idols." Furthermore, images, especially in the form of sculpture in the round, had always

Figure 3.3:
Christ, Ruler of All: Two traditions concerning the appearance of Christ existed side by side in early Christian art: Christ as the fairest of the fair, a young, clean-shaven, Apollo-type figure (see Figure 3.4), and Christ as the suffering servant, a bearded man of mature years as seen here. The *alpha* and the *omega*, the first and last letters of the Greek alphabet, on either side symbolize his universal dominion. (Drawing inspired by a fourth-century painting from the catacomb of Commodilla.)

been a part of imperial propaganda and their use quite natural for any emperor. The Lateran itself seems to have been decorated with a row of silver statues placed before the apse; Christ the teacher with his apostles faced the congregation, while Christ the resurrected, flanked by four angels, faced the clergy.

Meanwhile, as imperial power was no longer a force to be feared and sometimes hated but rather a source of strength to the Church, it could be seen in a positive light. The entire repertoire of imperial imagery was thus thrown open to Christian usage, and it accorded well with the growing emphasis on the more formal, indeed imperial, conception of the divine.[3] Most noticeably, images of Christ begin to take on the trappings of imperial grandeur. In an early fourth-century fresco in the catacomb of Commodilla, Christ appears not as a young and humble shepherd but as a mature and commanding figure between the *alpha* and the *omega*, the Greek letters symbolizing the beginning and the end, thus suggesting universal and eternal sovereignty (see Figure 3.3).

The idea of Christ's sovereignty is made even more apparent on the sarcophagus of Junius Bassus, a prefect of Rome and a baptized Christian who died in 359. (Since he was a relatively young man and his death unexpected, it may well be that the family of

Junius Bassus purchased an already completed sarcophagus. However, they bought the best and this work is often remarked upon for the beauty and classical elegance of its carving.) The front of the marble sarcophagus is divided into two tiers with five compartments each. In the center of the lower register, Christ is shown entering Jerusalem in a manner suggestive of the triumphal entry of a ruling king or his representative. Still more significant, directly above, in the center of the top register, Christ is portrayed enthroned above a **personification** of the cosmos (see Figure 3.4). Though young and unbearded, Christ is clearly the ruler over all, the cosmos being literally at his feet. To either side of Christ, Peter and Paul stand like court officials, and to them he gives scrolls symbolizing the laws, a gesture fraught with imperial connotations since only the emperor could promulgate the laws.

In the late fourth- or early fifth-century apse mosaic in Santa Pudenziana, Rome, Christ, robed in gold and regally enthroned, sits beneath a jeweled cross placed atop the hill of Calvary (see Figure 3.5). His right hand stretches out in a gesture of teaching and/or benediction, while in the left he grasps a book that proclaims him Lord of the Church. He is surrounded by his apostles garbed as Roman senators, now five on each side (only four of whom are clearly visible) but originally six, the change having occurred when a sixteenth-century prelate decided to

Figure 3.4:
Christ Enthroned: After the legalization of Christianity, Christian art began to incorporate imperial imagery. Here Christ hands on the laws to his disciples Peter and Paul, a gesture filled with significance since lawgiving was a strictly imperial function. As the emperor is ruler of the empire, so Christ is ruler of all, an idea reinforced by the personification of the cosmos beneath his feet. (Drawing inspired by the marble sarcophagus of Junius Bassus, c. 359, now in the Vatican, Rome.)

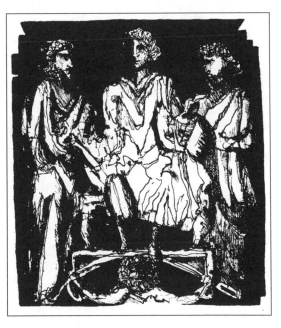

Figure 3.5:
Christ Teaching the Apostles: Christ enthroned sits beneath the triumphal cross of the resurrection instructing his apostles, some of whom are missing due to later work on this church. Similarly incomplete are the four zoomorphic symbols of the evangelists in the sky above. To our right a personification of the Jewish tradition crowns Peter while to our left a similar personification representing the gentile Church crowns Paul. This imposing mosaic reinforces the image of the imperial Christ (in contrast to the humble shepherd of earlier times) which appears after the legalization of Christianity.
(Apse mosaic, early fifth century, Santa Pudenziana, Rome; photograph by Orme Lewis, Jr.)

redecorate the church and make it more responsive to "modern" fashion.

The alteration also played havoc with the great winged zoomorphic symbols of the evangelists which hover, dark and brooding, in the sky above. These symbols have a double import, both designating the evangelists and referring to the "four living creatures" of the Book of Revelation. Now just two can be seen more or less completely: the lion of Mark (a lion because this animal suggests the wilderness, and Mark's gospel begins with the mission of John the Baptist, "a voice crying in the wilderness") and the ox of Luke (the ox probably being chosen for this evangelist because it is the sacrificial beast, and Luke's gospel begins with the sacrifice of Zacharias). Only parts of the other two, the man and the eagle, can be glimpsed. The man represents Matthew, whose gospel begins with the genealogy of Christ, and the eagle is the symbol of John, whose words transport us toward heaven.

To the right of Christ sits Paul, his long head emphasized by a dark beard, and to the left is Peter,

immediately recognizable with his white hair and beard and a square, chunky face. (Both apostles developed clearly identifiable physiognomies from an early date.) Since the right side is the side of greater honor, it is at first surprising to find Paul there, especially in Rome, where so much has been made of its connection with Peter. But, as it happens, at this early date the apostles were still interchangeable as to position, and it is only in the Middle Ages, when the papacy chose to stress its line of descent from Peter, that Peter became a fixture at Christ's right side. Meanwhile, at Santa Pudenziana a woman dressed as a Roman matron and representing the Church of the gentiles crowns Paul, while Peter is crowned by a female personification of the Church of the circumcised, also appropriately garbed. These figures reflect the missions of the two apostles: Paul's mission being oriented toward the gentiles, while Peter's mission was directed primarily toward the Jews.

Though the placement of the two apostles can be satisfactorily explained, there is a discrepancy in this work that should continue to disturb the careful observer (a discrepancy for which I can find no good explanation). Behind the head of Peter is an octagonal building that most scholars believe to be the Church of the Nativity, built by Constantine in Bethlehem at the spot where Jesus was said to have been born. Behind Paul is, scholars think, the Rotunda of the Anastasis, a round memorial building constructed over the cave in which Christ was said to have been buried and from which he rose from the dead. However, the mystery lies in the association of Bethlehem (a city commonly used to indicate the gentile aspect of the Christian faith) with Peter, whose mission was to the Jews, and the association of

Jerusalem (a city traditionally associated with Judaism) with Paul, missionary to the gentiles.

In any case, the depiction of the two churches at Santa Pudenziana probably shows them much as they existed at the time. Both were designed to combine the function of demarcating and honoring a sacred spot (usually calling, as we have seen, for a centralized building) with that of providing a basilica-like space for regular services. The Church of the Holy Sepulchre, which included the Rotunda of the Anastasis (resurrection), responded to a particularly complex problem, for it was called upon to commemorate both the crucifixion and the resurrection, each identified with a different spot. The apse of a basilica was placed over the site of the crucifixion, and this basilica was then connected with the Rotunda (located over the tomb) by a courtyard.

The Church of the Holy Sepulchre was reputedly begun by Helena, Constantine's mother, a convert to Christianity who, as legend would have it, found the remains of the true cross on a pilgrimage to Jerusalem. A great jeweled cross was actually erected on the site, like the jeweled cross that rises directly behind the nimbed head of Jesus in the mosaic of Santa Pudenziana.

A Dionysiac Diversion

As imperial imagery had lost its threat, so, too, pagan imagery could be viewed from a more sanguine perspective as the Church, protected by imperial favor, found itself in an increasingly comfortable position. Furthermore, the Church was now beginning to

attract more converts from the upper class, most especially in Rome itself, an element of society that had a strong pagan heritage. Of course, as we have seen, pagan images had been "baptized" from the very outset of Christian art. However, in the mid–fourth century, pagan imagery sometimes becomes so dominant that it is difficult to find the specifically Christian.

Such is the case with the charming mausoleum erected for Constantine's daughter, Constantina, or Constantia. Santa Costanza, as the mausoleum is called, was built outside the walls of Rome between 320 and 350, and completed perhaps as late as 361 (estimates vary widely). Entering the small circular church (its interior diameter is about sixty-two feet) from a cool, pleasant courtyard well sheltered from the busy Via Nomentana, the visitor is immediately struck by the dramatic contrast between light and dark. A relatively low, dark **barrel-vaulted ambulatory** encircles a high, bright central core consisting of a drum topped by a **dome,** once shimmering with mosaics, ringed with light from twelve large clerestory windows around its base. The drum in turn is supported by an airy arcade consisting of twelve pairs of columns topped by lavishly carved **impost blocks,** an addition inserted between the capitals and the lower points of the arches to prevent the illusion of the arches being flattened—an illusion caused by the effects of perspective.

To speak of a mausoleum as "charming" may seem strange, but this adjective truly describes Santa Costanza. Not only is there the immediate pleasure concomitant with its architectural form, but the mosaics which still exist in the **vault** of the ambulatory are some of the most delightful ever conceived

Figure 3.6:

Vintage Feast: Traditional pagan imagery such as the vintage feast had been adopted by Christian art at an early date and given a suitable religious interpretation—the vintage feast, for example, being a reminder both of the transformation of the eucharistic wine into the blood of Christ and of the metaphor of Christ as the vine, his people as the branches. But clearly such images were also enjoyed for their own sake, and as the pagan past became less of a threat they could be indulged in with special delight. (Mosaics, c. 350, Santa Costanza, Rome; photograph by Orme Lewis, Jr.)

(see Figure 3.6). Five zones of mosaics, the same on either side, begin at the entrance door and meet again at the point in the ambulatory opposite it. The subjects include those of Dionysiac origin like *putti* (baby cherubs), some with tunics or loincloths and others nude, harvesting grapes. There is also a variety of other subjects such as dolphins, birds, plants, fruit, and draped female figures, as well as abstract patterns and goblets touched with gold. Vine leaves (again

echoes of Dionysus) entwine portrait busts of a couple, probably Constantina and her husband, Gallus.

Though not all the imagery was strictly Dionysiac, this element asserted itself so strongly that during the Renaissance Santa Costanza was referred to as the Temple of Bacchus (or Dionysus). Even the more restrained mosaics of the dome, which we know from drawings, included Dionysian elements among scenes from the Old and New Testaments. Dionysiac imagery also flourished on the floor (likewise known from drawings), which was once covered by a riot of grapevines through which Silenus (a satyr who was the constant companion of Dionysus), attended by a cupbearer, rode his donkey. The Dionysiac theme is again celebrated on the great porphyry sarcophagus of Constantina, where *putti* proceed with the harvest, gathering grapes into tubs and pressing them in vats. (The sarcophagus the visitor sees is a copy, the original now being in the Vatican.) Although the grape harvest has its Christian interpretation, as do the peacocks and lambs we find there, the two Dionysiac masks on the lid of the sarcophagus seem hard to explain in Christian terms.

All in all, it is impossible to say how much of Santa Costanza's mosaic program was planned with serious purpose of Christianity in mind and how much was simply decorative. But whatever the intent, these mosaics retain all of the gaiety and visual charm of an earlier era. The latter, together with the building's intimacy and appeal, has made Santa Costanza a popular site for weddings, and the visitor is quite likely to find the church filled with flowers and the altar readied for yet another marriage ceremony.

There is another delightful example of fourth-century art in which pagan, though not Dionysiac, imagery is used in a vaguely Christian context. In the mid–fourth century, two wealthy Roman families were united by the marriage of their offspring, Projecta and Secundus. Among the wedding presents Projecta received was a silver-gilt casket (a little less than twelve inches by twenty-two inches by seventeen inches, now in the British Museum, London) probably intended to hold the accessories of her toilet. One panel of the lid shows Venus, a scantily draped nude lounging on a shell and surrounded by sea creatures and *putti*, gazing into a mirror as she prepares to attend to her coiffure. On the side of the casket a Roman matron attended by two serving women, one bearing a mirror and the other a small casket much like Projecta's, engages in a similar activity. Other scenes also draw upon mythology to suggest marriage or illustrate a Roman matron preparing herself for an important social occasion. There would be no reason whatever to associate this elegant example of fourth-century craftsmanship with Christianity (the peacocks in the corners probably being space fillers) were it not for the inscription engraved across the front of the rim: "Secundus and Projecta, may you live in Christ."

Constantinople: City of Constantine

Still another area in which Constantine's influence makes itself felt in art is more in the way of the initiation of a long-term development rather than the immediate changes such as we have seen in architecture and symbolism. In 324 the emperor founded a

city named for himself on the Bosporus, although "refounded" might express the situation more accurately, since the small Greek town of Byzantium (originally founded in 667 B.C.) already existed on the site. And what a site! Surrounded on three sides by water, possessed of good harbors, and located at the point where two of the main trade routes of the Roman world crossed, the only mystery about the place is why it was not fully exploited earlier. Constantinople, as Byzantium came to be called, had the additional advantage of being ideally situated for the emperor to reach and defend the two most troublesome areas of the empire's frontier, the Rhine-Danube area and the Euphrates.

The strategical excellence of the placement of Constantinople (now Istanbul) can be better appreciated when it is put into a twentieth-century context such as in Alan Moorehead's *Gallipoli*.

Like any project in which Constantine involved himself, "his" city was to be executed on a grand scale. The walls that he himself is said to have delineated extended the area of the city fivefold. On a more symbolic note, the original city had only one hill and Constantine's addition brought the number of hills to six, which later would be referred to as seven to emphasize the parallel with the seven hills of Rome. Once the outlines of the city had been decided, building immediately commenced and was carried on at an accelerated pace so that the city could be more or less ready for its formal dedication in May of 330. The emperor gave the new city a senate and even inveigled a few of the old Roman senatorial families to reestablish themselves there, but he had better luck with attracting common people to whom he promised freedom from taxation and conscription and free rations of corn, wine, and oil. (One disillusioned source says that the emperor brought to Constantinople the sort of hopeless cases who would applaud him at one moment and vomit up their wine the next.)

Much is made of the fact that Constantine wanted Constantinople to be a Christian city, free from the pagan attachments of old Rome. Although it is hard to doubt that this played a significant part in his thinking, his actions were more ambiguous. The old temples of Byzantium were not razed, and two more temples, though probably with the understanding that there would be no sacrifices, were built there before his death. The emperor consulted astrologers and augurs before laying out the new walls, and, at the dedication of the city, prayers were offered by both Christian and pagan priests. Ironically enough, the last pagan emperor, Julian the Apostate (d. 363), would be the first emperor to be born in the city.

There is equal ambiguity about what role Constantine expected his city to play in the empire. Did he or did he not intend it to be the capital of the Roman Empire and/or the "new Rome"? Although we can never know precisely how the emperor envisioned the future role of his city, there is no uncertainty about what actually happened. Constantinople grew and thrived so that, as the empire in the West crumbled, it became the bastion of the Roman Empire, existing long after anything of the sort in the West had ceased to be.

From the outset, Constantine's city had to be as beautiful as it was grand, and the emperor denuded the empire of the most precious artworks his agents could snare and transport there. Constantinople became a great storehouse of many of the treasures, both literary and artistic, of the ancient world. Further, it acted not simply as a repository but as the home of a vital, developing tradition in the visual arts.

Constantine himself was buried, as he wished, in the biggest of the churches he sponsored, the

The great destruction of these treasures took place not at the conquest of the city by the Moslem Turks in 1453, but in 1204 at the hands of Christian crusaders from the West.

Church of the Twelve Apostles, where he was laid in the midst of the twelve (present in theory if not in actual fact). In the East, he is considered the thirteenth apostle. Whether or not one wishes to elevate him to this exalted status, one cannot deny his considerable historic importance. For better or worse, Constantine had left his imprint on his world, on the Christian Church, and on its art.

Notes

1. The problem arose from the fact that the Jewish calendar, and hence the date of Passover, is based on a lunar system, whereas the Christians, in the Roman tradition, adopted a solar calendar. To add to this, Easter, according to Constantine and those who shared his views, had to be celebrated on Sunday. (In 321 Constantine had honored Sunday by declaring it a day of rest.) The resulting calculations of the date of Easter each year were sufficiently complex that during the Middle Ages monasteries possessed Easter calendars indicating the date of Easter for each year. Since extra space remained beside the date, quite often one of the monks would make a notation about the significant events of the year. These chronicles are very helpful to us in studying this period.

2. Joseph Jungmann states, "The Christians wanted to avoid the notion that the week closed with the Sabbath, hence that the Sabbath is the climax of the week. The Sabbath and the whole order of the Old Testament have been vanquished and superseded by the Sunday and by the saving order of the New Testament. God created the world in six days and rested on the Sabbath. But it was on a Sunday that He continued the work, bringing it to its close. On a Sunday He constructed the new creation. Thus, if the count is continued, Sunday becomes the eighth day. . . . The Fathers were so familiar with this idea that almost invariably in their commentaries, whenever they encountered the number eight in the scriptures, they saw in it a symbol of the Sunday, of the resurrection and of the world's renewal through Christ." (*The*

Early Liturgy: To the Time of Gregory the Great, trans. Francis A. Brunner [Notre Dame, Ind.: University of Notre Dame Press, 1959], p. 22.)

3. The exact extent to which Constantine and the conventions of imperial art influenced developing Christian art has recently been questioned by Thomas F. Mathews in *The Clash of Gods: A Reinterpretation of Early Christian Art* (Princeton, N.J.: Princeton University Press, 1993). Although the present author does not agree with much of what Mathews has to say, she must admit that his book makes for some lively reading, as does the recent review of *The Clash of Gods* by that much-respected scholar of early Christianity Peter Brown in *The Art Bulletin* (Vol. LXXVII, Number 3, September 1995, pp. 499 ff.). Undoubtedly, we can expect more controversy on this point in the near future, which again goes to prove that the past is not some inert, moribund sort of thing but a vital part of the present and constantly subject to reinterpretation.

CHAPTER

4

The Development
of Christian Symbolism

Creating Christian Art

Sometimes people assume that to "create" means to make something from nothing. On the contrary, the artist is necessarily influenced by all that he or she has seen or, in the case of music, has heard, these things being programmed into the unconscious, if not the conscious. Artistic creativity comes to bear when an artist fashions from these "old" elements something fresh and unexpected, something that only the individual's creative intuition was able to divine, a new vision that initially only the artist could intuit.

Early Christian artists, like any artists great or pedestrian, used what was available in the contemporary artistic repertoire for their own ends. We have already seen how adept they were at appropriating traditional symbols (the crown, the fish, the peacock, and so forth) and making something quite new and

different of them—the crown of martyrdom, for example, obviously existing on a different plane altogether from the crown won by any athlete. Initially, early Christian art concerned style and medium far less than it did symbolism.

Of necessity, the Christian artist drew primarily on the art of the Roman world, but it was a rich and diverse art, one that suggested several stylistic approaches. Most of what the artist saw was some variant of naturalistic, anthropomorphic, Hellenistic art with its roots in classical Greek art. The latter was distinguished by restraint, balance, and harmony; it portrayed an ideal world peopled by athletic heroes and calm, beautifully formed gods and goddesses with the bodies of ordinary mortals but looking much more the way we would like to look than the way we actually do.

In time, however, this ideal view was gradually transformed. As Hellenic (Greek) art developed into what is referred to as Hellenistic art (considered to have begun after the death of Alexander the Great in 323 B.C.) and began to spread through the Mediterranean area, significant changes occurred. Art became more expressionistic. There was a greater display of drama and emotions, artists often using distortion for the purpose of expressing these. Coming in part from lands east of the empire was a tendency toward abstraction, art that suggested a form rather than detailing it and that, on a two-dimensional surface, flattened figures rather than endowing them with the illusion of a third dimension. On the other hand, a realistic trend also emerged, and some artists began to portray humans with all the peculiar, individual characteristics—those lumps, bumps, squints, and warts—that make us the way we

are. Early Christian artists had access to all of this, which they used as their taste, or more likely the taste of their patrons, dictated.

Besides a variety of styles, there was much visual imagery to draw upon—and here we are not talking about symbols, but about conventional ways of showing certain emotions or states of being. For example, the Christian artist who wanted to portray a reclining Jonah did not invent that languorous pose—body sprawled back with genitals revealed, one leg partially crossed over the other, and an arm crooked to cushion the head (see Figure 1.2)—because he already had an excellent model at hand: This was the pose associated with river gods as well as with the sleeping Endymion. Classical conventions of other sorts were also absorbed into the Christian repertoire; for example, destined to have an important future were personifications including, as we shall see, some of the river gods themselves.

Similarly, Christian artists made use of conventional artistic media. Many early Christian works were executed in stone, specifically the **reliefs** with which sarcophagi are decorated. Media such as fresco, work in gold and silver, panel painting, weaving, and manuscript illumination were employed by the early Christians as well. Glass, though of ancient origins as we have seen, had developed wider uses during the period of the empire. One innovation was to create a design or image on a thin leaf of gold, which was then fused between sheets of glass and used as the bottom of a drinking vessel. This **gold glass** was very popular with the early Christians and often commissioned for some special occasion. Ivory carving also played an important role—for example, in the form of small lidded boxes known as *pyxides* (singular, **pyxis**), used

Endymion was a young man of such beauty that when the Moon saw him sleeping, she came down to kiss him and lie by his side. Whether at the insistence of the Moon, who so greatly valued his beauty, or from other causes (the stories vary), Endymion was made to sleep perpetually.

Diptychs, two small pieces of carved ivory that opened out like a book, were used originally to celebrate the term of a Roman consul. The Christians adapted this idea to their liturgical needs and inscribed in their diptychs the names of particularly illustrious members of the Church to be commemorated during the celebration of the mass.

by the Christians for relics, and of **diptychs,** which had their own special role in Christian worship.

But it was in the field of mosaics that Christian genius would find its highest expression. Mosaics had been used in the Mediterranean area since long before the birth of Christ. Originally they consisted of small colored stones put together in designs to cover floors, or later to create pleasing effects as part of fountains. Christians, too, used mosaics for floors; the mosaic floors of Santa Costanza have unfortunately been lost, but in other buildings such as the Church of San Vitale, Ravenna, part of the original flooring remains and can be seen by the visitor.

However, it was in realizing the possibilities of mosaics as a wall covering that the Christians were both innovative and particularly aesthetically successful. Here again, glass plays an important part. Instead of using colored stones and bits of marble for the walls of their churches, the Christians used glass **tesserae,** little cubelike pieces of colored glass— although the word *cube* should not be taken too literally, since any close examination of these mosaics reveals that their surface shape varies considerably. Colored glass was baked in thin sheets which were then cut into small pieces of varying shapes and placed in wet plaster to make designs and pictures of great vibrancy. By the time of the creation of the famous fifth- and sixth-century mosaics of Ravenna, the Christians had a palate of some three hundred colors to choose from, and the end results are spectacular; images emerge with much of the same vividness as resulted from the short brush strokes, even daubs, used by some of the most skilled of the French Impressionists.

Yet the mosaics contribute far more than merely vivid images to the buildings they decorate. Glass tesserae reflect light, thus taking on a shimmering life of their own. This effect was carefully calculated, and individual tesserae were placed at slightly different angles to reflect different nuances of light so that the resulting image is never static but always in a state of flux and change. Furthermore, because they reflect light, these mosaics seem to dissolve the surface of the wall beneath them just as mirrors (particularly dark mirrors) are sometimes used in interior decoration to make a wall "disappear" so that a room appears larger.

Dissolving the material substance of a building had a twofold advantage for the developing Christian aesthetic. In the first place, mosaics could create an atmosphere that was truly otherworldly. To step into a church decorated with mosaics is to enter a place in which the logic of the structural parts tells us it must be solid yet it has no appearance of being so. Mass disappears to be replaced by the ethereal elements of light and color. Such a place is a world governed by faith rather than reason.

In the second place, mosaic images are at the very far end of the spectrum from the solidity of bronze and marble sculpture in the round, so beloved in pagan art. As refined in the course of early Christian art, images executed in mosaic appear increasingly insubstantial, assuming an almost immaterial quality. "Graven" though they technically may be (and the problem of the appropriateness of representational art continued to prick more sensitive consciences), these mosaics seem about as far removed from the idols of yore as it was possible to be.

The Portrayal of Divinity

In one sense, satisfactory images of Christ (such as the Good Shepherd) were hit upon quite early, and these were supplemented after Constantine's rise to power by the imperial repertoire. Yet with regard to physical characteristics, representations of Jesus were not consistent throughout the early Christian period. Sometimes he is shown young and beardless; on the sarcophagus of Junius Bassus he seems to be barely an adolescent, a boy with full, childlike cheeks and the unlined face of youth (see Figure 3.4). At other times, as in the wall painting in the catacomb of Commodilla, he appears as a mature, bearded figure with large dark eyes which have witnessed their share of the world's suffering (see Figure 3.3).

Since Christian art did not begin until more than a century and a half after Christ's death, naturally there was no record of what Christ had actually looked like. Today, given the age of Jesus during the public period of his life and his Jewish origins, an artist with a realistic bent would surely portray him as a mature man with Semitic features and bearded, as was the custom in that place and time. But the idea of historical accuracy is a relatively recent one. In the early Christian era, no one thought of developing a picture based on a person's age and ethnic origin; instead the artist looked to the Bible for metaphorical suggestions. There he found two conflicting traditions, both of which seemed relevant: Christ as the suffering servant (Isaiah 53:2) and Christ as the fairest of the fair (Psalm 45:2). The first passage lent support to the mature, bearded Christ of the catacomb of Commodilla, and the second to the

There were traditions of images "not made by human hands." One of these is the Veronica, which refers either to the woman who offered Jesus a cloth to wipe his face on his way to Calvary or to the cloth that retained the imprint of his visage. Another is an image that, as legend would have it, Christ left on a towel for Abgar, king of Edessa.

handsome, unbearded young man on the sarcophagus of Junius Bassus. Both approaches had their adherents, and it was not until the eleventh century that the mature, bearded Christ became unquestionably predominant in Western art.

God the Father, on the other hand, almost defied representation altogether. The root of the difficulty lay, of course, in the Old Testament prohibition against graven images. Christ had assumed human form, and it was in this human form, so it would later be argued, that he was represented in art. But God the Father, invisible except in the extraordinary visions of the prophets Isaiah and Ezekiel, clearly did not lend himself to conventional modes of representation, if indeed he could be represented at all. Early Christian art skirted rather than resolved this issue by showing the hand of God extending from heaven. This image, perhaps coming into Christian art through Jewish tradition, being sufficient to express God's power and might and God's interaction with whatever event is portrayed, proved to be both satisfactory and enduring.

The third person of the Trinity was symbolized in early Christian art, as today, in the form of a dove. We find the dove of the Holy Spirit most often in scenes of the baptism of Christ (see Figures 1.2, 6.5, and 6.6), the only occasion on which the Holy Spirit is specifically described as taking this form. In some baptismal images, the dove, the hand of God the Father extending from heaven, and the human figure of Christ give us the three persons of the Trinity. Such representations are in accord with the gospels that describe God the Son being baptized, God the Spirit descending as a dove, and the voice of God the Father coming from heaven. They also have

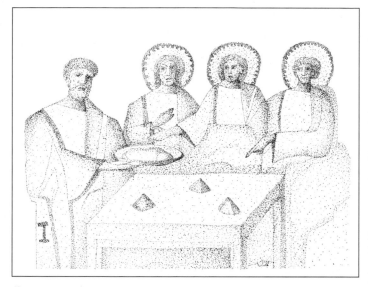

Figure 4.1:
Abraham and the Three Strangers: Perhaps no concept is more difficult to translate into art than that of the Trinity. Only two images of those experimented with in early Christian art proved to have significant staying power: the baptism of Christ and the appearance of the three strangers to Abraham (Genesis 18:1–15), seen here. The three strangers, portrayed as substantively alike yet ever so subtly different, speak visually of one God yet three divine persons. (Drawing inspired by a mid–fifth-century nave mosaic, Santa Maria Maggiore, Rome.)

the advantage of suggesting in visual terms the remarkably difficult concept of one God yet three divine persons, which has so exercised even the most acute Christian intellects, but only "suggesting," because the idea of the Trinity is much too complex to lend itself to an exact pictorial equivalent.

Whereas various images of the Trinity were experimented with in early Christian art, only two survived this period—the baptism of Christ and the three strangers who appeared to Abraham. The latter is based on the Old Testament episode in which three men appear to Abraham as he sits beside his tent on the plain of Mamre (Genesis 18:1–15). Abraham greets them, and Abraham's wife, Sarah, prepares food. One of the men prophesies that, though the couple are of an advanced age, Sarah will bear her husband's child within the year, a prophecy that was indeed to be fulfilled. The best-known and most accessible examples of this scene in early Christian art are a small fifth-century mosaic panel in the nave of Santa Maria Maggiore, Rome (see Figure 4.1), and a much larger sixth-century mosaic on the left of the altar in San Vitale, Ravenna. In both cases, three almost identical figures are shown being served a meal by Abraham under the oak of Mamre—three loaves, suggesting the bread of the eucharist, having been placed on the table before them. Three figures,

distinct but alike—one must admire the mind and imagination of the artist who first conceived such an image.

Christian Subject Matter

And so, gradually, the repertoire of Christian art expanded. We have already mentioned the significance of the Old Testament and, with the fourth century, the growing importance of the New Testament. Still another area that influenced the Christian artistic imagination was the New Testament Apocrypha, writings connected with the New Testament but not included in the official, or canonical, version. The Apocrypha associated with the New Testament (there being Apocrypha associated with the Old Testament as well) are filled with wonderful stories and cozy domestic details (here we find the birth of Mary, tales of her childhood and also of the childhood of Jesus). These Apocrypha were immensely popular up to the time of the Reformation and Counter-Reformation, at which point anything not strictly official was eschewed. But even though they were largely ignored from that point on, they had for centuries left an indelible impression on art.

Not surprisingly, the holy personages who populate both canonical and apocryphal writings begin to appear in Christian art early on. From the Old Testament, we encounter the likes of Abraham, Sarah, Moses, Noah, Daniel, and Susanna, together with a host of others, while from the New Testament we find figures such as Jesus, Mary, John the Baptist, Peter, Paul, and the other apostles. As has been said, Peter and Paul developed their own distinguishing

Loaves such as those portrayed in Santa Maria Maggiore and San Vitale were the form taken by communion in that day. Bread continues to be used in the Greek Orthodox Church as well as in many Protestant churches.

111

characteristics quite early—Peter with his square head, white hair, and beard; Paul with a longer skull, dark beard, and thinning dark hair. Also from an early date, John the Baptist can be recognized by his ragged hair and beard and animal skins used for clothing.

Other saints and martyrs were not neglected. Although the procession of twenty-two female saints and twenty-six male saints down either side of the nave at Sant' Apollinare Nuovo, Ravenna, may be the best-known representation of these from the early Christian period, one also encounters Saint Vitalis receiving the crown of martyrdom in his eponymous church in Ravenna, Saints Cosmas and Damian being introduced to Christ by Peter and Paul in the Church of Saints Cosmas and Damian in Rome, and other such examples. On the other hand, what is unusual is to find a scene of martyrdom such as that of Saint Lawrence in the mausoleum of Galla Placidia, Ravenna, where the saint goes eagerly to his death on a ready grill (see Figure 5.4). Representations of this sort, filled with the tension and drama so greatly appreciated later in the Middle Ages, are not a common part of early Christian art.[1] But then it must be remembered that the particulars of suffering and martyrdom were not something the early Christians wished to dwell on. One also misses those charming vignettes from the lives of the saints which enliven the great European cathedrals, but these depend to a greater or lesser extent on saints of future centuries and folktales and legends not yet in existence.

Another seeming lacuna that may strike the person familiar with medieval art is the rare appearance of those attributes that were in time to identify saints to all, including the illiterate. Even the uneducated peasant of the Middle Ages would have

recognized Saint Blaise, who, besides being dressed as a bishop with a mitre on his head and pastoral staff in his hand, was routinely distinguished from all other saintly bishops by the presence of a carding comb, the instrument of his torture, grown so large as to resemble a rake. It is true that Saint Agnes appears on the nave mosaics of Sant' Apollinare Nuovo with her lamb (see Figure 7.3), but she is the exception rather than the rule; the rest of the saints and martyrs depicted at Sant' Apollinare are identified not by attribute but only by name, which is inscribed in the mosaics above them. One saint regularly identified by an attribute in the early Christian period is the Egyptian Saint Menas with his camels. But the elaborate system of attributes, so characteristic of medieval art in the West, was yet a thing of the future. Also missing from the very early Christian repertoire were some of the scenes we consider to be a fundamental part of Christian art.

Menas was a semi-legendary Egyptian soldier believed to have been martyred toward the end of the third century. He is usually portrayed in the orant position (both arms raised in prayer) between two camels, but no one is quite sure why.

The Nativity

If any scenes strike most of us as being an integral part of Christian art, they are the nativity and the crucifixion. Yet neither of these appears in the earliest Christian art. Although the Virgin and child can be found in third-century catacomb art, the nativity itself, which is properly concerned with the birth of the child, does not become part of the Christian repertoire until the following century. This is somewhat less surprising when one realizes that the celebration of Christ's birth did not originally have the importance it later acquired. At the outset, Christian attention was focused on the Second

Coming, and then on the crucifixion and resurrection. In the New Testament, the nativity plays a remarkably modest role. Only two of the four gospels, Matthew and Luke, deal with the nativity as a concrete event (as opposed to the poetic passages at the beginning of John), and these quite briefly. The epiphany, commemorating the coming of the magi and understood as the manifestation of Christ's divinity to the gentiles, held far more significance for the early Christians than the actual birth of the child. In fact, the first documented evidence we have of the nativity being celebrated in Rome is not until the middle of the fourth century.

Because the magi are described as having come to Bethlehem, where they acknowledged the divinity of Jesus, this gives further weight to the association of Bethlehem with the gentile aspects of the Church.

When the nativity does make an appearance in Christian art (fourth century), it is found, of all places, on sarcophagi. Moreover, the emphasis is not on the birth of a little child but on the incarnation, the divine spirit made flesh, and what this momentous occurrence implies for human salvation. In our earliest extant representations of the nativity, found on fourth-century sarcophagi from Rome and Gaul, the elements have been reduced to the minimum, just those needed to convey this message.

Perhaps one of the most effective of the very early representations of the nativity is part of a late fourth-century stone sarcophagus cover now incorporated into the pulpit of the Church of Sant' Ambrogio in Milan (see Figure 4.2). Of the nativity scene per se, there are only three basic elements: an infant (proportionately quite large) wrapped in swaddling clothes, and two animals, which on closer inspection can be identified as an ox and an ass. Child, ass, and ox—this is all. But, as we shall see, nothing more is needed to tell the whole story of the nativity and to suggest its significance for humankind.

Figure 4.2:
The Nativity: This image—the Christ child lying on a manger between an ox and an ass—is simple in form yet rich in meaning. The animals speak of the humble surroundings in which the birth took place and also emphasize its universal significance, the ox representing the Jewish people and the ass the gentiles. The swaddling clothes resemble the winding shrouds used to wrap the dead (see Figure 7.1), thus reminding the viewer that as the child is born into the world in all of its poverty for all humankind, so too will he die.
(Drawing inspired by a fourth-century sarcophagus cover now in Sant' Ambrogio, Milan.)

The extremely large size of the child in comparison with the animals stems from a common artistic convention of the day in which size was used to express a figure's relative importance. In harmony with Luke's account, the child is wrapped in swaddling cloths and lying on a stone slab with a headrest indicative of a manger. But the swaddling clothes look like nothing so much as the winding shrouds that were used to wrap a body for burial. This visual reference is not accidental. For the early Christian, the importance of Jesus was not so much in his birth but in the sacrifice of his death and its promise of salvation; the nativity is only the beginning of a story that will climax with the crucifixion followed by the resurrection. The image of the child wrapped in swaddling clothes and lying on the manger thus speaks simultaneously of birth and death, the birth that is now and the death that is to come.

At first it may seem curious that two beasts are present when neither Mary nor Joseph nor any of the other figures commonly associated with this event is on hand. The animals are not even mentioned in the

scanty biblical accounts, although Luke does refer to the manger. But people then as now were curious and eager to flesh out the story. An ox and an ass were, after all, the type of animals which would have been present at a manger in that period, and so from the earliest nativities they become part of the scene, an eloquent reminder of the humble surroundings in which Jesus was born.

Soon the two animals developed symbolic connotations as well. Theologians remembered the words of Isaiah, revered by the Christians as the great Old Testament prophet of the nativity, who had said, "The ox knoweth his owner, and the ass his master's crib: but Israel doth not know, my people doth not consider" (1:3). The theologians interpreted this as meaning that the ox and ass bear witness to the child's role as the Messiah, a role not acknowledged by the Jewish people. Furthermore, such a passage seemed to imply that the nativity was an event foretold in the Old Testament, another instance of the harmony and close relationship between Old and New Testaments that was so fundamental a part of early Christian thinking.

The ox and the ass, then, by linking prophecies such as these with the event, reminded the onlooker that the nativity was something foreseen and foretold by prior generations, that in this as in other ways the New Testament fulfilled the promise of the Old. But some theologians went still further, finding yet another layer of meaning in the presence of the two animals. They interpreted the ox, or sacrificial beast, as a symbol of the chosen people—that is, the Jews—and the ass as a symbol of the gentiles. Seen in this light, the animals indicate that this child is born for all people, Jew and gentile alike. The event is of universal, indeed cosmic, significance.

Thus, a full reading of this very simple image—child, ox, and ass—would be as follows: (1) Christ has been born to the world in all of its poverty, a stable (suggested by the presence of the beasts) surely being among the most humble of locations; (2) this event was foretold in the Old Testament and fulfills its prophecies; (3) Christ has come for all people, for Jew and gentile alike; and (4), as the swaddling clothes cum winding shrouds remind us, as Christ has been born for all people, so too he will die for them in order that all may be saved. Whatever the viewer's personal religious convictions, if any, one must admit that this simple image (which almost no one entering Sant' Ambrogio appears to seek out) is breathtaking in the breadth and profundity of its message.

The essential elements of the nativity scene were thus established at the outset, and other pictorial elements that the scene accrued over time serve mostly to add detail to the story and to reinforce its symbolism. For instance, two scenes—the adoration of the shepherds and the coming of the magi, often depicted in conjunction with the nativity—reiterate the concept of its universality. Traditionally the homage of the magi is seen as representing the manifestation of God to the gentile world, and that of the shepherds as God's manifestation to the Jewish world; in other words, the universal symbolism of the ass and the ox is restated in a different guise.

There is no indication in the Bible as to how many of either group—magi or shepherds—came to pay their homage, but since three gifts—gold, frankincense, and myrrh—are mentioned in connection with the magi (Matthew 2:11; the first two are mentioned in Isaiah 60:6), generally, though in early Christian art by no means always, three magi are

portrayed. Eventually they were even given names, strictly the product of someone's imagination: Melchior, Caspar, and Balthasar. The three magi were commonly balanced by three shepherds, and in time it came to be the custom to portray magi and shepherds alike as being young, middle-aged, and old—thus reminding the viewer once again that the event portrayed is for all men of all ages.

In early Christian art, the magi, or wise men, are easily recognizable since they wear distinctive costumes consisting of short tunics, long leggings, and pointed hats—a type of dress associated with the Phrygians, residents of an eastern province, and hence with anyone from the East. By the sixth century, these costumes had become very elegant and encrusted with gems, as in the bottom tier of mosaics at Sant' Apollinare Nuovo and on the hem of the empress Theodora's robe at San Vitale (both in Ravenna). But the term *magi* (singular, *magus*) merely signifies members of the priestly cast of an ancient Persian religion similar to that of Zoroastrianism and has nothing whatever to do with ruling or rulers. Only later in the Middle Ages did people begin to think of the magi as kings and to depict them dressed accordingly.

Although the Virgin may be omitted from the earliest nativity scenes, she regularly appears in depictions of the coming of the magi, often holding the child while they pay homage. Such a representation raises the interesting question of how old the child was when the magi arrived. If the question of the child's age is put to a randomly selected group of people, inevitably some will say he was a baby while others will assert that he was two years old at the time. In fact, one answer is as good as the other,

because nothing in the biblical accounts specifies the child's age. We are told only that "when Jesus was born in Bethlehem of Judea in the days of Herod the king, behold, there came wise men from the east to Jerusalem" (Matthew 2:1), and that "Herod, when he saw that he was mocked of the wise men, was exceedingly wroth, and sent forth, and slew all the children that were in Bethlehem, and in all the coasts thereof, from two years old and under" (Matthew 2:16).

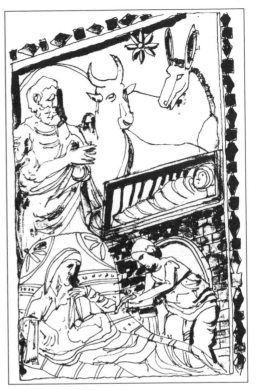

Gradually, representations of the nativity became visually more complex. An example of this can be found on one of the sixth-century ivory panels with which the so-called throne of Maximian, now in Ravenna, is decorated (see Figure 4.3). In the nativity panel, the child lies in the manger, while behind him the ox and the ass look on. Between the animals' heads shines a star, a device that in the artistic vocabulary of the time symbolized the birth of a king or other notable person and is here, of course, also the star of Bethlehem. To the left of the manger stands Joseph, right hand lifted toward the child, in a pose that suggests acknowledgment of the Savior's coming. Below, attended by a midwife (an addition from the Apocrypha), Mary reclines in evident exhaustion on a couch—a seemingly innocuous pose but, in fact, fraught with theological implications.

As we shall see in chapter 6, one of the most serious controversies to shake the early Church had

Figure 4.3:
The Nativity as a Prelude to the Passion: The death, of which the birth is but the prelude, is emphasized still more strongly here, where the manger has grown so large as to resemble an altar. This is the child whose body will be given up for all humankind for the forgiveness of sins, a sacrifice that will be reenacted in every celebration of the eucharist. (Drawing inspired by an ivory panel from the throne of Maximian, mid–sixth century, now in Ravenna.)

its origin in the dual nature of Christ—being, according to Church doctrine, both God and man. On one side were the **Nestorians,** who seemed, at least to their opponents, to emphasize the humanity of Christ as opposed to his divinity, while on the other side were the **Monophysites,** accused of doing just the opposite. The pose of the Virgin on this ivory panel speaks of the humanity of the child, for she is clearly exhausted as any new mother would be after normal childbirth. On the other hand, the star points to kingship and divinity, so perhaps Maximian, the wily bishop with whom this "throne" is associated, intentionally arranged to slip between the horns of a theological dilemma.

But perhaps the most interesting aspect of this small ivory panel is the manger, of brick or stone construction, which has grown so tall as to resemble an altar—a visual reference that is not accidental. The manger as an altar once again draws the parallel between Christ's birth and his sacrificial death, preceded as it was by the Last Supper with the institution of the sacrament of the eucharist. This, then, is the child who as a man will be made by John to say, "I am the bread which came down from heaven," to add to which *Bethlehem* means "house of bread" in Hebrew. This is also the child who will later be described as blessing bread, breaking it, and giving it to his disciples with the enjoinder, "Take, eat; this is my body."

Yet for all the additions, the message of the nativity as expressed through symbolism remains the same. Christ has been born to the world in all its poverty, an event foretold through prophecy. He has been born for all people, Jew and gentile alike, and for all people and their sins he will die.

The Last Supper

There are numerous meals depicted in early catacomb art, but there is no way to be absolutely certain which of these, if any, represents the Last Supper. A group of people, most often seven in number, reclining around a table supplied with bread and wine may represent the celebration of the eucharist, the *agape* (the Christian "love feast" held for the relief of the poor and also in honor of the dead), or the *refrigerium* (the pagan "refreshment meal" originally shared in honor of the dead, though in time the term became associated by the Christians with celestial or heavenly refreshment). How, then, does one distinguish between these, and how (short of finding twelve persons shown grouped around a leader) does one select a Last Supper? Each scholar seems to have his or her own system, but there is much to be said for that of Walter Lowrie, who claims that the celestial banquet, at least, can be recognized by the presence of servants. Lowrie's conclusion, if not based on strict logic, certainly rests on a good psychological foundation. "At my age, after a laborious life," he explains, "I long for rest, and in these times especially it is consoling to think that in heaven there will be someone to serve me."[2]

Although labeling any convivial meal in the earliest Christian art is a risky undertaking, scholars do agree that the Last Supper is prefigured by the multiplication of the loaves and fishes, and this scene, at least, is readily identifiable. Sometimes, as in the catacomb of Saint Peter and Saint Marcellinus, Jesus is shown blessing the loaves; but even, as in the catacomb of Callixtus, where one finds an extremely

Figure 4.4:
The Communion of the Apostles: Christ appears here twice, on our left dispensing the bread of communion to six of the apostles and on our right giving the wine to the other six. Such a scene emphasizes the eucharistic significance of the Last Supper. It also makes a liturgical reference since Christ's actions recall those of the priest distributing communion. (The Riha paten, sixth century, silver with gilding and niello, now in the Collection of Dumbarton Oaks, Washington, D.C.; Byzantine Visual Resources, © 1994, Dumbarton Oaks.)

abbreviated representation—here only a fish with a basket of loaves on the fish's back—the meaning is clear. The loaves and fish recall the miraculous feeding of the multitude, which in turn makes one think of the Last Supper, both as a meal and as the setting for the institution of the eucharist, intended to provide generation after generation with spiritual nourishment.

Two images of the Last Supper, unambiguously recognizable as such, emerge by the beginning of the sixth century: the communion of the apostles (represented only in Eastern art until a much later date), a scene that emphasizes the eucharistic and liturgical aspects of the event, and the Last Supper as a meal and one of the episodes of the Passion. An excellent example of the former is provided by the Riha **paten** (see Figure 4.4), a gilded silver piece probably crafted in Constantinople in the second half of the sixth century and used as a plate for the communion bread; today it is part of the outstanding Early Christian and Byzantine Collection at Dumbarton Oaks in Washington, D.C. In this work of art, Christ appears twice: on one side of an altar he dispenses the wine of communion to six of the apostles while on the opposite side of the altar he gives the bread to the other six.

An example of the second sort of Last Supper is found in the sixth-century nave mosaics of Sant' Apollinare Nuovo, Ravenna (see Figure 4.5). Christ,

distinguished by his cruciform nimbus and purple robe, reclines at the table with the twelve apostles. The table is covered with a long white cloth and upon it are small loaves of bread and a large platter containing two fish, food that recalls the feeding of the multitude and also serves as a traditional eucharistic symbol. In the mosaic Christ's right hand is raised; perhaps he is blessing the food but more likely he is telling of the coming betrayal since the apostles who are not gazing at Christ are staring at Judas, ever so slightly separated from the others, at the opposite end of the semicircular table. The Last Supper at Sant' Apollinare Nuovo is the first of a series of Passion scenes, twelve in all, followed by the resurrection (indicated by two women standing before an empty tomb beside which sits an angel)—a quite thorough visual rendering of the course of events with the omission only of the crucifixion.

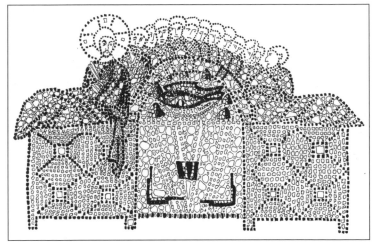

Figure 4.5:
The Last Supper: Christian artists have traditionally focused on the eucharistic significance of the Last Supper and/or the dramatic revelation of the betrayal of Judas. Here both come into play. Christ blesses the food (bread and fish, which have strong eucharistic connotations) as four apostles look on, while the seven others look askance at Judas. (Drawing inspired by an early sixth-century nave mosaic, Sant' Apollinare Nuovo, Ravenna.)

The Cross and the Crucifixion

The crucifixion was late in making its appearance in Christian art, although making the sign of the cross on the forehead may be one of the oldest Christian symbols. Early Christians may have associated the

sign of the cross with the *taw*, the last letter of the Hebrew alphabet (written at the time of Christ as a "t" or an "x"), rather than with the instrument of Christ's death.[3] As the last letter of the alphabet the *taw*, like the Greek *omega*, signified God. Christians were baptized with the sign of the cross in the name of the Lord. They used it (by making a cross with their thumb on their forehead) to ward off evil, and soon the sign of the cross found its way into the other ceremonies of importance to them, most particularly the eucharist. In time the original associations with the *taw* were forgotten, and the cross became connected in people's minds with the instrument of Christ's death and, hence, with the Passion.

Yet even without such associations, its form alone does much to recommend the cross as a symbol. The vertical member, seen as the spiritual principle, joins earth and heaven while the horizontal member, the earthly principle, running along the line of the horizon, encompasses the whole world. The cross thus unites mundane and spiritual and, as it points in all four directions, is all-inclusive. Further, it will be remembered that four is the number traditionally used to indicate the sum of all earthly things: the four corners of the earth, the four winds, the four elements (earth, air, fire, and water), the four rivers of paradise (Gihon, Pison, Tigris, and Euphrates), and—of course—the four gospels.

Even the wood of the cross has traditionally had special meaning for the Christian. According to one legend, the tree that provided the wood for the cross grew from an offspring of a tree generated by the tree of life in the garden of paradise. (Thus the same substance associated with the introduction of sin into the world through the tree of the knowledge of

The contrast between the tree of knowledge of good and evil and the tree of life, an offspring of which reputedly provided the wood used for the cross, is not the only way in which Christian art would juxtapose the sin of Adam with the redemptive death of Christ. According to legend, Golgotha, the place of the crucifixion, was also the burial place of Adam. In time, representations of the crucifixion would often include a skull (understood to be that of Adam, and also a reference to Golgotha as the place of the skull) beneath the cross.

good and evil also served as the vehicle for the redemption of the world.) Timbers hewn from the descendant of the tree of life were supposedly used to make a bridge for the Queen of Sheba when she visited Jerusalem, these same timbers later being reused for

Figure 4.6:
Jonah Thrown to the Big Fish: The earliest Christian art used disguised symbolism to refer to the cross as an instrument of the Passion. Here the mast of the ship, sails furled to emphasize its shape, refers to the cross while the three days Jonah will spend in the belly of the fish recall the three days Christ will spend in the tomb. (Drawing inspired by a third-century painting in the catacomb of Saint Peter and Saint Marcellinus.)

the cross. As Christianity spread north into the great forests of Europe, where trees were already considered sacred, the idea of the cross as a tree became even more significant—"a wondrous Tree," "a radiant Tree," "the Holy Tree," as the great eighth-century Anglo-Saxon poet Cynewulf would have it.

In the earliest Christian art the cross (and here we are speaking of it as an instrument of the Passion) appears in disguised form. We find it both as an anchor, an image that also brought with it the association of safe shelter from the storms of life, and as the ankh, a T-shaped cross with a loop on top, which the Copts of Egypt used as a symbol of life. The mast of a ship could also suggest the cross without actually depicting it. In the third-century wall painting of Jonah being tossed to the big fish, in the catacomb of Saint Peter and Saint Marcellinus (see Figure 4.6), the mast of the ship from which two sailors heave Jonah over the side is clearly in this form, the furled sails further emphasizing its shape.

But whereas the cross, even if in disguised form, made its appearance early, the crucifixion was yet

another matter. The early Christians were understandably reluctant to portray the crucifixion since crucifixion was, after all, the sort of fate suffered only by criminals representing the lowest echelon of society; no Roman citizen could be crucified. For the ordinary person in the Roman Empire, the crucifixion originally had the most negative connotations, including defeat and humiliation. In fact, the earliest extant crucifixion is a bit of crude graffiti showing an ass hung on a cross with a man, an arm raised in acknowledgment or prayer, standing to one side. Below is scrawled in almost illiterate Greek, "Alexamenos worships God."

However, all this was soon to change and, here again, the reign of Constantine is of crucial importance. From the outset the emperor stressed the cross as a symbol of pride and triumph by the *labarum* that he had emblazoned on his soldiers' shields. Constantine outlawed crucifixion as a form of punishment, and Constantine's mother, Helena, traveled as a pilgrim to the Holy Land, where she is credited with discovering the remains of the true cross. The great basilica of the Holy Sepulchre in Jerusalem was designed to display this relic as well as encompass the place where the cross was supposed to have stood and the cave in which the body was laid to rest. The cross, which Saint Ignatius of Antioch had spoken of as a "scandal" (in the sense of being a stumbling block to the unbeliever), had emerged victorious, the *crux invictus.*

Yet with all the respectability Constantine's actions imparted to both cross and crucifixion, our earliest extant crucifixions (excepting the graffiti and some third-century gemstones that probably belonged to members of a heretical sect) date from

fully a century after Constantine. These are two scenes from the second quarter of the fifth century. One of them is a carved cypress wood panel (about seven inches by thirteen inches) from the doors of the Church of Santa Sabina, Rome (see Figure 4.7). This panel, probably completed by 432, shows a bearded Christ, proportionately large to emphasize his importance, clad only in a loincloth. He stands between the two thieves; no cross is visible, only two small boards to which his hands are nailed. The thieves are depicted in a similar fashion except much smaller. The background is a brick or stone wall with three triangles that have the look of architectural elements. The head of Christ is framed by the center triangle, quite obviously serving as a nimbus, the other two triangles being above the heads of the thieves. The thief to Christ's right also has something that looks rather like a rounded window in the triangle above his head. Since the right side is

Figure 4.7:
The Crucifixion: The early Christians quite naturally found it difficult to reconcile themselves to the death of Christ by crucifixion, a type of execution reserved for the lowest sort of criminals. Even after the emperor Constantine abolished crucifixion, it was more than a century before this scene made an appearance in Christian art and then Christ is shown triumphantly alive on the cross, which is here indicated only sketchily. (Drawing inspired by a cypress wood panel, 422–32, on the doors of Santa Sabina, Rome.)

Figure 4.8:
The Contrast of Life and Death: In this fifth-century crucifixion scene, the living Christ is further emphasized by the contrast with the dead Judas hanging from a tree, his ill-gotten gains spilling out of a purse beneath his feet. Mary and the apostle John stand to Christ's right. On Christ's left is Longinus (the name given to the man said to have pierced the side of Jesus), his spear now missing. (Drawing inspired by a plaque from a small ivory box, or pyxis, c. 420–30, now in the British Museum.)

the favored position, this is undoubtedly the "good" thief who was saved and the "window" may well have been intended, like the triangle behind the head of Christ, to emphasize the idea of a nimbus. All this may be a bit unexpected, but the most startling thing about the Santa Sabina panel for the unprepared viewer is the fact that Christ is unquestionably alive; his eyes are open and his face has an alert expression. He stands by his own power, and his body betrays no marks of torture or suffering.

Likewise, the crucified Christ—shown on an ivory relief (about three inches by four inches), a side of a small box, or pyxis, from the same period and now in the British Museum—is very much alive and conscious (see Figure 4.8). Here Christ is unbearded but as in the Santa Sabina panel he wears only a loincloth and is a large and dominant figure. On the ivory panel Christ is nailed to the cross; the thieves are absent, but Mary and the apostle John stand to Christ's right and Longinus (the traditional name

given to the man who pierced Christ's side with the lance), his lance now missing, to the left. Christ's head is encircled with a nimbus and above it a cross bar proclaims *Rex Ivd*, or "King of the Jews." The living Christ, eyes open and body unmarked, contrasts vividly with the dead Judas, who hangs from a tree to the far left of the panel, while beneath the latter a pouch spills out the ill-gotten pieces of silver. Perhaps originally the sun and the moon were found to either side of the head of Christ as they so often are in later images, the sun and the moon being traditional cosmic symbolism expressing the idea that the entire universe is concerned with the event.

As can be seen from these examples, when the crucifixion does at last appear in early Christian art, it is as a symbol of triumph rather than suffering. In spite of the accounts of all four evangelists and the theology involved (all emphasizing that Christ's sacrificial death was necessary in order that he could achieve his mission of salvation), the need for a triumphant hero was so strong that Christ is depicted alive on the cross throughout the early Middle Ages. This image is so persistent that it comes as something of a shock to happen across the *Gero Crucifix* (c. 975–1000) with the dead Christ slumping lifeless on the cross, the lines of terrible suffering so cruelly marked along his nostrils and in his down-turned mouth. But it is thus throughout Christian art: the same episode may be represented in different ways to express different outlooks and interpretations. When the iconographer identifies a symbol or a scene, his or her work is only partly done. Perhaps the more intriguing part of the investigation comes in noting changes in the symbol or scene and then trying to discover the reasons for them.

Notes

1. Even early depictions of Saint George and the dragon are not quite the "action scenes" they at first appear to be, for the dragon is a symbol of disbelief, slain by the saint and his faith, and the beautiful maiden is actually the personification of the province of Cappadocia giving thanks for its conversion to Christianity. For this and other delightful insights into how the saints came to be depicted in medieval art, see Emile Mâle's perennial favorite *The Gothic Image: Religious Art in France of the Thirteenth Century*, trans. Dora Nussey (New York: Harper & Row, 1972; originally published in 1913).

2. Walter Lowrie, *Art in the Early Church*, p. 52.

3. This is the thesis of Jean Daniélou, expressed in *Primitive Christian Symbols* (a part of *Les Symboles chrétiens primitifs*, pub. in Paris in 1961), trans. Donald Attwater (Baltimore: Helicon Press, 1964), pp. 136 ff.

CHAPTER

5

From Rome to Ravenna

Continuity and Change

Constantine, for all of the aid that he gave the Christian Church and all of the prestige that he lavished upon it, never made Christianity the official religion of the empire. This was left to Theodosius I (379–95; sole emperor, 392–95), who ordered the temples closed to the public and prohibited sacrifices. Though such measures by no means killed paganism, they did recognize the special position now enjoyed by the Church.

Meanwhile, Theodosius, like Constantine before him, found the Christian Church sadly disunited and was forced to call a second ecumenical council, which met in Constantinople in 381. Again Arianism was condemned, and again this was not the end of it. Moreover, the great number of Germans who had been converted to Arian Christianity during the course of the fourth century ensured that in the

Theodosius I was not the first emperor to legislate against the pagans, but such a program was viewed with increasing seriousness as the fourth century progressed. However, none of the measures taken stamped out paganism and it remained a viable force, particularly among the influential senatorial class in Rome.

As is clear from the need to have a second ecumenical council, the first such council may have condemned Arianism, but it had no great success in stamping out this heresy. Furthermore, during the course of the fourth century, many Germans were converted by men with Arian sympathies. One, Bishop Ulfila, even translated the Bible into Gothic for them.

future Arianism was to create political as well as religious difficulties.

In other respects as well, the reign of Theodosius seems a sort of continuation of that of Constantine. The earlier emperor is forever remembered for founding the great city that, until 1930, bore his name. Yet it was Theodosius who, though he spent much of his time traveling to the troubled spots of the empire, became the first emperor to make Constantinople his usual residence and thus confirm its significance. From the time of Theodosius to the final fall of the Byzantine Empire in 1453, with the exception of the period of Latin conquest (1204–61), emperors and empresses would live in and rule from this almost impregnable city on the Bosphorus. Though their language would become Greek and their culture would be strongly influenced by the East, the "Byzantines" would consider themselves Roman to the end, the proper inheritors of the Roman Empire.

In the meantime, the saga of the Roman Empire as it progressed from the death of Constantine to the accession of Theodosius has a by now familiar refrain: struggles for the imperial succession, battles against the barbarians on the northern frontiers, bloody engagements with the Persians, and skirmishes with the restless tribes of the Sahara. But of far greater significance than these, the Roman Empire was gradually pulling apart, East and West, like two great land masses divided by a widening fault. Actually there was really nothing—no beliefs, no community of interest, no strong economic bonds—to hold this vast empire together except the force of the personality of a strong emperor. In the last thirteen years of his life, Constantine had reunited in his person an empire that had been divided by

Diocletian for administrative purpose, though it continued to remain one in theory. However, the centrifugal forces continued to gain momentum. Theodosius, too, united the empire in his person, but for only three tumultuous years. When he died in 395, Theodosius left his older son, Arcadius, as ruler in the East and his younger son, Honorius, as ruler in the West. The two halves of the empire were never again to function effectively as a whole.

Even after the death of Theodosius, the empire might have continued to lumber along for a while in much the same way as it had before, two emperors but one empire, had it not been for external developments that no one could have foreseen. What set in motion the course of events that would alter forever the Roman Empire, eventually destroying it in the West and greatly changing its character in the East, began like a landslide under the ocean, unremarked on at first but with momen-

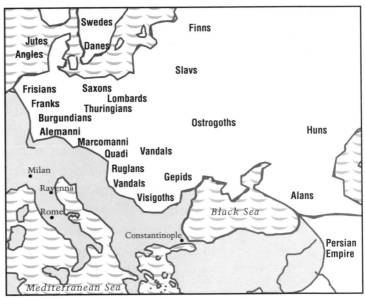

Figure 5.1:
Advent of the Huns,
second half of fourth
century A.D.

tous consequences. Something, we are not really sure what, occurred in north central Asia that caused the Huns, a Mongolian people ethnically unrelated to the peoples with whom Rome had previously dealt, to begin to migrate westward (see Figure 5.1). Like a tsunami, the gathering movement was almost unnoticeable until the Huns ran into the Germanic tribes

on the western fringes of Asia and the eastern fringes of Europe. Then, as the waves of the tsunami grow to tremendous heights when the surge reaches shallower waters and proceed to engulf everything before them, the Huns overran the hapless Germans.

The Huns—who have not, to say the least, received very good press—struck fear into the hearts of all with whom they came into contact. It was reasoned that nothing this awful could be altogether human, and the rumor spread that the Huns were the offspring of unclean spirits who had mated with witches. To turn to more credible, if no less uncomplimentary, details, our sources report that the Huns were small, foul-smelling, emaciated creatures with tiny eyes stuck in the large lumps of flesh that passed for their faces. To make matters worse, their faces were scored with a sword immediately after birth, leaving horrible scars and giving them a most ferocious appearance. Still further, which seemed to contemporaries to be the final degradation, the men had no beards to mark the coming of maturity or to give dignity to old age. But even their worst detractors had to admit that the Huns were awesome horsemen—their steeds being so much a part of their lives that the Huns are reputed to have eaten raw meat warmed only by carrying it between their thighs and the sides of their mounts.

The value of such a reputation as a tool of intimidation was incalculable. The Huns were so fearsome that they are credited with defeating tribes that should have been their equal in battle simply by the frightening nature of their appearance (evidently it was not for nothing that their faces were defaced at birth). When they swept out of the Russian plains (about 370) and defeated the German Ostrogoths (or

East Goths), the Visigoths (West Goths, next in the line of dominoes) begged piteously to be allowed to cross the Danube into Roman territory. This is not as strange a request as it may first seem, because the Visigoths were already allies of the Romans and not altogether uncivilized.

The Roman frontiers had become a gray area as more and more "barbarians" (i.e., Germans) had been recruited into the Roman army. These men and their families were often settled along the borders of the empire, on the far side of which were more "barbarians," allied with the empire and paid to fight for it. Germans on both sides of the border absorbed a certain amount of Roman culture, and in the course of the fourth century many were converted to Christianity, albeit in the form of the heretical Arianism. Even the regular army (as opposed to these allies, or *foederati* as they were called) had a strong Germanic element, and a growing number of important commanders were German. Thus many Germans were, in one way or another, slowly being absorbed into the Roman way of life.

The Visigoths were given permission to enter the empire and countless numbers of them (the twentieth-century historian J. B. Bury estimates eighty thousand or more), men, women, and children, crossed over the Danube to what they hoped was safety. But, although they were safe from the Huns for the time being, the venal representatives of the Roman Empire proved to be in their own way almost as bad. The Visigoths, who had surrendered their weapons as part of the price of admittance to the empire, were set upon and robbed. Their wives and children were sold into slavery, and those who remained were systematically starved. To add to the

The migrating Germanic peoples were never a monolithic unit. The groups with which we will be primarily concerned are the Ostrogoths, the Visigoths, the Vandals, and ultimately the Lombards.

infamy, the sons they had given as hostages were murdered. Not unreasonably, the Goths rose in revolt. The Visigoths may have feared the Huns, but these Germans were mighty warriors in their own right, as the Romans discovered to their regret. At the battle of Adrianople (August of 378), a Roman emperor and two-thirds of his army fell before the Gothic onslaught.

Although they had triumphed so decisively, the Visigoths had no idea what to do next, and after a bit of pillaging they were happy enough to make peace with Theodosius, appointed *augustus* in the East to replace the emperor lost at the battle of Adrianople. The Goths were to fight loyally for him, but why Theodosius allowed this large group to remain intact and to enjoy virtual autonomy within the empire remains a mystery. His decision was to have grave consequences in the future.

Theodosius and Family

Theodosius the Great, or Theodosius I, was born about 346 in Spain, the son of Count Theodosius, who had proven himself to be an unusually able commander, repelling Picts and Scots in Britain, protecting the Tyrol area, and putting down a revolt in North Africa. But in spite of his brilliant record, the count was condemned to death on what historians agree was probably a trumped-up charge (we are not even sure of the particulars) and was beheaded in Carthage in 376. (He received the sacrament of baptism shortly before his death and, we are told, met his end with great composure.) After the father's execution, the son retired to private life, where he might have

stayed had it not been for the dreadful Roman defeat at Adrianople.

The reign of Theodosius I was not an easy one. He had to deal with the body of Visigoths now within the empire; twice he was forced to put down usurpers, and the pressures on the frontiers were never-ending. Occasionally the emperor's body broke down under the strain; in 380 Theodosius fell seriously ill and, believing that his end was near, was baptized. But even Christianity was not without its concomitant problems. Within a year of his baptism, Theodosius found himself calling an ecumenical council to resolve issues that had supposedly been resolved almost sixty years earlier.

Nor was the personal life of Theodosius as a Christian without its upheavals. By and large, especially given the standards of time, Theodosius appears to have been a strong and relatively just ruler. But he was also proud, egotistical, and capable of extreme cruelty as well as momentous lapses of good sense, the most notorious of which concerned Antioch (in 387) and Thessalonica (in 390). When crossed by elements of these cities, the emperor fell into a temper and ordered the most severe reprisals, which led to the death of many innocent people. After the butchery at Thessalonica, Ambrose, the powerful bishop of Milan, refused to allow Theodosius into the cathedral until he had done penance. Clearly this did not sit well with the emperor, who saw his role as telling others what to do, not being told himself. But the bishop won the contest of wills, and Theodosius was forced to acknowledge his sins before the citizens of Milan and to do the penance the Church laid on him—a very interesting role reversal between Church and state and one that foreshadows the Middle Ages.

Amid these trials and tribulations, the great happiness of Theodosius's life was his marriage to Galla, sister of the then emperor in the West. Although the union was a political one, the former widower fell deeply in love with his new young wife. She bore him a daughter, Galla Placidia, but died in giving birth a second time in 394, when the little girl was only five or six. Theodosius did not long outlive her. Disheartened by the loss of his beloved wife and worn out by the intense exertions of campaigning, the emperor died of dropsy in Milan in January 395.

Figure 5.2:
Division of the Roman Empire, early fifth century A.D.

Before his death, Theodosius had been reconciled with Bishop Ambrose, and Ambrose himself delivered the eulogy at the emperor's funeral. In the course of

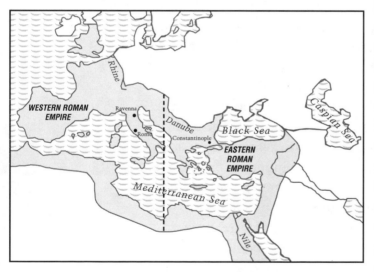

his remarks, Ambrose assured his listeners that Theodosius was not completely gone, for he still lived through his two sons, in whom one could see and feel the presence of their father. Unfortunately in this case, the good bishop was well off the mark since neither son measured up to the standards of their father; instead, it was his daughter who would evidence the best of his genes.

When Theodosius died, his older son, Arcadius, to whom he left the empire in the East, was about seventeen or eighteen, and his younger son, Honorius, to whom he left the empire in the West, was about ten (see Figure 5.2). Both boys were the offspring of

the emperor's first marriage. Arcadius was lethargic, slow both mentally and physically. Contemporary sources describe him as a short, dark, thin, inactive, sleepy-eyed young man who rarely appeared outside the imperial palace in Constantinople. But Arcadius was a dynamo and a veritable genius compared with his younger brother, Honorius, whose only action of lasting significance would be taken out of fear and whose only serious interest in life was raising poultry. Mentally, Honorius was definitely not up to par, and his level of physical energy must have been extremely low (or perhaps he was impotent), for it is said that both of his wives died as virgins. Edward Gibbon in *The Decline and Fall of the Roman Empire* remarks dryly that "in the eventful history of a reign of twenty-eight years it will seldom be necessary to mention the name of the emperor Honorius."[1]

Even if blinded to their character (or lack thereof) by parental love, Theodosius realized that his sons were too young and inexperienced to rule the empire without help. To assist Honorius he chose the German Stilicho, a Vandal by birth, who became the power behind the throne and twice father-in-law of the emperor Honorius. Tall, handsome, a leader of proven ability, Stilicho was married to Serena, the beloved niece of Theodosius, and had already attained the highest military honors before the old emperor's death. All of his military talents were most sorely needed when, soon after Theodosius died, the Visigoths revolted, laying waste what is now northern Greece. Stilicho managed to settle them down temporarily, but in 401 the Goths were on the move again, and this time their objective was Italy.

The Italy the Goths entered had changed in certain important respects from the earlier days of

the Roman Empire. Though Rome still enjoyed its traditional prestige, the emperors in the West had used Milan for almost a century as their principal headquarters. This city had begun to emerge as the center of an imperial colony in the second century A.D., and almost from the beginning its strategic location was appreciated. In the heart of the Po basin, at the intersection of several important transportation routes, and, of still greater significance, near the Alpine passes that gave access to the northern frontier, Milan's location well served the needs of late Roman emperors, and the city functioned as the de facto capital of the West from 305 to 402.

Not being so thoroughly enmeshed in the pagan past as Rome, Milan easily made the transition to a predominantly Christian city. It will be remembered that Constantine's edict legalizing Christianity was issued from Milan in 313, and in the fourth century the Church of Milan administered a district as large as today's Switzerland. The Church of Milan gained still further power and prestige with the election of Ambrose as bishop in 374.

Ambrose, scion of an ancient Roman family, was born in Gaul, where his father held a high imperial office. The young man was educated at Rome, practiced law, and then was appointed governor of northern Italy. When the old bishop of Milan died and a riot threatened to break out between Arians and Catholics, Ambrose came to restore order. Legend has it that a small child called out "Bishop Ambrose," an idea which appealed immediately to the citizenry, who insisted that Ambrose be given the episcopal honor. Whatever the actual sequence of events, Ambrose was elected bishop. Perhaps never before or since has anyone moved up through the

ranks so quickly. Upon his election, Ambrose was baptized (heretofore he had been only a catechumen), instructed in his priestly duties, and consecrated as bishop only eight days later (December 7, 374).

Ambrose brought to his position as bishop, and as a consequence into the medieval Church, much of what was best in the Roman world. He had the advantage of a fine classical education (Greek as well as Latin), the intellectual discipline of law, and an intimate understanding of imperial organization, thanks to the period he had served as governor. He was by birth and training one of the aristocracy of the late empire, a man thoroughly aware of the importance of his position and one who, by force of personality as much as anything, could make even an emperor come to heel. (As far as Ambrose was concerned, an emperor was part of the Church, not above it, an idea that he had expressed long before his clash with Theodosius.)

Intelligence, strength of character, organizational skills, and knowledge of the workings of his world—Ambrose had all the worldly attributes to make him a great leader as well as the one, less tangible, attribute so important for one in his position—a belief in his Church and a deep and abiding faith in God.

Although Ambrose is honored as one of the four Fathers of the Latin Church, he is not remembered for his theology so much as for the organization of his church and the care of its souls. Like any good Roman aristocrat, he was a competent and thorough organizer, a skill much needed in a time in which the fabric of society was becoming decidedly frayed. Besides his example of pastoral care, no insignificant legacy for the troubled times to come, the bishop left

A Father of the Church must "combine these four necessary qualifications: orthodoxy of doctrine, holiness of life, ecclesiastical approval, and antiquity."[2] The other three Fathers of the Latin Church are Augustine, Jerome, and Gregory the Great.

Figure 5.3:
San Lorenzo Maggiore, Milan: For most of the fourth century, Milan, being much closer than Rome to the troublesome northern frontier, served as the de facto capital of the empire in the West. Lacking the strong pagan traditions of Rome, it readily developed into an important Christian city, a fact indicated by the size and magnificence of a church like San Lorenzo (completed c. 375).

to future generations writings filled with classical allusions (such allusions in Christian writings being one way classical culture survived, albeit in a fragmented form), many hymns, and the Ambrosian Rite—a form of liturgy long used in Milan. We also have fragments of an impressive architectural heritage which is, at least in part, associated with the bishop.

Milan, as acting capital in the West, naturally developed church architecture on a grand scale. In some cases, it was also quite innovative. According to some, the great Church of San Lorenzo Maggiore was completed the year after Ambrose was elected bishop. Although today much altered, San Lorenzo (see Figure 5.3) still imparts a sense of its original design, a large quatrefoil structure composed of outer walls, ambulatories, and galleries, into which is set a second quatrefoil made up of the columns and piers that support the dome. This double-shell design is executed on a grand scale, the outer diameter along the central north-south axis being 157 feet, while the inner space is 78 feet square and was originally some 90 feet tall. In the time of Ambrose, this large, complex space was made still more elegant by walls sheathed with marble and

decorated with stucco friezes and moldings. While much of the original decoration has been lost with time, the complexity of the space and the subtle play of light and shadow can still be enjoyed. Meanwhile, a trace remains of the fourth-century decorations in the Chapel of Sant' Aquilino—an apse mosaic that depicts a young, beardless Christ with a cruciform nimbus (halo) teaching the apostles. These are full-formed figures with individualized physiognomies, the classical tradition still being much in evidence. Christ gestures upward with his right hand, while in his left he grasps a scroll. A basket of scrolls before him underscores his didactic role.

The Milanese Church of San Nazaro (originally the Church of the Apostles), again much altered over time, was reputedly laid out by Ambrose himself in the form of a **Latin cross** in 382. The Church of Sant' Ambrogio is also closely associated with the bishop. Originally a typical basilical structure, little remains predating the ninth century with the exception of the Chapel of San Vittore, where we still find remnants of the early Christian mosaics. Between the large, round-headed windows which light the chapel so effectively, Ambrose stands together with five local martyrs, the men's white robes shimmering against a background of dark blue. Above is a gold dome that has earned this chapel the title of Chapel of the Golden Heaven. Its centerpiece is a bust of San Vittore within a garland of fruits and flowers. In one hand the saint holds a cross and in the other the Book of Life in which his name is imprinted.

Unlike the scrolls encountered in the mosaics of the Chapel of Sant' Aquilino, the book that San Vittore grasps is a **codex,** the pages bound together so that one can leaf through them, the kind of book we

take for granted today. The codex was an innovation that gained popularity only in the fourth or early fifth century. The ancients used **papyrus rolls** (or scrolls) up to thirty feet long. A scroll was practical enough if a person wanted to read straight through a text, but not if a particular passage had to be located in order to be read on a given day. For this and other reasons, Christians found the codex much better suited to their needs than the scroll.

The shift from roll to codex also had a profound influence on a branch of Christian art which was to produce many treasures during the Middle Ages, that of manuscript illumination. A flat page offered an entirely new scope for illustration. From the point of view of subject matter, an illustration occupying a page or even part of a page could function as a separate unit and did not need to follow along with a seamless text. From the perspective of execution, a flat page on which an illustration would not suffer from rolling, which might flake the paint, provided the artist with a great deal more stability than the more fragile surface of a scroll. The artist could cover an entire page with illustration, even use relatively thick paint, without worrying about what would happen to the illustration during normal usage. Although by no means all codices produced at this time and subsequently were religious works, the Christian belief in the sacred significance of holy books, particularly the works of the evangelists, gave tremendous impetus to the art of manuscript illumination. From as early as the sixth century, we have some handsomely illustrated (though incomplete) manuscripts in codex form executed on purple **parchment** and lettered in silver and gold.

Meanwhile, by the close of the fourth century, Milan had other large and impressive churches undoubtedly adorned by some of the finest crafts-manship of the day. The city also enjoyed many amenities (the gifts of various emperors) such as fine public baths, a theater, an amphitheater which may have seated as many as thirty thousand of its inhabi-tants, a circus said to have been the delight of the people, and many handsome pagan temples as well as the Christian churches. But with the fifth century came a dramatic change, and Milan began a gradual slide from prominence that was not reversed until the Renaissance.

Escape to Ravenna

When the Visigoths entered Italy in 401, Honorius (as has been suggested, not a young man of courage or resolute character) became exceedingly afraid. His fear was not lessened by the fact that, while he quavered in Milan, Stilicho with the main army was north of the Alps trying to turn back the barbarians (Vandals and others) who had just burst through the northern frontier and were now also threatening Italy. After Stilicho had checked the onslaught, he returned to relieve Milan and rescue Italy from the Visigoths. But, although his father-in-law's efforts were successful where Milan was concerned, Honorius had had enough; he wanted some place a great deal safer than a city on the open plains. The emperor considered Gaul but decided on Ravenna, guarded as it was then by the marshes of the Po River on three sides and the waters of the Adriatic on the fourth. Safety being the objective, this turned out to

be an excellent choice, perhaps the only good one Honorius ever made. Where his own well-being was concerned, the emperor would brook no delay, and during the summer or early fall of 402, Honorius and his court repaired to the shores of the Adriatic.

Ravenna, located south of what later became Venice, had an imperial lineage of sorts. Augustus (d. A.D. 14), the first Roman emperor, had established Classe, the port of Ravenna, as the station for his north Adriatic fleet with its 250 vessels. While the empire faced its many ups and downs, Ravenna continued to exist, even to flourish on a modest scale—a small, provincial town, built like the Venice-to-be on a series of islands, which had a hard time shaking its reputation for lack of fresh drinking water.

This was an irony not lost on Sidonius Apollinaris, a bishop from Gaul visiting the city in the second half of the fifth century, who could see that Ravenna had more than its share of nonpotable water. It was, so he reported, a place where one could be surrounded by water and still die of thirst, where salt tides assailed the city's gate, and any unsalty water (sluggish backwater at best) was fouled by the movement of vessels and the bargemen's poles, which stirred up the slime on the bottom. (But the good bishop's sarcasm aside, no one was really likely to die of thirst since the town had a perfectly good aqueduct, built in the early second century A.D. and still functioning in the fifth century, a fact that he conveniently failed to mention.) Among his litany of complaints, Sidonius Apollinaris noted that in this town the waters stood (remained constant) as walls fell, the towers floated (many of the city's buildings were constructed on piles) and the ships stuck fast,

the dead swam (one can appreciate the problems of burial when one thinks of New Orleans) while the living remained dry.

As a city built almost in the water and surrounded by marshes and the sea, fifth-century Ravenna was a very damp place indeed. Arriving in midsummer or at best in early fall, the court must have found the humid heat extremely oppressive, and with all that sluggish water about, one can only assume that the air was less than salutary and mosquitoes were swarming. Having to give up all the amenities of Milan for a hot, humid, muddy town undoubtedly infested with insects cannot have been a change in circumstances that the courtiers greeted with enthusiasm. But now the timorous emperor could rest easy at night, at least after the first frost killed off the mosquitoes.

However, although it cannot originally have compared well with the elegance and sophistication of Milan, Ravenna was not entirely a lost cause. It boasted an arena, an amphitheater, and a selection of temples which, even if they could not be used for sacrifice, added to the tone of a city. The rich and noble soon constructed a series of luxurious villas along the Adriatic to the north of the town, and a sumptuous palace complex was begun within the city walls. More to the point, by the time that the critical bishop from Gaul paid his visit, Ravenna was already the site of some of the most beautiful buildings in Christendom—a variety of churches, a splendid baptistery, and a mausoleum that is one of the treasures of the Western world. This is the mausoleum of Galla Placidia, erected in honor of a woman remarkable by anyone's standards and a key player in the politics of her day.

The Greek geographer Strabo, writing in the first century, said that the tides scoured out the canals of Ravenna and consequently the air of the city was pure. But increased building would have tended to reduce the effectiveness of the tidal action (not that the Mediterranean has all that much tidal action anyway), and in any case the sea was slowly receding from the town. Also, we must not forget that the burgeoning population in the fifth century surely brought with it problems of waste. Undoubtedly, the canals served both as dumps and sewers, which would hardly have contributed to the city's salubrious character.

Daughter of Theodosius the Great by his second marriage, half-sister to Arcadius and Honorius, Galla had all of the qualities her brothers lacked; she was bright, energetic, courageous, and determined. And she had need of these attributes, for her life was filled with drama and challenge. Galla was born in Constantinople or Thessalonica about 388; her mother, it will be remembered, died in 394 and her father the following year. The little girl was raised chiefly in Milan and Rome under the care of Serena, niece of Theodosius and wife of Stilicho, commander-in-chief of the Roman army in the West and protector of the feeble Honorius. Stilicho and Serena also had three children of their own: two daughters, who were married successively to Honorius, and a son, Eucherius.

Stilicho was a man for his time, and during the difficult early years of the fifth century, it took a man of Stilicho's intelligence, talents, and drive to keep the empire in the West on anything like an even keel. Not all of Stilicho's actions have been praised by subsequent historians, but the fact remains that there was no one else on hand who could have proven half so successful—a fact soon borne out most painfully. Not surprisingly, the weak and fickle Honorius was an easy prey to court gossip, and when he was not concentrating what faculties he had on planning a splendid new poultry yard at Ravenna, he allowed himself to listen to the insinuations of an evil minister, Olympius. Olympius suggested to the emperor that Stilicho planned to murder Honorius's nephew, who was now ruling in the East (Honorius's brother, Arcadius, having just died), and set his own son, Eucherius, on the throne. To Honorius's mind such a plot encompassed three abominations: the

alleged murder plot, the interruption of the lawful imperial succession, and the unacceptability of Eucherius's barbarian heritage, for his father Stilicho was a Vandal and as far as Honorius and other Romans of his time were concerned, no German could *ever* be a Roman emperor. In 408, on Honorius's orders, Stilicho and Eucherius were foully murdered.

With Stilicho dead, there was no force capable of containing the Visigoths led by the extremely capable Alaric, who, in the same year that Stilicho was killed, menaced Rome. Faced with continuing famine (Alaric had cut off all supplies), the people of Rome finally paid off the Visigoths with 5,000 pounds of gold and 30,000 pounds of silver (these vast amounts of precious metal amassed by stripping down the remaining pagan idols), 4,000 silken tunics, 3,000 fleeces dyed scarlet, and 3,000 pounds of pepper. But the next year (409), after negations between Alaric and Honorius were botched by Honorius's new favorite minister (Olympius having lasted less than a year), the Visigoths again blockaded Rome. The Romans, loath to face another famine, told Alaric to do what he willed— his will, as it happened, being to appoint his own emperor. However, the emperor of his choice failed to live up to Alaric's expectation, and when a final attempt at reaching an accord with Honorius failed, the Visigoths turned toward Rome for a third time. Alaric had lost patience; on this occasion there was no blockade, no bribe, no compromise. Instead he sacked the city. Rome, the city that had conquered the world, had fallen. The events of August of 410 shocked the civilized world to the very core.

During this first siege of Rome, Serena (the widow of Stilicho) was put to death by the order of the Senate on the (probably false) charge of abetting Alaric. It has been said that Galla approved of this barbarous act, although this is not in agreement with what else we know about her.

Galla Placidia Augusta

But Alaric did not long enjoy his triumph, for shortly after the fall of Rome he died and was succeeded by his brother-in-law, Athaulf. For the next two years Athaulf and the Visigoths wandered through Italy, then crossed the Alps into southern Gaul. With them were the hostages they had taken at Rome, including Galla Placidia, who, unlike her half-brother Honorius, had not hidden away behind the marshes of Ravenna. Athaulf and Galla were both intelligent, attractive young people with similar interests and concerns. Circumstances dictated that they were thrown constantly into each other's company, and the inevitable happened—they fell in love. In January of 414, having finally received reluctant permission from her half-brother Honorius, Galla and Athaulf were married with all pomp and circumstance in the home of a wealthy citizen of Narbonne. But unfortunately they were not to live happily ever after.

First, their baby son died. They buried him in a silver coffin in Barcelona, whence the peripatetic Visigoths had come. Then Athaulf himself was killed by one of his own men in whom a supposed wrong had long been festering. All this would have been difficult enough for Galla, but she was immediately subjected to persecution and humiliation. Athaulf's successor, in an attempt to insult his predecessor, forced the young widow to walk twelve miles before his horse. However, within eight days he, too, was murdered. The new chief of the Visigoths, a good man and a fine leader, was happy enough to conclude an honorable peace with Honorius and to send his sister home.

However, the difficulties facing the young woman had by no means ended, for an old and unwanted suitor awaited her return. This was Constantius, a soldier who had proven himself to be an effective commander but had nothing more to recommend him. Constantius was a gloomy sort of man, given to sulking, and with none of the bright, stimulating conversation Athaulf is reported to have offered. The only time Constantius seems to have loosened up was at banquets and festive gatherings, where he tried so hard to be the life of the party that, reading between the lines, one thinks he must have made a fool of himself. He was not even physically attractive, having a flat head, thick neck, and large sullen eyes which darted about continuously. Galla did everything she could to discourage the match— but to no avail. Why she finally agreed remains a mystery (although no woman of the time, not even a Galla Placidia, was entirely master of her own fate), but marry him she did in 417. The couple had two children—first a girl, Justa Grata Honoria, and then a boy, who would one day reign as Valentinian III. Honorius raised Constantius to the imperial purple (in other words, he made Constantius his co-emperor), but seven months after receiving this honor, Constantius died, whether of pleurisy or sheer ennui depends upon which account one thinks most reliable.

Galla Placidia may have felt a sense of relief in losing a husband whom she never loved, may never have even liked, but her troubles were still not over. Honorius began making incestuous advances toward her, even publicly. Upset with the resulting gossip and furious with the behavior of her half-brother, Galla quarreled with him. Honorius responded by

ordering Galla to leave Ravenna for Rome, which she had no intention of doing, undoubtedly fearing both for her own safety and that of her children so long as she and they were within range of her half-brother. Instead, Galla turned for help to her old friend Boniface, now count of Africa, who immediately sent her money so that she could escape with her children to Constantinople. She remained there for two years, not returning to Ravenna until after Honorius's death (423), at which time her small son, Valentinian, became emperor in the West. But it was the mother who would wield the power, both during his minority and after.

A Tiny Gem

Tucked into the courtyard behind San Vitale, Ravenna, the mausoleum of Galla Placidia, most likely originally attached to the portico of Santa Croce (another building for which Galla was responsible), stands alone today—a small brick building (roughly forty-one feet by thirty-three feet) with a red tiled roof. The exterior is simple and very restrained, the only ornament being **blind arches.** The mausoleum (its date is usually given as 450, the date of Galla's death) is in the shape of a Latin cross, the entrance arm being somewhat longer than the others. If the building seems a little stubby, it is because it was originally five feet taller (the ground has risen), a change that affects the vertical proportions both inside and out. However, this does not seriously compromise its beauty.

Perhaps, as some scholars think, the facade was once sheathed in marble. In any case, the effect

would have still been plain, the contrast between exterior and interior proportionately dramatic. Clearly in evidence is the early Christian attitude that the interior of the building is of primary importance, and at the mausoleum of Galla Placidia the interior space glows with mosaics as rich and intricate as any stained-glass window. The visitor enters through a barrel vault (echoed by a similar barrel vault directly opposite) emblazoned with an entire galaxy of stars glowing against a midnight blue sky—a flowering firmament of swirling, multi-colored celestial bodies, the core of some being predominantly golden-orange, encircled with blue and white and green, whereas others have a white center, delicate as a snowflake, protected by a perimeter of gold. Throughout are touches of green, white, and shimmering gold, all seeming to radiate their own light.

In the central space where the four barrel-vaulted arms meet, another night sky—also dark blue—fills the curve of the dome above the crossing. (In keeping with the sobriety of the exterior, this dome is concealed on the outside by a square tower.) Here more than eight hundred gold stars revolve around a gold cross in the summit of the dome. In the four corners at the base of the dome are the zoomorphic symbols of the evangelists—man (Matthew), lion (Mark), ox (Luke), and eagle (John). Upon further examination, it can be seen that these "corners" are what are technically known as **pendentives,** concave, upside-down isosceles triangles with the acute angle pointing down, thus making possible a smooth transition between a square area (the crossing itself) and a round dome above. It speaks to the compelling quality of the mosaic decoration that one has to stop

and think consciously about the logistics of the construction, but this is the case in the mausoleum of Galla Placidia, and indeed elsewhere in Ravenna, where the overwhelming impression is one of the richness of color and intricacy of design. Only incidentally does one notice, let alone analyze, the structure itself. The mosaics, reflecting as they do the soft light, appear to dissolve the substance beneath them, existing in an almost immaterial world of their own.

In the wall segments below the dome and above the openings to the vaults of the four arms are eight white-robed apostles, two for each side, the needs of symmetry accounting for the unusual number. (However, the two figures amid a riot of gold acanthus leaves in each of the vaults of the side arms are probably apostles, too, bringing the total number to twelve.) The eight coupled apostles stand on either side of a small fountain visited by two doves. The reference to water, that ever-popular symbol of spiritual life and refreshment, is repeated in **lunettes** (the half-moon spaces created when the barrel vaults are intercepted by a wall) at the end of the two cross arms. In each lunette two deer, depicted amid acanthus leaves, face each other as they quench their thirst, recalling the words of Psalm 42: "As the hart panteth after the water brooks, so panteth my soul after thee, O God." The spirit of the life-giving nature of the word of God is further enhanced by grass and flowers.

In the lunette at the end of the barrel vault opposite that through which the visitor enters, one is confronted by a dramatic scene of martyrdom. Holding a cross in his right hand, and a book that some think is a copy of the Psalms in his left, Saint Lawrence willingly, even cheerfully, approaches the

grill on which he will be martyred (see Figure 5.4). To the far side of the readied grill, in which a hot fire already burns, is an open cabinet with copies of the works of the evangelists representing the beliefs for which Lawrence will give his life.

The most striking lunette of all is above the entrance, where, for the last time in antiquity, one finds the Good Shepherd. This shepherd, however, is a far cry from the humble shepherd of earlier representations. He is a handsome, beardless young man dressed in a long gold tunic with a purple mantle draped around him (see Figure 5.5). Since purple was the royal color (worn only by the emperor or members of his immediate family), this is a paradigmatic example of the tendency, beginning with Constantine the Great, to associate imperial attributes with Christ. In his left hand, the shepherd holds a gold cross, which may originally have been a shepherd's crook; with his right he pets one of the

Figure 5.4:
The Martyrdom of Saint Lawrence: Although the circumstances of martyrdom, which so intrigued the artists of the Middle Ages, are rarely shown in early Christian art, here is an outstanding exception. Saint Lawrence, perhaps grasping a copy of the Psalms, goes readily, even eagerly, to his death on the grill. Behind him a cabinet holds copies of the writings of the evangelists, which inspired the saint's faith and subsequent martyrdom. (Drawing inspired by a mid–fifth-century mosaic, mausoleum of Galla Placidia, Ravenna.)

155

Figure 5.5:
The Good Shepherd: Perhaps no image expresses more vividly the change in Christian art beginning with Constantine. Gone is the simple shepherd of earlier times to be replaced by a commanding figure robed in gold and the imperial purple. Instead of carrying one of his charges he absently fondles one of six sheep carefully placed in a stylized landscape. Yet the message remains the same: Christ's love and his promise of salvation. (Drawing inspired by a mid–fifth-century mosaic, mausoleum of Galla Placidia, Ravenna.)

very tame white sheep, which are neatly positioned (three on each side of him) as he sits formally yet at ease in the stylized landscape.

But whatever changes there are in representing the Good Shepherd, the promise of salvation remains the same. This image repeats once more the message found again and again in these mosaics and indeed the preponderance of early Christian art: divine care with its promise of salvation (the shepherd) and eternal refreshment (birds and deer; in other places, fruit, flowers, and grass), and the grace and saving power that come through the words of the evangelists, through the teachings of the apostles, and from the sacrifices of the martyrs.

Some of the most beautiful of the mosaics in the mausoleum of Galla Placidia are abstract designs that are very modern in feeling. Bands at the beginning of the vaults that lead to Saint Lawrence and the Good Shepherd are a multicolored pattern that can only be

156

described in terms of Op art. The other two vaults, the vaults of the cross arms, each begin with a band of yellow, grass-green, and deep blue. Red bands ribboned with blue and a copper-green with delicate tendrils of white outline the base of the dome and its pendentives.

The lower portion of the walls is covered with slabs of rich yellow marble from Sienna, which, although most of it represents a restoration, must give much of the feeling that the original gave. The windows are covered with sheets of alabaster, donated early in the century by King Victor Emanuel III. On bright days, these windows provide a soft, golden light. Perhaps the windows were originally covered with alabaster, or perhaps they were left open, both alternatives being used in early Christian architecture.

Within the mausoleum are three large marble sarcophagi. For many years it was assumed that they held the remains of Galla, her husband Constantius, and their son, Valentinian. But it is most unlikely that Galla Placidia ever lay here, since she died in Rome in November of 450 and was probably buried with other members of her family in the Theodosian mausoleum there. We are not even certain that she was responsible for the mausoleum attributed to her, although this does seem likely. But it is such a beautiful, peaceful spot, it seems a shame to think that after her long, adventurous life Galla could not rest here amid symbols of the promises of her religion in the Ravenna that surely she had learned to love.

Notes

1. Edward Gibbon, *The Decline and Fall of the Roman Empire*, vol. 2: 395 A.D.–1185 A.D. (New York: The Modern Library, n.d.), p. 90.

2. Johannes Quasten, *Patrology*, vol. 1 (Allen, Texas: Christian Classics, 1995), p. 10.

CHAPTER

6

The Center Will Not Hold

A Shock Felt around the World

The fall of Rome to the Visigoths in 410 evoked a wide variety of responses. The emperor Honorius got the news while he was working in his poultry yard, where among his stock was a particularly fine fowl named Rome. When a servant rushed up to the emperor to announce that Rome had perished, Honorius was perplexed and disturbed. "But I just fed her with my own hands," he protested. When the servant explained that it was the city of Rome to which he was referring, the emperor was mollified. "Oh, I thought it was the *bird* that had died," he replied, we assume with considerable relief.

On the other hand, when the rumor of what had happened reached Saint Jerome at his monastery in Bethlehem, he broke off his commentary on Ezekiel to give vent to his distress, so great and all-consuming that he claimed almost to have forgotten his own name. To Jerome it seemed that with the fall of Rome

Augustine was born in North Africa of a Christian mother and a non-Christian father. Thanks to the help of a local dignitary he received a fine classical education. He became a professor of rhetoric at Milan, where he gradually fell under the influence of Bishop Ambrose. Augustine, who had struggled both with various philosophical currents of the time and with his own strong sex drive, finally turned to Christianity. Putting sex and worldly ambition behind him, he was baptized by Ambrose (Easter, 387). Augustine later returned to North Africa and, traveling through the town of Hippo Regis, was proclaimed their bishop by its citizens.

the light of the world had been extinguished. And if Rome fell, could any place be safe? At Constantinople a similar feeling of consternation found an expression in three days of public mourning.

While much of the Roman world registered shock and dismay, the pagans (and, in spite of anti-pagan legislation, paganism still had an active following, particularly in Rome) also took a grim sort of pleasure in pointing out that so long as the gods under whose favor Rome had flourished were respected and the traditions of the ancient religion were observed, both the empire and the imperial city had been safe. But when Constantine and Christianity had changed all that, the formerly indomitable Rome had fallen prey to her enemies. The moral was clear: Rome should never have abandoned pagan ways.

"Not so," Saint Augustine thundered from North Africa. Paganism does not assure happiness in this world or the next, he maintained. The key to human history is the coexistence of two cities: the Earthly City and the City of God. It is the City of God that matters most and will eventually triumph as the things of this world fade away. Rome, he argued, could never be eternal since it, like everything mundane, must inevitably decay. Furthermore, the fall of Rome to the Visigoths, dreadful though that was, had been no worse than many of the calamities Rome had suffered before the advent of Christianity.

Not content to stop there, Augustine encouraged his friend the Spanish priest Orosius to expand this theme into a book covering the horrors suffered over the entire course of human history. Compared with the plagues, famines, fires, wars, earthquakes, crimes, and other disasters described in *Seven Books*

Against the Pagans, the fall of Rome appears as simply one more event in a long, calamitous chronicle. And perhaps not as bad as many, as Orosius takes care to point out, because when the Visigoths entered Rome, Alaric had allowed the populace to take refuge in the holy places, especially the great basilicas of Saint Peter and Saint Paul, and he had further commanded his followers to refrain from shedding blood so far as possible. Nor was the city destroyed. Though buildings were burned, in the past an accidental fire had done far more damage.

In such fashion the awful news reverberated in every corner of the empire, where it was explained, rationalized, lamented. But for all of the chaos that it caused, the importance of the fall of Rome lay chiefly in its psychological impact. Rome was the center of the world, the symbol of all that was civilized. Rome's rule had extended to the edges of the earth and in doing so had absorbed what was best, intellectually and artistically, from the lands Rome had conquered. From one end of the empire to the other, Roman citizens still enjoyed a common culture and a small measure of that peace which was Rome's primary blessing. The antithesis to Rome, as people of the fifth century could see all too clearly, was chaos and a cultural desert.

The practical import of the fall of Rome was much less significant. It had long ceased to function as an imperial city; Honorius, safe behind the marshes of Ravenna, suffered only a moment's worry about a prized chicken. Rome itself had not even been that severely damaged. Historians disagree about the extent of the destruction caused by the Visigoths, but there is no doubt that the city they left was still quite capable of functioning. The writers

who give the most dire accounts, who speak as if all Rome were left in smoking ruins, are men like Jerome who at the time were far away. After all, Rome was a vast city and the Visigoths were there for just three days. (At least this seems to be a reasonable estimate, although the figure given by our sources varies from two days to six days.) Only a fire burning badly out of control for some time could have been destructive enough to level the entire city. Though we know that a palace was burned in the northern part of the city and excavations have revealed traces of fire on the Aventine hill, there is no evidence whatsoever of total cataclysm.

In fact, the physical structures of the city undoubtedly fared better than the populace. As has been mentioned, at the express orders of Alaric, the great basilicas of Saint Peter and Saint Paul were spared together with the people who took refuge in them, but that could only account for a small part of the Roman population. Even if the Visigoths used moderation and heeded Alaric's command to spare unresisting citizens, the Huns who made up part of the horde would have felt no compunction to exercise restraint. Unquestionably many people were slaughtered and there was much raping and looting; prisoners were taken and a high percentage of the populace was left destitute. In Bethlehem, Jerome wept as the exiles poured in.

Out of the Ashes

The city, however, was no more denuded of its entire population than it was utterly destroyed (see Figure 6.1). Although it would be a long time before Rome

became the place it had been as recently as the fourth century, it showed remarkable recuperative powers. In 422, just twelve years after the city was sacked by the Visigoths, construction was begun on the Church of Santa Sabina, arguably the most perfect example of an early Christian basilica extant. Located at the top of the Aventine hill, the same hill that may have suffered some fire damage

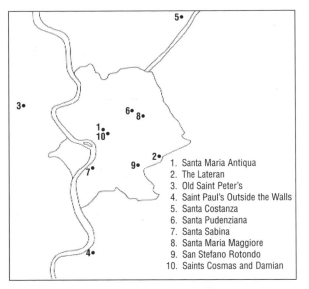

1. Santa Maria Antiqua
2. The Lateran
3. Old Saint Peter's
4. Saint Paul's Outside the Walls
5. Santa Costanza
6. Santa Pudenziana
7. Santa Sabina
8. Santa Maria Maggiore
9. San Stefano Rotondo
10. Saints Cosmas and Damian

Figure 6.1:
Rome and Some of Its Early Christian Remains

under the Visigoths, Santa Sabina and the park next to it occupy the edge of a high bluff with an impressive view of the sweep of the Tiber below, as well as of much of the city. The church itself is of mellow, unadorned brick which accentuates its form—a long, tall, slender structure (no transept interrupts its sleek lines) culminating in a gently rounded apse (see Figure 6.2). The visitor enters through a porch on the west containing the famous cypress doors (see Figure 4.7) and passes into a basilica which is a model of restraint, elegance, and classical harmony.

The length of the nave is emphasized by a graceful continuous nave arcade and its height by an open-timbered ceiling which adds to the building's impression of lightness and space. Both the columns of the arcade and their capitals are spolia (that is, parts reused from previous buildings), but they match beautifully. The arches joining them extend below the semicircular diameter, giving them a buoyant, springy look, this being another technique, like the use of impost blocks, designed to counteract the

The Church of Santa Sabina is about 207 feet long, including the apse. Nave and aisles together measure about 81 feet across, and the nave walls are approximately 62 feet high.

Figure 6.2:
Santa Sabina, Rome: Dedicated in 432, twenty-two years after the Visigoths sacked Rome, this church makes it clear that though the city had suffered both psychologically and physically it was not entirely bereft of will or resources. The clean, balanced lines remind the visitor of the continued influence of the classical tradition. The simplicity of the plain brick exterior is typical of early Christian churches in which the emphasis was placed on the interior and more spiritual part of the building.

flattening effect of perspective. Each clerestory window is placed precisely above an arch, the rounded top of the window echoing its form. The traditional triumphal arch at the east end of the nave does not act as a barrier so much as an unobtrusive point of reference, setting off the swelling curve of the apse with its half-dome into which the space of the nave flows quite naturally.

But what is particularly striking about the interior of Santa Sabina is the light that pours in from the extremely large clerestory windows (fourteen feet high, originally probably filled with micah set into gypsum), spaced only four feet apart along the upper wall of the nave, and from the three matching windows in the apse. The great quantity of light thus admitted would once have been enhanced by the reflection from the mosaics and highly polished marble that covered the church's walls. Although today little of the original decoration remains and it is mostly restored, the visitor can still experience the dramatic contrast between light and shadow that is such an essential part of the church's ambiance. The light-flooded nave is flanked on either side by a dimly lit aisle, the aisles serving as darker foils for its brilliance. People would have crowded into this shadowy space as the clergy proceeded down the brightly lit nave toward the altar placed before the even more brightly lit apse—the holier parts of the church being thus

emphasized by light, considered to be the visible manifestation of God.

Thanks to the removal of medieval accretions and some careful restoration, Santa Sabina may be enjoyed today in something resembling the form it had in the fifth century. The most obvious reminders of the period separating the fifth century from our own are the paintings in the vault of the apse and on the triumphal arch, both from the sixteenth century and later. But these are reasonably discreet and there is none of the heavy, and often distracting, Baroque additions found elsewhere. Meanwhile the delicate design of chalices and patens in the marble-covered **spandrels** between the arches gives some indication of the original decoration, simple yet elegant, a complement to the church itself.

Santa Sabina was planned as a parish church. Perhaps Sabina was a woman who let her house be used for Christian worship in the early days of the Church, and who later, through one of those numerous confusions during the Middle Ages, was assumed to be the basilica's patron saint. In any case, Santa Sabina's generous dimensions, though impressive enough in their own right, do not begin to compare to those of the great fourth-century basilicas, nor do they equal that of another Roman basilica begun in the same year Santa Sabina was consecrated (432). This is the church of Santa Maria Maggiore, built by the order of Pope Sixtus III. Some have suggested that erecting a basilica on so great a scale (the nave is 282 feet long and more than 100 feet high) was a way of reasserting supremacy of the papacy, and hence orthodox Christianity, after the disaster at the hands of the Arian Visigoths. This may well be, but it was probably not all that Sixtus had in mind, and many

scholars believe that the pope was motivated by yet another ecumenical council.

As we have seen, the first two ecumenical councils (both held in the fourth century) primarily addressed the relationship of the Father and the Son—the official declaration being that the Son is of the same substance with the Father and is co-eternal. The second two ecumenical councils (both held in the fifth century) delved into the dual nature of the Son as both God and man. The third ecumenical council, which met at Ephesus in 431, dealt with the problems raised by a group known to history as the Nestorians. Their opponents accused the Nestorians of splitting apart the two natures embodied in Christ and of emphasizing his human nature at the expense of the divine. If one carried what was purported to be the Nestorian position (it may be that it has been misrepresented) to its logical conclusion, then one could not speak of Mary as the Mother of God (Theotokos), a name by which she was much revered particularly in the East, but only as the mother of the human Jesus. Although one might think that this matter could be only a secondary issue at best, it was exactly the sort of thing which was close to people's hearts and generated such heat that it almost managed to obscure the central argument.

Sixtus III became pope in 432, the year after Nestorianism had been officially condemned, and ordered construction to begin on a basilica to honor Mary, whose title as the Mother of God had been reaffirmed at Ephesus. The church for which Sixtus was responsible is large and impressive, though not quite as large and impressive as the basilicas of the Lateran, Old Saint Peter's, and Saint Paul's Outside the Walls. Mary, no matter how important a figure,

The opponents of the Nestorians, the Monophysites, were accused of emphasizing the divine nature of Christ at the expense of the human. The Monophysite point of view was condemned at the fourth ecumenical council, the Council of Calcedon, in 451. However, the Monophysites continued to be a viable force within the empire.

was still a woman, and women, though they were admired as martyrs and often played an active role in the early Church, did not enjoy quite the same status as men.

However, while Old Saint Peter's no longer exists, the Lateran has been altered out of all recognition, and Saint Paul's is a reconstruction, Santa Maria Maggiore still stands much as built, at least inside. The interior is restrained and severely classical. It is sumptuous yet sober, with none of the buoyancy of Santa Sabina. Columns march beneath a flat **architrave** (no slender, graceful arches here) at a regular, subdued pace down the nave. The nave is spanned by a coffered ceiling embellished (much later, of course) by the first gold to come from Peru. (The vaulting in the aisles is of a later date as is the magnificent marble floor; the various side chapels were also added later.) The clerestory windows in the nave are similarly measured in their stride and are both proportionately smaller (given the overall space) and placed considerably further apart than those of Santa Sabina. The nave culminates with an enormous Baroque baldachino, which cuts off the apse and obscures the triumphal arch with its priceless fifth-century mosaics. However, it says much for the size and power of this church that it can contain such a baldachino and not be overwhelmed by it.

Santa Maria Maggiore has two sets of fifth-century mosaics. One consists of two series of mosaic panels (each about forty-seven inches by eighty inches) above the nave colonnade. These, unfortunately, are neither complete nor easy to see. They depict scenes from the Old Testament, and it is here that one finds the representation

of Abraham entertaining the three strangers (see Figure 4.1).

Although the panels undoubtedly express a lively interest in the Old Testament for its own sake, they are not without symbolic value. The mosaics on one side of the great nave feature Abraham and Jacob, the former figure being particularly significant. Since Abraham was willing to sacrifice his only and much beloved son, Isaac, at the command of God, he is traditionally seen as a symbol of faith. On the opposite side of the nave, the mosaic panels illustrate episodes from the lives of Moses and his successor, Joshua. As it was Moses who received the commandments on Sinai, he is viewed as symbolizing the law. Thus we have Faith and the Law, the two pillars of the Church, expressed here by figures from the Old Testament, on which the New Testament, and hence the Church, is founded.

The mosaics on the triumphal arch of Santa Maria Maggiore, for which the church is justly famed, are much more accessible to the visitor than are the panels in the nave but still a bit difficult to see behind the Baroque baldachino. Their style is quite different from that of the nave panels; the figures on the arch tend to be weightier and more massive, the action is more restrained, and the extensive use of gold adds an aura both regal and timeless. The exact interpretation of the scenes on the triumphal arch, which include incidents from the childhood of Jesus, has been a subject of scholarly debate, but certainly Mary appears and is honored there. This impression would have been further enhanced by the original apse (destroyed at the end of the thirteenth century), which was decorated with an image of the enthroned Virgin.

A Still Greater Menace

Yet even the construction and decoration of a great basilica such as Santa Maria Maggiore could not obscure the events of August 410, and these had ominous implications for the future. Within less than a decade after the fall of Rome the Visigoths had established their own kingdom in the area of Toulouse. Although the Visigoths still considered themselves soldiers of the Roman Empire, they governed the area they controlled without imperial interference.

Nor were the Visigoths unique. From the beginning of the fifth century on, more and more troops were withdrawn from the frontiers to combat problems closer to home. The peoples on the edges of the empire were not slow to take advantage of the opportunity this provided. As a Roman general had done in earlier times, they came, they saw, they conquered. The Franks claimed a corner in the northeast of Gaul, the Burgundians a piece around Lake Geneva, and while the Angles, Saxons, and Jutes nibbled away at Britain, the Vandals settled in Africa. (Saint Augustine, bishop of Hippo, died in 430 as the Vandals were besieging the walls of his city.)

But although the western part of the Roman Empire was rapidly being dismembered, an emperor continued to rule, in name if not in fact, in Ravenna. When the ineffectual Honorius died in 423, he was succeeded by his nephew, Valentinian III, the son of Galla Placidia and her second husband, Constantius. Since Valentinian was only a small child when he became emperor, his mother served as regent and continued to be a power behind the throne even after Valentinian came of age. It was not an easy time to

The Visigothic kingdom of Toulouse endured for almost a century (419–507), until the Visigoths were driven south of the Pyrenees by the Franks, the tribe that would produce Charlemagne and eventually give its name to modern France. The Visigoths then concentrated their power in Spain, which they already controlled. The Visigothic kingdom of Spain lasted two centuries until it was conquered by the Moors in 711.

169

rule, for not only were the various German tribes busy appropriating segments of the empire in the West, but the seemingly indomitable Huns continued to be a menace. Having penetrated the empire, they had remained for some time in the upper Balkan area, extorting tribute from Constantinople. However, under the leadership of Attila, the "Scourge of God" as he came to be known, their gaze turned west again, their next move being given impetus by the daughter of Galla Placidia.

By some irony of fate, among the descendants of Theodosius the Great it was always the females who received the genes of intelligence, vitality, and leadership while the males enjoyed none of these gifts nor any talents that might have compensated for the lack of them. True to form, Valentinian III was a weak emperor unfitted by either intellect or temperament to rule. His sister, however, was made of sterner stuff. Justa Grata Honoria was one of those women of energy and intelligence (though not of particularly good common sense) who grow easily bored and restless without the opportunity to make use of their abilities.

There is much we do not know about life at Ravenna in this period, but the upper stratum seems to have been increasingly Byzantine—highly formalized, organized around court protocol and religion—which means that for a person like Honoria it must have been stultifying. A woman of imperial rank could distinguish herself in two ways. If she were the wife of the emperor she could provide him with offspring, and any woman of the imperial family could impress those around her and even form a power base by a display of extreme, and hence intimidating, piety.

The first of these was not open to Honoria, and for the second she was not temperamentally suited. Unmarried, she became pregnant with the child of her steward. Valentinian responded by having his sister's lover put to death (the emperor feared that the intention was to raise Honoria's lover to imperial rank, thus creating a challenge to his own rule) and banishing Honoria to Constantinople, the fate of the child ominously escaping mention in our sources. The next move was to try to marry the rebellious Honoria off to a rich and extremely respectable man in whom she had not the slightest interest.

Angry, frustrated, resentful, Honoria turned to outside help and in 449 or 450 sent a message to Attila the Hun asking him to be her champion. She obviously based her choice on the power he wielded, not on anything she could have heard of his looks, since Attila is described as a short man with a disproportionately large head, swarthy complexion, small eyes sunken in the flesh of his face, and a flat nose. With her request Honoria sent her ring, perhaps to show the genuineness of her message or to express the sincerity behind it, but Attila chose to interpret the ring as a proposal of marriage. Valentinian, of course, was incensed and only the intercession of his mother, Galla Placidia (who died shortly afterward), prevented him from ordering the death of his sister. Nothing, however, could stop the emperor from having the man who served as his sister's emissary to Attila tortured and killed, the savagery with which his orders were carried out giving some indication of what Valentinian would have done to Honoria if their mother had not intervened.

Attila, on the other hand, was as pleased as Valentinian was furious. The Huns had raided the Balkan area so often that there was little more to be had there, and to make matters worse, Constantinople was balking at the idea of paying more tribute. It was obviously time to move west toward new and more fruitful lands. Attila decided to claim Gaul as the marriage portion of Honoria, and he acted accordingly. He invaded Gaul—the furthest west that the Huns penetrated—but was checked there by imperial forces in the summer of 451. Ironically enough, both armies contained a large German element, and on the imperial side the Visigoths fought particularly loyally for the empire they had helped to undermine.

Still claiming Honoria as his bride, Attila next invaded Italy and menaced Rome. Although the emperor was in Rome at the time, it was (according to tradition) Pope Leo I who emerged to negotiate with the invaders. This was probably just as well, because the sources suggest that Leo was an imposing figure, not at all like the ineffectual males of the Theodosian line. Also, so the legends say, Leo had backup help in the persons of Saints Peter and Paul, who appeared to Attila and properly intimidated the Hun. But, especially if one doubts that the Scourge of God could be cowed by any celestial manifestation, there is the more mundane explanation that subsequent events were influenced by the fact that the Huns were running short of food and their numbers had been severely decimated by the plague. For whatever reason, after Attila's meeting with Pope Leo, the Huns retreated northward.

Attila, however, did not give up his claim to Honoria, although this did not stop him contracting another marriage in the interim. The morning after

the wedding night, Attila's attendants found him dead and the young woman in tears. A burst artery or murder? There is, of course, no way to tell. In any case, the Hunnish horde soon broke up, for a commanding leader was the force necessary to hold such amorphous groups together.

But the Romans and Pope Leo had managed to avoid one foe only to be confronted by another. In 455 the Vandals moved north from Africa and soon appeared at the gates of Rome, from which Leo again issued forth to negotiate. This time the pope was not so successful. He did not manage to dissuade the Vandals from entering Rome but did strike a compromise. Gaiseric, the Vandal leader, agreed to order his troops to restrain themselves from wanton murder and torture. Yet we know how difficult it is to enforce moderation in war—consider modern warfare where discipline is far better than among any fifth-century barbarian rabble and yet we can still perpetrate our own horrors.

Gaiseric's promise may, however, have had a mitigating influence, and perhaps some lives were saved and much needless destruction was prevented because of it. On the other hand, the Vandals did not allow any considerations to stop them from thoroughly sacking the city and plundering it on an unprecedented level. Anything of value that could be transported was added to the spoils of war, including numerous captives, the empress Eudoxia (widow of Valentinian III, who had been murdered three months earlier), and her two daughters, Eudoxia and Placidia. Luckily enough for her, Placidia was already married, but the unfortunate Eudoxia was wed to the Vandal Huneric, in no way a love match as had been the first marriage of her grandmother, Galla Placidia.

The Vandals gave us our modern word *vandalism*, but neither they nor other "barbarians" devastated Rome to the extent Spanish troops did in 1527.

173

Figure 6.3:
San Stefano Rotondo, Rome: This church from the second half of the fifth century is one of those early Christian treasures usually over-looked by the visitor to Rome. A quiet courtyard buffers it from the hustle and bustle of the city. Inside, simple, rhythmic lines emphasized by plain white walls (the original mosaic decoration has mostly been lost) add to the sense of calm. Once the outer wall of the ambulatory which surrounds the central core would have been open to four chapels alternating with four courtyards. The loss of these is to be much regretted, but the real (and rectifiable) shame is that all but eight of the twenty-two windows surrounding the dome have been blocked.

In spite of the devastation wrought by the Vandals, Rome had sufficient resources and vitality for the construction of yet another church that is still extant though in a somewhat altered form. San Stefano Rotondo (see Figure 6.3) was built during the pontificate of Pope Simplicius (468–83), its founder, most likely to house the relics of Saint Stephen, the first Christian martyr. As the name would suggest, it is a round building, originally consisting of three concentric circles: (1) a central core resting on a colonnade of twenty-two granite columns with white Ionic capitals, matched by twenty-two windows in the dome; (2) an ambulatory surrounding the central core; and (3) an outer wall which enclosed four deep chapels extending from the ambulatory like the arms of a **Greek cross.** These chapels alternated with four small gardens from which light entered through the arcade that formed the outer circumference of the ambulatory. The church thus combined interior space with nature in a very contemporary fashion,

introducing the out-of-doors into the building yet buffering it from the sights and sounds of the city.

Today, outer wall, chapels, and gardens are gone, and consequently the ambulatory (no longer an open arcade) has become a dark ring around a lighter center, though not as light as it once was since a large number of the windows in the drum have been boarded up. For the most part, the decoration has similarly vanished. But simple, stripped down, and unadorned though it is, San Stefano continues to delight, its architecture still communicating a feeling of space, height, and buoyancy.

The central drum has a diameter of 74 feet, and probably rose to a height of 74 feet as well. As the building stands today, its outer diameter is 216 feet. The diaphragm wall that crosses the central core is from the Middle Ages.

An Early Christian Baptistery and a Great Medieval Poet

Even as the city of Rome was being bruised and battered, and the empire in the West survived by a hair's breadth, life in Ravenna went on much as before, except with increasing elegance as construction turned the town into a truly imperial city. Today it takes an effort to imagine the Ravenna of the fifth and sixth centuries—its imposing monuments, sumptuous palaces, dark winding canals, and numerous beautiful churches—since the present city has a pleasant but unremarkable and mostly modern appearance (see Figure 6.4). But it is the land that has changed even more dramatically than the evidences of human habitation. Ravenna's physical contours have altered slowly but surely over the centuries; most notably the land has risen as the sea has receded to the east. Today it is a city of bicycles rather than boats, surrounded by broad green fields rather than inhospitable marshes, the Po River, too, having

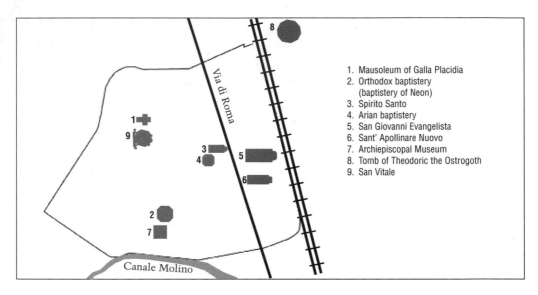

1. Mausoleum of Galla Placidia
2. Orthodox baptistery
 (baptistery of Neon)
3. Spirito Santo
4. Arian baptistery
5. San Giovanni Evangelista
6. Sant' Apollinare Nuovo
7. Archiepiscopal Museum
8. Tomb of Theodoric the Ostrogoth
9. San Vitale

Figure 6.4:
Early Christian Remains
in Ravenna

changed its course. In consequence of the rising land, the buildings of the fifth and sixth century have either had their floors raised as at the mausoleum of Galla Placidia, or are approached by descending stairs, changes that have consequently altered their proportions.

Among the buildings of imperial Ravenna that can still be seen and enjoyed is the cathedral baptistery, known both as the baptistery of Neon after the bishop responsible for its splendid decorations and also as the baptistery of the Orthodox to distinguish it from the later Arian baptistery. The baptistery was originally constructed in the late fourth or early fifth century and probably received its dome (together with its justly famous mosaic decorations) in the second half of the fifth century, since Neon, to whom these embellishments are credited, was bishop of Ravenna from 449 to 475. As befits a baptistery, the building is octagonal, a tall (about forty feet, but originally higher), severe tower of brick with minimal embellishments on the exterior. Under the

roof line are elongated double blind arches, two to a side. Below these, one on each of the eight sides, is a large window with a rounded top. At the base of the tower, apses swell out on four alternate sides. The sides without apses once had doors, but today only the archways close to the ground are visible. (When first built, the level of the baptistery was almost ten feet beneath the existing street level.) The door now in use, obviously added later, is at the present ground level.

The glory of the baptistery is its dome (like that of the mausoleum of Galla Placidia, not visible from the outside), amazing both in its construction and in its decoration. The interior diameter of the dome is roughly thirty-one and a half feet, although the walls supporting it are only three feet thick and have no additional buttressing. This marvel was made possible by the use of **tubi fittili,** hollow interlocking terracotta tubes (they have been compared to a series of syringes inserted one into another) laid in quick-drying cement and set in diminishing concentric circles. The end result is a dome that is as light as an eggshell and only about ten inches thick.

The mosaic decoration of the dome takes full advantage of the dome's height and sweep. The dome mosaics are arranged in three concentric levels. In the center medallion, directly above the octagonal baptismal font (actually a small pool, or piscina, of the sort previously mentioned), is the baptism of Jesus (see Figure 6.5). Wavy blue lines across Christ's lower body suggest the waters of the Jordan River. Further, the classical figure of a river god labeled as "Jordann," holding a reed in one hand and in the other a green cloth with which to dry Jesus, emerges from the water to Christ's left (the onlooker's right). On the

Figure 6.5:
Baptism of Christ, Baptistery of the Orthodox: Both in form and decoration this baptistery speaks to the sacrament to be celebrated there. The octagonal shape recalls Christ's resurrection on the "eighth" day, and as Christ died and rose again from the dead, so the person to be baptized will die to sin and be reborn to a spiritual life. In the dome directly above the baptismal font, John baptizes Christ in the Jordan (personified by the half-submerged figure to our right). (Drawing inspired by the dome mosaic probably mid–fifth century, baptistery of the Orthodox, Ravenna.)

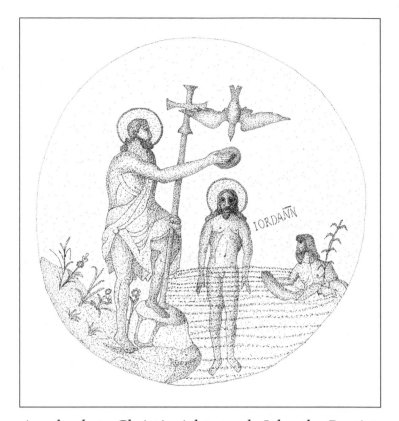

river bank to Christ's right stands John the Baptist, with his left foot balanced on a rock. Grasping a jeweled cross in his left hand and a paten in his right, John baptizes Jesus by anointing him with water from the paten. Above the head of Christ hovers the dove of the Holy Spirit, but this part of the mosaic (including both Christ's head and the Baptist's right arm) is a restoration, easily enough seen by the difference in the coloring of the gold background. It has been speculated that the nineteenth-century restorer also made one change. The paten is surely an addition, one that appealed to him because of its popularity in the Renaissance. In the original, the Baptist was probably shown touching Christ's head as in other representations of this scene from the early Christian period.

Around the center medallion circle the twelve apostles, half led by Peter and the other half by Paul. Each holds a jeweled crown representing spiritual triumph, often in hands draped with a corner of the saint's mantle—covered hands being considered a gesture of reverence and respect. A deep blue background sets off their costumes, a gold mantle over a white tunic or, alternately, a white mantle over a gold tunic. Although there is a certain sameness in the bodies, the faces of the saints are highly individualized and the name of each is given in gold letters. The sense of stately procession is enhanced by the white swags patterned in red and gold which surround the central medallion like scallops, one fold hanging down behind the head of each saint and serving as a nimbus. The saints are separated by tall gold-leaved plants which look much like the spokes of a wheel and add to the impression that this band is rotating around the center medallion.

A third circular band surrounds the apostles. Here, amid a profusion of plants and flowers which may suggest the garden of paradise, are four vacant thrones, symbols of either Christ's dominion or the Second Coming. These alternate with four altars, on each of which lies an open book, undoubtedly a gospel. To either side of each altar is an empty chair, perhaps a place in heaven prepared in advance for those who have been born into the spiritual life through baptism.

The sense of a gentle wheeling motion around a fixed, immobile core may remind the visitor of the double row of twenty-four lights, the visual manifestation of spirits, which circles Dante and Beatrice in Canto XII of Paradise in *The Divine Comedy*, written almost nine centuries later. Both the sense of rotation

179

and the emphasis on light—for these mosaics with their lavish use of gold manage to radiate light even on a dark day—are very Dante-esque; Dante's Paradise, as will be remembered, is saturated with light which ultimately culminates in the shining substance of Christ. The great medieval poet, who is buried only a few short blocks from the Orthodox baptistery, never fulfilled his wish to return to his beloved Florence, but perhaps he was not altogether displeased in his final resting place near the great mosaics of Ravenna.

The End of the Roman Empire in the West

Yet even as these mosaics, which speak so eloquently of eternal peace and harmony, were set into place, Ravenna, which had so long escaped the barbarian incursions, was about to suffer the fate of other parts of the Western empire. Galla Placidia died in 450 and her son, Valentinian III, was murdered in 455. There followed a series of ineffectual emperors, ending, ironically enough, with the deposition of the child emperor Romulus (the name of the legendary co-founder of Rome), known to history as Romulus Augustulus, or the baby emperor, in 476. Power then passed to the German Odovacar, who ruled as "king" (being a German, he could not be emperor) in the name of the emperor in Constantinople. This transition ended the succession of emperors in the West, but it can hardly be called the "fall of the Roman Empire," as it so often is, since there was still an emperor in thc East who was the acknowledged source of authority for someone like Odovacar.

Romulus Augustulus was not even considered worth killing. Having been deposed, the young boy was sent to live the rest of his days with relatives in Campania.

The rule of Odovacar was brought to an end by the Ostrogoths, a group last heard from more than a century before when they were being swallowed up by the Huns—swallowed and then disgorged when the Hunnic power finally disintegrated. One group of Ostrogoths (the Ostrogoths were not a united nation under a single ruler any more than the Visigoths or the Huns had been until a strong leader arose) settled in the poor, much-battered Balkans under the leadership of a young man of royal lineage named Theodoric, who was probably only sixteen or seventeen when he was elected king. The emperor in Constantinople realized that such a force on imperial soil and so close to home posed a threat, so when relations between Theodoric and Constantinople began to deteriorate, the emperor conceived of the idea of sending Theodoric and his Ostrogoths west to deal with Odovacar. Whether or not the emperor had any real quarrel with Odovacar we do not know, but it was an excellent excuse to get Theodoric out of territory claimed by Constantinople.

Theodoric defeated Odovacar time after time in the field, but taking Ravenna was another matter, for the cowardly and long-dead Honorius had chosen his place of refuge well. The siege of Ravenna lasted two and a half years. Theodoric settled in the pine woods east of Ravenna and tried to blockade the city, but provisions still got through by sea. It was not until Theodoric acquired a fleet and blockaded its harbors that Ravenna could be taken. Theodoric then entered into a compact with Odovacar by which they would rule Italy jointly, but the conqueror probably never meant to honor it. Within days of entering Ravenna (493), Theodoric murdered Odovacar with, we are told, his own hand. Although in theory Theodoric, like Odovacar before him, ruled as representative of

In an otherwise exemplary reign, there are two strikes against Theodoric: the murder of Odovacar at its outset and the execution of Boethius (see chapter 7) toward its end. Whereas the murder of Odovacar is a typical example of the *real politik* of the time, the execution of Boethius represented a monumental error of judgment and one Theodoric lived, though not long, to regret. In one sense both actions were "barbaric," but viewed in the context of their age they were nothing different or more barbaric than many of the actions taken by the most "civilized" of Roman, and later Byzantine, emperors.

the emperor at Constantinople, in practice he was highly independent. Italy, the heart of the old Roman Empire, had been claimed in its turn by a barbarian ruler and his people.

However, it is very hard to consider Theodoric a complete barbarian. He had spent much of his youth as a hostage in Constantinople, where, though he may not have learned to read, he developed an appreciation of Roman civilization, which as a ruler he tried to preserve. He saw to the repair of the aqueduct that served the people of Ravenna, encouraged agriculture, and attempted to maintain the roads. He is also remembered with respect for preserving buildings and monuments and building new ones. He even engaged a secretary, Cassiodorus, to put his official papers in elegant, if somewhat circumlocutious, Latin.

Being Arians, not Catholics, the Ostrogoths needed their own place of worship, and probably the first building, or at least the first church, constructed in Ravenna under Theodoric's rule was the cathedral of the Arians (Anastasis Gothorum), now Spirito Santo. The original mosaics have been lost and the architecture of the building, too, has suffered alterations; the floor has been raised six feet, the original open-timbered ceiling replaced with a coffered one, and a sixteenth-century portico now dominates the facade. Also, Spirito Santo, like most basilicas, managed to attract its share of side chapels added over the centuries, though it lost most of these during bombing in the Second World War.

What remains is a simple basilica with an arcade separating the nave from a single aisle on either side. At the east end is an apse, rounded on the interior and polygonal on the outside. The church (about eighty-six feet by fifty-three feet) is executed on a modest

scale. Since presumably Theodoric could have ordered up a building that would have overwhelmed the populace of Ravenna by its size alone, one wonders if the dimensions of Spirito Santo reflect the influence of churches further to the east (i.e., Greece and Constantinople) which were familiar to Theodoric or whether in its restraint Spirito Santo expresses Theodoric's admirable religious policy.

Theodoric was a tolerant man who realized that religion cannot be commanded, because no one can be forced to believe against his or her will. As legend would have it, he ordered the death of one hypocritical Catholic deacon who converted to Arianism simply to please him. The only people Theodoric would have liked to convert were the Jews, but here again his good sense triumphed over abstract theories, and he made sure that the Jewish population, too, received a full measure of toleration.

Just across from Spirito Santo is the Arian baptistery, also dating from the end of the fifth century. The Arian baptistery has clear parallels with the earlier baptistery of the Orthodox. Both are octagonal brick buildings with four apses on alternate walls, both have high windows with rounded tops (one on each of the eight sides), and inside the central feature of both baptisteries is a dome decorated with mosaics. Originally the Arian baptistery had an outer ambulatory around seven sides, but overall the space is much less complex than that of its predecessor and the proportions are much more modest. This is taking into consideration the fact that now the Arian baptistery is sunk about four and a half feet below street level (one walks down steps to enter it) and the original floor was probably another three feet below that.

Figure 6.6:
Baptism of Christ, Arian Baptistery: Except for the position and additional prominence of the personification of the Jordan River, this central medallion seems much like that in the baptistery of the Orthodox (see Figure 6.5). However, these solid, three-dimensional figures emerge out of a tradition quickly being replaced by a less physical, more spiritual approach toward the human figure.
(Drawing inspired by the dome mosaic, c. 500, Arian baptistery, Ravenna.)

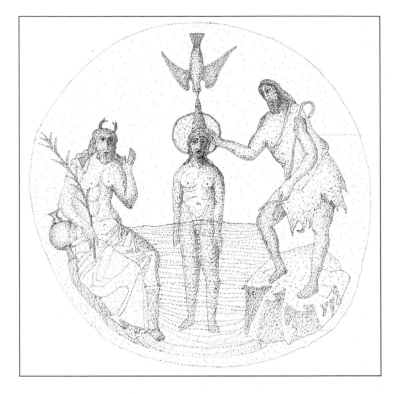

Today, the interior of the baptistery of the Arians is exposed brick against which the mosaics in the dome stand out brilliantly by contrast (see Figure 6.6). The choice of decoration is much the same as that in the dome of the baptistery of the Orthodox. In the center medallion, John the Baptist, garbed in the traditional animal skins, baptizes Jesus (but from Christ's left and in the usual manner of the time by putting his hand on his head). The dove of the Holy Spirit hovers overhead and a personification of the Jordan River looks on (though from Christ's right, rather than the left, as in the earlier mosaics).

In the Arian baptistery, Jordan has become a much more well-fleshed and dominant figure; he is in scale with the other figures and occupies a far more prominent position than the proportionately smaller,

half-submerged river god in the Orthodox baptistery.
Holding his reed he sits, seemingly atop the water—
a very solid-looking, older man with a vivid green
drape (matching the color of the rock on which John
stands) wrapped around his thighs and legs, one foot
peeking out below. Water gushes forth from a vase
(symbolizing the source of the river) behind him, and
on his head are two red lobster claws (more water
elements). Nor is the size and stature of Jordan the
only readily apparent difference between the two
baptismal scenes, for at the Arian baptistery Jesus is
depicted as a less mature figure than in the Orthodox
baptistery, perhaps harking back to the tradition of
showing Jesus as a child (*infans*) in representations of
the baptism.

In the Arian baptistery there is only one ring
around the central medallion. In this band the
apostles parade sedately in a circle around the
baptismal scene. They carry jeweled crowns—except
for Peter with his keys and Paul with a scroll, the
counterpart of Peter's keys symbolizing the laws or
the rule of God—and follow these two lead apostles
toward the empty throne, here surmounted by a
jeweled cross. The design of the Arian dome is far
simpler than that in the baptistery of the Orthodox
and far more restrained. The apostles, dressed
uniformly in white and depicted against a plain gold
background, are separated by palms like the spokes of
a wheel, but there are no swags of drapery and alter-
nating colors of robes such as those that enliven the
movement of the figures in the dome of the Orthodox
baptistery and give the composition its delicate
rhythms. The apostles at the baptistery of the Arians
are also more solid, earth-bound figures than those in
the earlier mosaics and are nothing like the lithe,

animated figures of the Orthodox apostles. As is the case with the personification of the Jordan River, the Arian apostles have the weight and substance one associates with the classical tradition.

Quite naturally, these two baptisteries are often compared, especially with respect to the mosaics in their domes, and usually to the detriment of the more modest Arian baptistery. However, the mosaics of the Arian baptistery are impressive enough when seen in situ. The gold, green, and white contrast dramatically with the mellow, pinkish color of the bricks, and the solid figures clearly tell their tale. It is a worthy monument to the rule of Theodoric, which, "barbarian" though it might have been, set a high standard for its time. It is also a poignant reminder of a world in rapid flux, for Theodoric's kingdom would not long outlast its leader.

CHAPTER

7

Teetering on the Edge
of the Abyss

Felix (Happy) Ravenna

In comparison with the rapidly disintegrating social, political, and economic order in the West, Theodoric's rule in Ravenna (493–526) represents a relatively benign period of stability. His panegyrist dubbed it a "golden age," but then the role of a panegyrist, or eulogist, is to lay it on as thickly as possible. However, even a much later chronicler, under no such obligation, speaks with a note of longing of a time distinguished by happiness, peace, and abundance. Considering the chaos that engulfed Italy soon after his death, Theodoric's reign must have looked very good indeed to subsequent generations.

Although Theodoric technically ruled as king under the aegis of the Byzantine emperor, he appears to have seen himself as a cut above ordinary kings, a ruler who was only slightly, very slightly, less than his imperial overlord. And, versed in the imperial

tradition from his youthful experiences in Constantinople, Theodoric played his role well. Patronage of building and public works being an important part of the imperial image, it is not surprising to find Theodoric ordering land to be reclaimed from the marshes, roads repaired, and harbors improved. Repairs were made to existing buildings, and new ones were begun. The king, who believed that the rebuilding of ancient cities was particularly worthy of royal attention, made substantial improvements to old Rome and engaged in large-scale building projects elsewhere in his kingdom. But it is with Ravenna that Theodoric's name is most closely associated.

By the beginning of the sixth century, the little, surely insect-infested village on the mud flats had grown into a city that boasted some 324 spacious streets, 46,603 dwelling places (1,797 homes of the very rich), and 24 Catholic churches—a total that presumably does not include Arian places of worship. The town once accused of having water, water everywhere but not a drop to drink now slaked the thirst of its residents from no less than 1,352 reservoirs, by which our sources must be referring to the sort of spigots pouring forth good, cold, potable water that, still plenished by aqueducts, continue to serve Rome today. Although not all of this development can be credited directly to Theodoric, he did play his part as royal patron with enthusiasm. His contemporaries praise him particularly for the repair of Trajan's aqueduct, the principal water source for Ravenna.

Meanwhile, in addition to his many public works projects, Theodoric demonstrated an active interest in buildings of a more spiritual nature. To Spirito Santo (the former Arian cathedral) and the

Arian baptistery, we should now add the justly revered basilica of Sant' Apollinare Nuovo (the new Saint Apollinaris), originally dedicated to the Savior and intended to serve as palace chapel. Here again Theodoric exercised restraint in a building intended for Arian worship. The facade (now dominated by a medieval **campanile,** or bell tower, and a Renaissance portico), and indeed the entire exterior, were originally very plain, embellished only by simple Milanese brickwork, much of which can still be seen. The interior of Sant' Apollinare Nuovo is relatively modest (about 104 feet by 71 feet on the interior), larger than Spirito Santo but smaller than at least one contemporary Catholic church in Ravenna and certainly no match for the great basilicas of Rome.

In the latter case, however, the contrast is far more than a matter of size. Sant' Apollinare is both proportionately higher and wider than the major Roman churches of the time. But the contrast does not end there. The most striking difference between a Ravennate church like Sant' Apollinare Nuovo and the early Christian basilicas we have seen in Rome hinges on light, that most illusive yet most important element in the early Christian palate. The subdued, almost otherworldly light that filters through the high clerestory windows of Saint Paul's Outside the Walls (rebuilt, but along the original lines) and the dramatic spotlighting of nave and apse achieved at Santa Sabina are both quite different from what the visitor finds in Ravenna. In a church such as Sant' Apollinare, at least as originally constructed, light poured in through generous windows in the aisles, one on either side of the central nave, as well as through the clerestory windows and more windows in the apse. There were neither shadowy

corners nor dramatic highlights. The same gentle luminosity filled the entire interior, enveloping both congregation and clergy.

The addition of chapels, and the consequent blocking of the aisle windows, along the north side of Sant' Apollinare Nuovo has severely compromised the intended effect. However, one can get some idea of the original lighting by visiting another Ravennate basilica only a matter of blocks away, the earlier (c. 426) and larger (163 feet by 73 feet) church of San Giovanni Evangelista (Saint John the Evangelist). San Giovanni is another structure associated with the famous Galla Placidia, although in this case, unlike her mausoleum, which celebrates the peace of death, it is a monument to her tempestuous life. Returning from Constantinople where, it will be remembered, she had fled to avoid her brother Honorius's improper advances and the resulting gossip, the empress was caught with her two children in a violent storm at sea. As the wind lashed the ship and the waves battered it, Galla swore an oath that if she and her children were saved she would build a church, a promise that, upon returning to Ravenna, she immediately honored. San Giovanni commemorated the empress's vow with a large mosaic of Galla Placidia and her children escaping shipwreck, but this has subsequently been lost along with the church's other, originally quite extensive, mosaic decorations.

The building has suffered its own trials, including being heavily bombed in the Second World War. After the war, it was rebuilt along its original lines, although the floor, as is typical of Ravenna, is now some six and a half (one commentator claims nine) feet higher than when the church was first constructed. There are also the usual medieval

additions, in this case a Gothic portal on the facade and a proto-Romanesque campanile. But aside from the mosaics now long gone, the inside of San Giovanni creates much the same impression it did in the fifth and sixth centuries—an elegant, serene, spacious building permeated throughout by a strong but diffused light. Here space and light work together, flowing freely up through the exposed beams of the high trussed ceiling, between the wide arches of the nave arcade, and into the apse where seven contiguous windows create an almost uninterrupted band of illumination behind the altar. (When and why the three lower windows in the apse were filled in is a matter of conjecture.)

Today, the visitor must use the experience of San Giovanni as a spur to the imagination in Sant' Apollinare, where not only has the effect of the lighting been impaired by the addition of side chapels, but the sense of unconstrained space has been compromised by the addition of a gilded Baroque coffered ceiling which seems to press down with almost unendurable weight on the delicate nave mosaics while its bright blue color distracts from their ethereal brilliance. This is not at all what was intended; once the worshiper could have looked up through open beams at the underside of a roof embellished with so much gold that when the Catholics rededicated the basilica to Saint Martin of Tours in the second half of the sixth century, the church was called Saint Martin of the Ceiling of Gold. (This dedication was not inappropriate, since Saint Martin was known as the "hammer of the heretics," and no one in Ravenna was likely to forget that the church had first served the Arians.)

Sant' Apollinare received its present name in the ninth century, when further political deterioration in

Italy made the Church of Sant' Apollinare in the port of Classe no longer a safe place to house the bones of Saint Apollinaris, a saint particularly beloved in Ravenna because he was believed to have brought Christianity to the city and served as its first bishop. The saint's remains were translated (i.e., moved) to Saint Martin's within the walls of Ravenna, at which point the basilica was dedicated, or actually rededicated, for the third and last time, becoming the "new" Sant' Apollinare.

Compared with the jarring impact of the ceiling and the restriction of light by the addition of chapels, the raising of the floor of Sant' Apollinare Nuovo by about four feet seems incidental. To do this it appears that a section of the nave wall above the columns and below the beginning of the nave mosaics was eliminated. But the columns, twelve on either side of the nave, were not altered and they still bear the working marks (in Greek letters and figures) of the men who carved them, probably craftsmen in Constantinople. The impost blocks are quite likely original as well.

Today, the nave ends in an absolutely plain apse, semicircular on the interior and polygonal on the exterior (as is also the case at San Giovanni Evangelista). It was built on the foundation of the original apse as recently as 1950 to replace a deep Baroque apse which, if it were as distracting as the present Baroque ceiling, is not much to be regretted. The original apse and the triumphal arch setting it off from the nave were covered with a rich tapestry of mosaics considered quite a marvel by contemporaries. Unfortunately these were lost in an eighth-century earthquake. The nave mosaics, however, survived and it is these for which Sant' Apollinare Nuovo is justly renowned.

The continued existence of these mosaics has often hung by a thread. Earthquakes, alterations to the structure of the basilica, the Baroque fervor for embellishment—all these have threatened them, but perhaps none more so than circumstances surrounding the rededication of this Arian basilica to Catholicism after the death of Theodoric and the defeat of the Arian Ostrogoths. Here, after all, was a church founded by a barbarian and a heretic. The powers that reigned in Ravenna, Catholic and Byzantine by the time of the rededication, might well have insisted that, though the building itself could remain, every trace of Theodoric should be expunged. That such a travesty was avoided should surely be credited to the character and good sense of Bishop Agnellus (557–70), under whom the "reconciliation" (i.e., the rededication of the church to orthodoxy) was effected.

A wealthy man of noble lineage, Agnellus had pursued a military career until the death of his wife, after which he became increasingly involved in the Church and was eventually chosen bishop. Still vigorous and imposing in appearance in his seventies, Agnellus was a man who by birth and training had never been one to bow to the whims of others and who had nothing more to prove either to himself or his community. In a world in which moderation and tolerance were not common virtues, he evidenced both to a remarkable degree in his dealings with the disparate elements of Ravenna's many-faceted religious community. And, whether economics, aesthetics, or just plain good common sense motivated him, Agnellus demonstrated these same virtues in dealing with what has been fittingly referred to as the "artistic reconciliation" (paralleling

Figure 7.1:
The Raising of Lazarus: This nave mosaic from the upper tier of Sant' Apollinare Nuovo, Ravenna, should be compared with that of the Last Supper (see Figure 4.5) across the nave. In both cases, Christ is a commanding figure distinguished by a cruciform nimbus and wearing the imperial purple, but in depictions of the miracles such as that of Lazarus, he is clean-shaven and the number of participants is pared to the minimum; in scenes of the Passion Christ is bearded and there are more figures involved with the scene. The reason for these choices is a matter of conjecture. (Drawing inspired by an early sixth-century nave mosaic, Sant' Apollinare Nuovo, Ravenna.)

the religious one) of Sant' Apollinare. No decorations were disturbed that were not clearly at odds with the current political situation (the reconquest of Ravenna by the Byzantines) or the religious order of the day (Catholicism). Even an inscription, now lost, that acknowledged Theodoric as the basilica's founder was left in situ.

The nave mosaics of Sant' Apollinare Nuovo are laid out in three horizontal zones, or tiers; the upper two remain as originally executed. The top tier consists of twenty-six panels, thirteen on either side, depicting scenes from the life of Christ. The two sides appear to have been the work of two teams of craftsmen and, deliberately or otherwise, evidence some interesting differences. On the left (the north side), the panels depict scenes of Christ's public life and are concerned with his teaching and the miracles he performed (see Figure 7.1). These scenes are pared down to their basic elements in a manner reminiscent of the abbreviated images found in some of the earliest Christian art, such as third-century representations of Noah in his boxlike ark and the three

Hebrews lapped by the flames of the fiery furnace (see Figures 2.4 and 2.5). But there are reminders of imperial tradition as well. Christ is clothed in royal purple; his head is framed by a great jeweled nimbus inscribed with the cross, and he is accompanied, as a prince or ruler would be, by a helper or companion. In all of these scenes, Christ is portrayed young and beardless, the idealized divine Savior of the sarcophagus of Junius Bassus.

The mosaics in the corresponding tier of the opposite wall focus on the Passion and resurrection, although they do not show the crucifixion itself, this being a subject eschewed by the early Christian artists of Ravenna. The artistic approach is noticeably different. Whereas scenes on the left recall the tradition of abbreviated images, those on the right fit more closely into the category of narrative images with more figures and somewhat more action. But the most striking dissimilarity is that the figure of Jesus who, though again distinguished by a jeweled cruciform nimbus and wearing the imperial purple (see Figure 4.5), is bearded. Whether this variation is meant to suggest the doctrine of the dual nature of Christ, whether it arose from diverse artistic traditions, or reflects the difference in subject matter between the two sides is anyone's guess.

The reasons for the ordering of the scenes in the upper tier of the nave of Sant' Apollinare Nuovo have been much debated, but some choices seem too natural to question. Next to the altar on the right wall is the Last Supper, the remembrance of which is celebrated by the mass, and on the left is the changing of water to wine at Cana, Christ's first miracle and an action seen as parallel to the actions of the priest in the blessing of the sacrament.

Adjacent to the Last Supper one finds Christ on the Mount of Olives, where he prayed that, if possible, the chalice (a reference to the chalice of the eucharistic celebration) would pass from him, whereas next to the miracle at Cana is the multiplication of the loaves and fishes, a prefiguration of the eucharist.

The subject matter chosen for the panels at the west end of the nave (the end opposite the altar) is equally appropriate. Here, in times gone by, one would have come into the church through the great central door. (Today, the visitor enters from a side door in the south wall.) Upon entering, the worshipers would have found themselves greeted by reminders of baptism, the sacrament that "opened" the church to them by initiating them into the Christian community, and that prepared them to take part in the sacrament of the eucharist. To their left they would have seen the paralytic healed at the pool of Bethesda (suggestive of the spiritually healing waters of baptism), the casting out of devils from the Gadarene swine (recalling the exorcism that is part of the rite of baptism), and the miracle at Capernaum (as the paralytic was lowered into the room through the roof as the baptized would have been lowered into the baptismal water or had it poured over them). On the right, the same themes are repeated. The incredulity of Thomas and the encounter at Emmaus (in both cases Christ opened the eyes of doubters as baptism opens the eyes of the baptized to the Christian faith) are followed by the three women at the sepulchre (a reminder of the baptismal font and the death and rebirth symbolized by that sacrament paralleling Christ's own death and resurrection).

All this shows a trend, noticeable as early as Dura Europos, to develop an art increasingly in tune

with its surroundings, one that enhanced the function of the area in which it was found through the message conveyed. Of course, not all Christian art was or would be directly related to the sacraments or to the liturgy, but where it was, in churches and baptisteries, it showed an ever-greater sensitivity to its setting. More and more visual art was seen as an integral part of church life and a complement to its ceremonies.

The early Christian who worshiped at Sant' Apollinare would have become very familiar with the scenes in the top tier, and if he or she had any doubts as to their meaning, repeated sermons would have served as clarification. However, these panels are high and relatively small; the visitor on a tight schedule and without sufficient time to study them is likely to be somewhat bewildered. (It is wise to come prepared with opera glasses or light binoculars, perhaps even to spend a little time beforehand studying the scenes in reproduction.) Fortunately, the process of viewing these scenes is made somewhat easier by the decorative panels, each with a large shell inset with a jeweled crown and surmounted by a cross with a dove on either side, separating them. Not only do these decorative panels prevent the narrative from becoming too jumbled, but the shells also act as additional nimbuses for the white-robed male figures (sixteen, originally seventeen, on either side) in the middle tier, an appropriate enough usage since a shell symbolizes resurrection or immortality.

We have no idea of the identity of the doubly blessed white-robed figures (symbolizing that their garments have been washed clean by the blood of the Lamb, i.e., Christ), each holding a book or scroll, who stand in stately fashion between the clerestory

197

Figure 7.2:
Patriarch or Prophet: The solidity of the figures executed under the Ostrogoths points back toward the classical Roman tradition so beloved by Theodoric, which emphasized naturalistic appearances, real figures with volume, weight, and normal human proportions. (Drawing inspired by an early sixth-century nave mosaic, Sant' Apollinare Nuovo, Ravenna.)

In the bottom tier on the right, the strange object Christ holds in his left hand is supposed to be a scepter. It is the work of a nineteenth-century restorer who, for reasons unknown, used the scepter to replace an open book inscribed with the words *Ego sum rex gloriae,* or "I am the King of Glory."

windows (see Figure 7.2). Although their physiognomy is individualized, there are no definite clues as to their identities. Informed guesses have included patriarchs, prophets, and apostles—all reasonable assumptions, though without proof.

As has been said, the two upper tiers of nave mosaics remain almost exactly as completed under the Ostrogoths. The subject matter, after all, is not in any way identifiably Arian. But even the tolerant Agnellus could hardly leave untouched a depiction of Theodoric and his court, as scholars believe the original subject matter of the lowest tier to have been. The theory is that the Ostrogothic mosaics in the bottom tier on the left depicted members of Theodoric's court proceeding from the port of Classe toward the Virgin, enthroned with the Christ child in her arms and flanked by four angels, whereas on the right, courtiers moved from Theodoric's palace toward Christ enthroned and also flanked by four angels.

Yet even here Agnellus showed considerable restraint. The bishop (at least we presume it was he) merely ordered Theodoric's retinue to be removed to

make room for two long rows of saints, twenty-two female saints led by the three elaborately costumed magi on the left and twenty-five male saints following Saint Martin of Tour, that "hammer of the heretics," on the right. Theodoric's palace is to this day labeled as "Palatium," but the courtiers once shown there have vanished—almost. Looking carefully, one can still see amid its columns the ghostly arms and hands of expurgated Ostrogoths.

Besides being a continuing reminder of the church's "reconciliation" to Catholicism, the mosaics of Sant' Apollinare Nuovo suggest another, more subtle sort of transition that is not strictly the result of tension between the vanquished Arian Ostrogoths and the triumphant Byzantines with their Catholic orthodoxy. This is a change in style, and the middle and lowest tiers offer an excellent opportunity for comparison in this regard. Examining these mosaics more carefully, one notes that the figures in the middle tier, executed under the Ostrogoths, are considerably more solid, more three-dimensional, than the saints below. The use of shading suggests the existence of real bodies beneath the white robes; drapery seems to fit around an arm, the contour of a leg is visible beneath a garment's folds (in some cases even a knee can be distinguished), and an exposed foot is placed solidly on terra firma.

In contrast, the bodies of the saints below are flat and linear. Lines are used to convey the idea of bodies intellectually, but there is no shading to indicate that anything of weight and substance is actually there. The figures look like cutouts of the same pattern, though on closer inspection it can be seen that they are never quite identical. While the heads in particular show some slight variations, the initial

The interesting markings on the robes of the male saints are known as *gammadiae* because the Greek letter *gamma* so often appears among them. They are not uncommon in mosaics of this period, being found also in Milan, Rome, and Naples, among other locations. However, their significance is still a matter of debate. Theories range from the *gammadiae* being added as a matter of design (rather unlikely, given the intense spiritual/symbolic outlook of the time) to the assertion (more likely) that they had a meaning for contemporaries now lost.

impression remains one of rhythm created by the repetition of closely matching, two-dimensional forms.

Instead of standing solidly on the ground, the male saints sometimes appear to tiptoe through the grass, but no more so than the female saints, who are perhaps even less of this world. The women's tiny red-clad feet would be totally inadequate to support their bodies if these possessed any weight and volume, but their figures are as flat and linear as their male counterparts. They are richly ornamented paper dolls passing in parade with their jeweled gowns, slightly inclined heads, oval faces dominated by large dark eyes, and hair piled high, encircled by diadems. There are minuscule variations (Agnes has her little lamb [see Figure 7.3]), but the overall impression is one of rhythmically repeated form.

These differences in style are far more than a simple visual disparity—they suggest fundamental changes both in the art and culture of the West. The solid figures of the patriarchs point back toward the Roman tradition so beloved by Theodoric. They grow out of a world whose art had long emphasized naturalistic visual appearances—real figures, naturally proportioned, moving easily in real space. The saints below step gingerly toward the Byzantine and the Middle Ages. They are the harbingers of a new and distinctly Christian approach toward art.

The beginning (with Constantine) of an imperial bias toward Christianity coupled with the gradual repression of paganism had removed the practical difficulties associated with representational art. No Christian emperor would ask his subjects to worship his image as if he were a god nor require them to do homage before the images of the gods supplanted by Christianity. (However, it must be admitted that

Figure 7.3:
Saint Agnes: This saint is a harbinger of the style known as Byzantine. Her figure lacks weight and substance, which is just as well since her tiny scarlet-clad feet would never support a real body. She is like a paper doll as are the other female saints and martyrs with whom she proceeds down the nave wall, all being two-dimensional variations on a single theme. (Drawing inspired by a mid–sixth-century nave mosaic, Sant' Apollinare Nuovo, Ravenna.)

Constantine, "vicar of Christ" and "thirteenth apostle," considered himself to be on a level far above that of ordinary human beings and not simply because he was emperor.) "Idols" as an ever-present subject of fear and loathing, a fear and loathing that tended to throw suspicion on all representational art, were no longer so threatening.

Of course, none of this affected a word of the Old Testament exhortation against graven images. But figures such as those found in the lower tier of nave mosaics in Sant' Apollinare Nuovo must have seemed less like "graven images" as the Christians had once known them (usually solid, three-dimensional works of art) than beautifully colored but insubstantial shadows that reflected not this

world but the world of the divine. Though this emerging style did not resolve the theoretical problem of images, it must at least have made them somewhat more palatable.

A Forgotten Corner of Time

Meanwhile, not all ecclesiastic construction carried on in Ravenna during the reign of Theodoric was connected with the Arian faith. Although its dates have been a matter of some dispute, the Archiepiscopal Chapel, formerly known as the **Oratory** of Saint Andrew the Apostle, probably dates from this period. This delightful little chapel, designed for the sacrament of confession and used by the bishops of Ravenna for some fifteen centuries for their own private devotions, is tucked away on the second floor of the Archiepiscopal Palace, today the Archiepiscopal Museum, located beside the cathedral and across from the baptistery of the Orthodox. Being on the second floor (and of a museum no less), the chapel is just far enough off the beaten track to be bypassed by the "let's see Ravenna in two or three hours" sort of tourist and is generally discovered only by the more adventurous or knowledgeable visitor.

The entrance to the chapel proper is through a hall-like room or vestibule where a young, beardless, and very solid Christ dressed as a warrior stands guard above the entrance door (see Figure 7.4). His large eyes gaze steadily forward; his nimbus bears the jeweled cross. Beneath him he tramples the snake and the lion, both used here as symbols of the forces of darkness and undoubtedly referring to Psalm 91:

"Thou shalt tread upon the lion and the adder." In his right hand the Warrior-Savior holds a cross and in his left, a book proclaiming, "I am the way, the truth, and the life" (John 14:6).

In contrast to this stern figure, the mosaics decorating the barrel vault of the vestibule are positively festive. Groups of four lilies form a series of crosses interspersed with a wide variety of birdlife, including fat little blue and white ducks with saucy white tails

Figure 7.4: Christ Treads upon the Forces of Darkness: A very solid, robust Christ figure reminiscent of an old Roman emperor treads upon the forces of evil in the form of a snake and a lion (Psalm 91). In his right hand he holds a cross and in his left a book proclaiming, "I am the way, the truth, and the life." (Drawing inspired by a mosaic from the Archiepiscopal Chapel, early sixth century, Ravenna.)

which waddle insouciantly along. The upper part of the walls below the vault contains an extended Latin inscription explaining the purpose of the chapel or oratory, the first lines of which suggest that light, either born or imprisoned here, now reigns here freely. Although this is no longer quite true since in many places the light-reflecting mosaics have been replaced with painting in tempera designed to mimic lost tesserae, both vestibule and oratory still project much of their original flavor.

The vestibule is at right angles to the chapel itself, a small cross-shaped room which, above the soft gray marble that sheathes the lower part of the walls, is richly decorated. Entering, the visitor looks

directly across the room at an apse surmounted by a half-dome where a gold cross floats in a blue sky studded with gold stars. The arch in front of the apse is embellished with seven busts inset within medallions—the young, unbearded Christ in the center with Paul to his right and Peter to his left, and four other apostles, two on either side; the other six apostles, three on either side of another representation of the youthful Christ, are to be found in the arch opposite. The Christ figures may be bland almost to an extreme, but the faces of the apostles are individualized and full of character.

The arch to the visitor's right is decorated with six male saints while that to the left contains six female saints. These four arches with their apostles and saints (all identified in the mosaics) carry the gold dome that floats above the central space of the room. Rising from the corners of the dome, four angels support a medallion placed at the apex of the dome and inscribed with an *iota* (I) intertwined with a *chi* (X), the Greek letters symbolizing Jesus Christ (there being no exact equivalent of our "J" in Greek). Between the angels are the winged zoomorphic symbols of the four evangelists, each of which clasps a jeweled book representing his gospel, the message being that the good news of Christ is transported to the four corners of the world.

This small room is a peaceful place to catch one's breath, a place of calm and harmony in which not even the Renaissance paintings in the lunettes are distracting. To see the decorations clearly, the visitor needs to switch on the lights (the switch is found in the vestibule), but it is also pleasant to sit in the half-light, reaching back over the centuries to

understand how art could create such a soothing setting as well as one so conducive to rising above personal cares, to realize that even in times of intense stress and danger there were still those who could immerse themselves in such an atmosphere and find peace through meditation and prayer.

The End of Ostrogothic Rule in Italy

Theodoric the Ostrogoth gave Italy the last period of sustained peace it was to experience for centuries. It was under him, too, that we find the final pre-medieval resurgence of the classical Latin intellectual and literary tradition, an occurrence that redounds both to Theodoric's credit and to his shame. Two great scholars are associated with Theodoric and his reign, Boethius and Cassiodorus. The former, scion of a noble Roman family (a class of society long dedicated to paganism as part of the old order with which they associated themselves) yet a Christian, was well educated and deeply interested in the philosophical thought of the classical world. His goal was to translate the most important works of Greek philosophy into Latin for the benefit of a world in which, even among the best educated, Greek was rapidly becoming an incomprehensible tongue.

Unfortunately, however, Boethius never got to complete his project because under Theodoric he was accused of treason (most unjustly, it seems) and executed by slow garrotting, an order that the king soon regretted. While he was awaiting death, Boethius wrote *The Consolation of Philosophy*, a work in which he discusses the age-old problem of

injustice in this world. Both the translations that Boethius had completed and *The Consolation of Philosophy* became mainstays of literature in the West during the Middle Ages.

Though a committed Christian himself, Boethius relies in the *Consolation* less on faith than on reason. In this regard, the writings of Boethius, like the mosaics in the middle tier of the nave of Sant' Apollinare Nuovo, transmitted something to the Middle Ages that, though running counter to the mainstream of the sensibility of the age, was to remain a constant source of inspiration. Boethius's legacy to the dawning Age of Faith was a taste of the logic and reason that distinguished ancient thought, as the legacy of the mosaics was a reminder of an artistic tradition that attempted a rational presentation of the world of appearances. Although reason and logic in literature, and naturalism and realism in art, might no longer be the first order of the day, they were part of a heritage never quite lost, always there to be drawn upon in the future.

The other man of great learning to be associated with Theodoric, Cassiodorus, was the descendant of another illustrious Roman family, yet also a Christian, who served as the Ostrogothic king's secretary. Cassiodorus lacked Boethius's depth and subtlety of thought, and today his writings seem quite humorously stilted (Cassiodorus's simplest statement or comment may wander off into a disquisition on ancient history, pseudogeology, or whatever else struck his fancy). However, the minds that followed him were not, for the most part, to be particularly subtle either, and any evidences of learning that filtered into the centuries to come, especially the simplest and most easily absorbed, were to be of great importance.

Cassiodorus's most significant contribution to Western civilization was undoubtedly the monastery he founded on his family estate on the southernmost coast of Italy when he retired from public life at about the age of seventy. (He lived to be about ninety, dying c. 585.) Monasticism had been born in the third century in the Egyptian desert, the creation of men and women fleeing the sinful life of the cities. The most famous of these was Saint Anthony. Taking quite literally the injunction of Jesus to "Go and sell that thou hast, and give to the poor, . . . and follow me," Anthony renounced his inheritance (he was the son of well-to-do peasants) and headed into the desert to live a life of great austerity, denying himself even the most basic comforts, struggling constantly against temptations both of flesh and spirit, and striving always to purify himself in order to come closer to God. He spent his time in prayer, study, and in the manual labor necessary to support himself. Although like-minded men gathered in his vicinity, Anthony continued to lead a solitary, eremetical life (i.e., the life of a hermit) until his death in 356 at more than one hundred years of age.

Meanwhile another Egyptian, Pachomius (d. c. 346), was also exploring the problem of escaping the temptations of the world. Pachomius favored the cenobitic, or communal, mode of life. He founded several monasteries for men and one for women in which members lived as part of a disciplined, cooperative environment which emphasized manual labor as well as prayer. Although there were always hermits in the West during the Middle Ages, it was the cenobitic life that was to be the more influential, especially as given shape by the *Rule of Saint Benedict*. Benedict (d. c. 540) demanded of his followers poverty, chastity, and obedience. He had a great

appreciation for the weaknesses of ordinary humans (one can see him thinking in terms of whatever was the contemporary version of "the Devil makes work for idle hands"), and his regime, or rule, balances regulated hours of prayer with other activities such as manual labor. It also makes provision for study and reading, the emphasis being on spiritual matter, although some of the wealthier monasteries had secular books available. But to have any books available it was necessary to copy them laboriously by hand—a service that was to be to the lasting credit of those medieval monks.

As royal secretary, Cassiodorus's chief task had been to put his master's state papers and correspondence into official Latin, so it is not surprising to find that in retirement he emphasized the intellectual side of monasticism. He directed monks to spend their leisure time studying and copying manuscripts. Though how much direct influence his monastery had has been debated, surely it must have contributed to the concept of a monastery as a place of learning, an intellectual haven in a sea of ignorance and illiteracy. Thanks to men such as Cassiodorus, the monastic **scriptorium,** the room set aside for the scribes, became an important factor in preserving at least some part of classical culture through the tumultuous centuries to come. Although Christian thought and learning in the West in the early Middle Ages could not hope to rival the depth and subtlety of the Jewish intellectual tradition, of which it stubbornly knew virtually nothing, or later to compete with the scientific brilliance to be evidenced by the Arabs, at least some foundation, modest though it was, was maintained and served as the basis for future intellectual development.

Figure 7.5:
The Tomb of Theodoric, Ravenna: Standing apart and somewhat outside the old city, constructed (c. 526) of gray Istrian limestone at a time when Ravenna was built mostly of brick, and consisting of a floor plan that has never been satisfactorily accounted for, the tomb of Theodoric, like the Ostrogothic leader himself, leaves us trying to categorize something that refuses to be pigeonholed. Defender of Roman traditions, Theodoric is notorious for unjustly ordering the death of the Roman philosopher and trans- lator Boethius. A heretic Arian, the Ostrogoth is more happily remem- bered as a believer in freedom of religion (a most unusual position at that time). A man who may never quite have perfected the art of writing himself, he is also known for employ- ing Cassiodorus, whose ideas on the role of books in monastic life were to influence the centuries to come, to put his correspondence in elegant Latin.

Theodoric, who cared enough about the Roman tradition to hire a Cassiodorus to put his official papers in elegant, if circumlocutory, Latin, died in 526. Today his tomb still stands—solid, somber, remote, mysterious—amid dark cypress to the northeast of the old city walls (see Figure 7.5). In Theodoric's time, Ravenna was a city of brick, but the mausoleum is built of large blocks of gray Istrian limestone. There are two levels, both decagonal on the exterior although the interior of the upper, smaller one is round, while that of the lower is cruciform. Scholars can only guess how the two were originally joined except that it could not have been from interior stairs; the stair and footbridge that today allow access to the upper floor were built in

1927. There is equal uncertainty about the function of the two rooms, although one, quite likely the cruciform lower floor, probably served as a chapel and the other as the burial place. Today a huge, reddish porphyry tub dominates the upper floor, but it has not always been in the same location. (After centuries of peregrinations, it was placed in its present location only in 1913.)

Theodoric's mausoleum is covered by a dome some thirty-six feet in diameter, rising to a height of almost ten feet. Cut from an enormous single slab of Istrian stone weighing more than 230 tons, it rests on a cornice decorated with pincherlike designs. Around the outer edge of the dome are twelve evenly spaced stone handles, or spurs. Efforts to explain their presence have elicited much creative thinking, but one of the more practical ideas is that ropes were anchored to them when the monolithic piece of stone was settled into position. On the other hand, since each of these extrusions is inscribed with the name of an apostle, there is much to say for the theory that Theodoric, through the use of such symbolism, was drawing a parallel between his burial and that of Constantine the Great, the "thirteenth apostle." Nor does one theory necessarily rule out the other.

By one of those ironies of history, the year following Theodoric's death (caused by dysentery not, as legend would have it, by lightning striking him through the dome of his mausoleum where he had taken refuge during a storm), Justinian I became emperor in Constantinople—a juxtaposition of dates well worth noting because Theodoric's death left a vacuum in the West just as a strong ruler with decided ideas about empire was about to ascend the throne in the East. Unfortunately for Theodoric, he had no son

to whom he could leave his domain. He did, however, have an intelligent and well-educated daughter, Amalasuntha. Theodoric arranged for her to marry an Ostrogoth of royal family who had been living obscurely in Spain, and this union produced a son who was forthwith pronounced his grandfather's heir.

At Theodoric's death, Amalasuntha, by this time a widow, became regent for her son. Not surprisingly, a struggle for power ensued, and intrigues were greeted with counterintrigues. Perhaps Amalasuntha could have continued to cling to power since she lacked neither determination nor intelligence, but when her son died she made the fatal mistake of calling in her cousin Theodahad to become the nominal ruler. (A woman might, and later did, rule the Byzantine Empire alone but never a Gothic kingdom.) The treacherous Theodahad had no intention of being a front for a woman he secretly despised. Amalasuntha was first exiled to a lonely island in Lake Bolsena in Tuscany, then brutally strangled to death in her bath with Theodahad's foreknowledge—if not his actual connivance.

Both elements of the Italian population, Roman and Goth alike, were shocked by Amalasuntha's death. She was, after all, a virtuous woman of royal birth, and although she made some poor decisions (like turning to Theodahad), she had done nothing to deserve such a harsh fate. Many who were repelled by the treatment of Amalasuntha surely questioned Theodahad's right to rule, yet the awkward situation might still have been smoothed over if Theodahad had shown himself a strong and capable ruler, which he did not. And without a strong and capable ruler enthusiastically backed by his people, the Ostrogothic situation was indeed tenuous.

Figure 7.6:
Justinian: The emperor Justinian was much in the tradition of the great emperors of the past such as Constantine, and, like him, was a dedicated administrator as well as an active participant in the politics of the Church and its theological disputes. Though Justinian, unlike Constantine, was not a military man himself, he envisioned great military triumphs that would restore most of the territory of the old Roman Empire. Unfortunately he over-strained his resources and created a vacuum of power in Italy just when other forces were moving in. (Drawing inspired by a mid–sixth-century apse mosaic, San Vitale, Ravenna.)

The Reconquest of the West

Across the Adriatic the emperor Justinian, who probably had plans to reconquer Italy all along, was not slow to realize the possibilities of the situation. Perhaps the most famous of all the Byzantine emperors, he came from humble roots—a small village in the Balkans roughly sixty miles south of that in which Constantine the Great was born. From this area his uncle Justin traveled the long, rough road to Constantinople on foot to seek his fortune as a soldier. When he was able, the older man, who had no children of his own, sent for his nephew and saw to it that Justinian had the sort of classical education he himself had never enjoyed. However, lack of education did not unduly hamper Justin, who rose to the position of captain of the guard and then, backed by his men (the Senate not wishing to debate the issue with armed soldiers), became emperor.

But the nephew was the real power behind the throne, his position giving him the opportunity to acquire a practical grasp of government to complement the fine education his uncle had afforded him. When the old soldier died, Justinian, by then a man of mature age (probably in his mid-forties) and one with an unusual degree of prepa-ration for his new position, ascended the throne. Unlike his uncle, the new emperor (see Figures 7.6 and 8.4) was not a soldier and had none of the tough military look one associates, for exam-ple, with a Constantine. Rather, he was a man of medium height and build, a bit on the chunky side, with a round face,

firm chin, and straight nose—the face of a man whose strengths would be best expressed in the daily details of government rather than on the field of battle, though, of course, Constantine, too, had been very effective at running the empire. Furthermore, Justinian and the great Constantine had more than their administrative skills in common. Like Constantine, Justinian was one of those men of high intelligence, great energy, and clearly defined goals who make such notable emperors. And the primary goal for Justinian in the sixth century was, as it had been for Constantine in the fourth, the protection and promotion of the empire.

Justinian's approach, although he might not have articulated it as such, was threefold: to defend the perimeters of the empire and reconquer lands lost to various barbarian tribes in the West, to nurture religious orthodoxy (the empire now saw itself as a Christian empire: the fate of Church and empire were intertwined far more than in the time of Constantine), and to encourage administrative reform, the great codification of the law known as the *Corpus Juris Civilis* being the ultimate and lasting example of his achievement in this area.

The *Corpus Juris Civilis* admirably fulfilled the emperor's aim for it—that is, to organize, synthesize, and present in usable form the results of a millennium of Roman legal development—and it is only here that Justinian can be praised without qualification by our own era. The Romans (and the Byzantines, although their culture by this point was almost entirely Greek, continued to think of themselves as Romans) saw law as the epitome of civilization and the summit of their own achievement. Thanks to Justinian and those who labored at

his behest, Roman law survived to become the basis of most of the legal systems of western Europe, with the major exception of the Common Law of England.

With regard to his first two objectives, Justinian's achievements were far less durable. Religion proved to be particularly vexatious. As we have seen, Constantine the Great cared less about the nature of what the Church agreed upon than about the fact that the disparate elements of the Church agreed on something. For Justinian, on the other hand, orthodoxy was everything. Predictably, he called his own ecumenical council (the fifth ecumenical council, which met in Constantinople in 553), but in spite of efforts to go between the horns of the old dilemma (i.e., the dual nature of Christ as both God and man), large elements of the population continued to embrace a "heretical" form of Christianity.

The Nestorians had been driven from the empire, spreading through Iraq and Iran and even to India and China, but the Monophysites remained a significant force within its borders. The Monophysite outlook particularly suited the spirituality of the Near East and Egypt. The vast illiterate or at best semiliterate populace of these areas had no strong bond with Constantinople; they were farmers and laborers from a variety of different traditions and without even a language in common with their Byzantine overlords. Religion was a serious matter, in fact the most serious matter with which a person was confronted. Whereas life in this world was a short, discouraging, and disheartening struggle, life in the next world promised all that this world lacked and it endured forever. But an individual had to follow the right religious path to attain his or her eternal reward, and the form of belief that the

emperor was trying to impose on the committed Monophysite violated the latter's deepest beliefs. Better to be persecuted, which the Monophysite often was, than to compromise. Thus religion, which might have joined Egypt and the Near East to Constantinople, became a most divisive factor.

The consequences were disastrous. When the Arabs burst forth from their peninsula after the death of the prophet Mohammed in 632, these impressive warriors, alight with a burning religious fervor, opposed an empire weakened by its recent and final bout with the Persians. Yet this alone cannot explain why Egypt, Syria, and Palestine fell so quickly to the advancing Arabs. It is not until one remembers that these were strongly Monophysite areas in which the people had been persecuted for their heterodoxy (and heavily taxed as well) that the rapidity with which they fell into Arab hands begins to make sense. The populace refused to bestir itself to defend an unpopular government, and indeed the new rulers must have seemed an improvement on the old. In the eyes of Islam it mattered not at all whether a Christian was orthodox or a heretic. As a Christian, the person would be taxed more highly than a neighboring Arab but would not be persecuted for his faith.

Justinian's foreign policy was in the long run no more successful than his domestic policy. He made the classic mistake of fighting too many wars on too many fronts, wars that the empire lacked the resources to prosecute. Justinian's conception of an empire stretching to its ancient limits lured him into committing himself deeply and unnecessarily in the West. The various barbarian groups had been able to carve out their own territories as easily as they had because the West lacked the glue to hold it together.

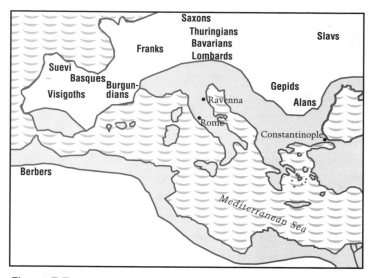

Figure 7.7:
Reconquest of the West under the Emperor Justinian, mid–sixth century A.D.

Most particularly the economy of the West was becoming a local, rural economy—a situation in which smaller, looser political units were almost inevitable.

Nonetheless, Justinian's attempts at reconquest began quite well (see Figure 7.7). The Vandals in Africa, who had lost their fighting zeal and become very decadent, were no match for Justinian's generals. Internal problems among the Visigoths allowed the Byzantines to secure the southeastern corner of Spain, and the Byzantine navy easily picked off the Mediterranean islands. Italy, on the other hand, proved to be another matter entirely. The peninsula became a battleground for almost twenty years (535–54), and, though nominal victory ultimately went to the Byzantines, the unfortunate Italian struggle only succeeded in creating a vacuum of power soon filled by another migrating group of Germans, the Lombards.

Justinian, whose western conquests barely survived his death, left an exhausted empire just as new and fearsome forces were about to assail it. But although in the political sphere the results of Justinian's involvement in Italy were both fleeting and vain, the artistic consequences were quite the opposite, and the Byzantine reconquest of Ravenna in 540 led directly to the final, glorious flowering of early Christian art.

CHAPTER

8

The Final Flowering of Early Christian Art

Justinian and Theodora

When Justinian came to the throne in 527, he had all of the assets hitherto mentioned plus something the historians have never been sure whether to label as an asset or a liability—his wife, Theodora. Unfortunately for Theodora, the most complete account we have of her life is the so-called *Secret History* (the name alone should serve as a clue to its attitude and perspective) by that sixth-century historian and malicious gossip Procopius. Theodora appears in these pages in the worst possible light, a woman of loose morals and no modesty.

However, the salacious details with which Procopius titillates his readers should be taken with a grain of salt. What does seem reasonably certain is that Theodora was one of the three daughters of a bear-keeper at the circus in Constantinople. She

became an actress (a profession looked on then with as much horror as in Victorian England), but whether she became a prostitute, as alleged, is debatable. In her youth, she does appear to have lived a fast life— Procopius (among his more believable statements) speaks of constant flirtations, wild parties, and numerous lovers. And, it seems, she bore a child out of wedlock.

Theodora became the mistress of a man who was appointed governor in North Africa, where she followed him. They quarreled and Theodora was thrown out, reportedly in a quite destitute state. Somehow she got to Alexandria, a place of strong religious feelings and endless theological controversy, where she spent some time and may have had some sort of religious conversion. Eventually she made it back to Constantinople, where she met Justinian.

The emperor-in-training became quite infatuated with Theodora, and she became first his mistress, then his wife. The latter required special legal action on the part of the emperor—who, as it will be remembered, was Justinian's uncle Justin— since senators and high dignitaries were forbidden by law to marry certain sorts of women, specifically those in servile condition, innkeepers' daughters, actresses, and courtesans. But uncle or no uncle, the permission for Justinian to marry his mistress might never have been given had Justin's wife, who wanted nothing to do with the likes of Theodora, not died at this time.

One can understand why Justinian was attracted to Theodora. She was a petite brunette with a delicate oval face, large dark eyes, and a slender, supple figure in which she took great pride (see

Figures 8.1 and 8.3). Even through the gutter gossip of Procopius emerges the picture of a bright, charming woman full of interesting and amusing conversation but also capable of discussing the complex political and religious issues of the day. In fact, her intellectual gifts may well have drawn Justinian as much as her physical ones.

Figure 8.1:
Theodora: Justinian's wife, the empress Theodora, was an intelligent and attractive woman with a shady past. However, whatever her early transgressions, she was completely loyal to her husband, with whom she was crowned and with whom she reigned. (Drawing inspired by a mid–sixth-century apse mosaic, San Vitale, Ravenna.)

Justinian set great store by this sort of thing, and Theodora was highly intelligent, with a mind capable of challenging even her husband's fine intellect.

Though they had many common interests, particularly religion, Justinian and Theodora were quite different types of people. Justinian was extremely temperate, even ascetic, in his habits, loved work and slept little. In fact, he was dubbed "the sleepless" by those around him and wore out armies of secretaries as he attended personally to the most minute details of affairs of state.

Theodora, on the other hand, was notably fond of her luxuries—long baths, plenty of good food and drink (though she always watched her figure), and travel to various of the sumptuous suburban palaces or to hot springs. She also liked her sleep, both at night and during the long afternoon siestas that are such an integral part of Mediterranean life. But, pleasure-loving though she might have been, Theodora did not spend her later life in immorality or self-indulgence. Not even her worst enemies ever

suggested any sexual impropriety in her behavior as a married woman. And she used her position as empress to help others less fortunate; for example, she spent her own money to rescue young women from the provinces who had been sold into prostitution by their parents.

Theodora was quite actively involved with events of the day; some thought too much so. The empress was a known Monophysite sympathizer (one will remember her time in Alexandria, a Monophysite stronghold), and she even discreetly protected heretic monks and clergy within the palace. Clearly she was not the sort of person to remain quietly in the background. She was crowned with her husband and together they reigned until she died.

Theodora was also extremely courageous. When the Nike Revolt broke out in Constantinople and all seemed lost, she would not hear of her husband fleeing as he was strongly tempted to do. According to one account, Theodora said that she did not care whether or not it was proper for a woman to give brave counsel to frightened men, but those present should remember that sooner or later everyone must die and that purple (the color worn only by the emperor and his immediate family) made a fine winding shroud. It is clear that Theodora herself, having achieved the highest position a woman could enjoy in the empire, would far rather have died than relinquish it. Her courage turned the scales; Justinian stayed and, with the help of loyal generals, prevailed.

In the course of the Nike Revolt, some thirty thousand citizens lost their lives, and many buildings, including the Church of Santa Sophia (Holy Wisdom), were destroyed. Once things quieted down again, Justinian decided to rebuild Santa Sophia

immediately. In just five years, ten months, and four days, a work of surpassing splendor was completed. The new church was an architectural wonder embellished with the finest marbles, precious onyx and porphyry, and glittering mosaics. Justinian, upon entering the new church, is supposed to have remarked, "Oh, Solomon, now I have surpassed you!"

The Church of San Vitale

Although Santa Sophia is beyond the scope of the present study, another church closely associated with Justinian is within its purview—San Vitale in Ravenna. San Vitale was begun under Bishop Ecclesius in 526, the year of Theodoric the Ostrogoth's death and the year before Justinian ascended to the imperial throne. Building went on in fits and starts while the political scene in Ravenna kaleidoscoped in a myriad of changing patterns. Then in 535 Justinian's generals began the reconquest of Italy from the Ostrogoths. Though the peninsula was to be a battleground for almost twenty years, Ravenna itself was taken in 540.

With the fall of Ravenna, construction on the church speeded up, although there were probably still delays thanks to the difficulties of getting supplies in the face of the ongoing war. However, the Byzantines undoubtedly did what they could to facilitate the progress of the church, for San Vitale was developing strong political overtones. It was emerging as a visual statement of Byzantine supremacy in both the political and religious spheres, a monument to the recent imperial victory over the Arian Ostrogoths and the triumph of the orthodox Catholic faith.[1]

Given the meticulous care with which Justinian saw to every aspect of imperial business, we may well imagine (though there is no actual evidence) that much of the impetus for the evolution of San Vitale after the reconquest of 540 came from the emperor himself. Although Justinian rarely left Constantinople and certainly never came to Italy himself, he had two powerful allies in Ravenna who were ready and able to do his bidding. The first was Bishop Maximian, consecrated in 546, under whom San Vitale was completed (in 547 or 548).

Maximian is said to have been the only choice for high office about whom both Justinian and Theodora ever entirely agreed. Unfortunately, however, since Maximian was not a native of Ravenna and since his appointment undoubtedly meant that popular local men were passed by, the citizens were not equally enthusiastic about their new bishop. Maximian was forced to take up lodgings on the outskirts of the city, from which vantage point he gradually gained allegiance by blandishments and bribes. Only when his support was sufficiently strong did the crafty bishop take up residence within Ravenna.

As the representative of the emperor, Maximian had his work cut out for him. Ravenna was the most important city in Italy in Byzantine hands; elsewhere the war was going poorly for the Byzantines. Nor was that the extent of his imperial master's problems. Even as his armies were battling the Arian Ostrogoths, Justinian (who considered himself, and not without some reason, a theologian) was in conflict with the bishops of most of the important sees of the West, particularly Rome, over theological issues arising ultimately from the old Nestorian/

Monophysite controversy, that is, the nature of Christ as both man and God. Maximian's brief, then, was to uphold Justinian's conception of orthodoxy in the face of opposition not only from the Arians but also from the bishop's Catholic peers. Since theological positions in the sixth century were determined as much by a display of strength and overwhelming grandeur as by subtle argument, Maximian was undoubtedly pleased with the opportunity of making San Vitale a visual statement of imperial and, from Justinian's and his perspective, orthodox power.

The other key figure in the building of San Vitale was Julianus Argentarius. Argentarius was, from what we can gather, a wealthy and highly influential Ravennate businessman (perhaps a Greek banker) who contributed the enormous sum of 26,000 pieces of gold for the building of the church. Very likely this sum was not all out of his own pocket, however, for Argentarius may well have worked as a broker for the emperor, receiving monies from Constantinople and making sure they were used as designated. Though we know little personally about the man, traces of him abound in San Vitale. His monogram is found next to that of Bishop Victor (one of the several bishops to be associated over the years with the building of the church); his name is on the small box containing sacred relics that was deposited in the sanctuary when the church was dedicated, and his portrait is included in the great dedicatory mosaic with those of Bishop Maximian and the emperor. We also see Argentarius's imprint on the outside of San Vitale in the long thin bricks found exclusively in buildings associated with him—for this church, although the most magnificent, was not the only one financed (in name or actual fact) by this man.

Figure 8.2:
San Vitale, Ravenna: An octagon within an octagon, San Vitale (526–47), though not as large as the great churches of Rome, is still impressive enough in its own right. The dome (its base diameter is about fifty-two feet) ringed with eight large windows appears to float above the central core. Space and light ebb and flow around the core through ambulatory, balconies, and recesses in a gentle, continuous movement like small waves lapping at the shore. Light shimmering from marble and mosaic would have created an insubstantial, ever-changing impression reminiscent of images reflected on the surface of a lake, thus robbing the structural elements of any sense of solidity—a church to be accepted on faith rather than grasped by reason.

Though of unadorned brick, the exterior of San Vitale is far from simple because the complexity of the interior space is echoed on the outside. The visitor gets very little idea of this in the normal approach through a cloister and down a flight of stairs, the latter being another adjustment resulting from the rising ground of Ravenna, but one can go through the church to the open area on the far side (the same area in which is found the mausoleum of Galla Placidia) for a much better view (see Figure 8.2). From this open area one can see how the interlocking blocks of space were used to make this building.

San Vitale is an octagon within an octagon, the inner, taller octagon being crowned by a high central dome some fifty-two feet in diameter which rests on eight piers linked at the top by arches. These piers, though by no means small, are relatively slender considering their function, for they, together with outer walls only three feet thick, are all that support the dome, this being possible because the dome is constructed of *tubi fittili* (those light, hollow terracotta

tubes that fit into each other like syringes). Eight windows (one on each side of the inner octagon) ring the dome with a luminous glow.

Between the supporting piers are semicircular niches which create a scalloped effect around the central core. They are defined in part by tripartite arcades (one at the ground level, another directly above it on the gallery level) which, without impeding the spatial flow, add to the play of light and shadow. Both niches and piers rise two levels, visually uniting the ambulatory (the aisle that circles seven sides of the inner octagon at ground level) and the gallery directly above it, which was the space reserved for women. The result is at the same time both subtle and arresting. As seen today, the well-lighted sanctuary (occupying the eighth side of the octagon) and the high, bright core of the church stand out in contrast to the somewhat shadowy ambulatory and gallery, though these are not entirely cut off because the arcaded niches allow the central space with its light to penetrate the periphery. However, it would seem that once unencumbered windows in both ambulatory and gallery would, in true Ravennate fashion, have contributed to a more even distribution of light throughout.

San Vitale just misses having a strong central axis because the main entrance is not quite in line with the dominant feature of San Vitale's floor plan, the sanctuary, called a **bema** in the Eastern Church. In San Vitale the sanctuary is an elongated space which, beginning at the outer edge of the central octagon, bisects the ambulatory and gallery and ends in an apse that extends beyond the enveloping outer octagon. A wide variety of ingenious reasons have been suggested to explain why the entrance is

Some scholars think that originally the windows in San Vitale were glazed with panes of glass in colors ranging from green, deep blue, and purple to off-white and gold.

Men and women were always separated during church services. Men stood (there were no benches or pews) on one side and women on the other, or, as in San Vitale, the women were relegated to the gallery.

Bishop Ecclesius had just returned from Constantinople when work was begun on San Vitale and, though the mighty Santa Sophia—domed and centrally planned—had yet to be built when he paid his visit, the bishop could have sensed the trend.

off center to the powerful line created by the sanctuary, but the truth is no one really knows.

However, with or without a definite axis, San Vitale is still a centrally planned structure. Some have seen the church as the martyrium of Saint Vitalis, the patron saint of Ravenna, and thus falling into a category (martyria) for which a centrally planned structure was often chosen. But whether or not we accept this interpretation, San Vitale is very much both of its own time and of times to come, for it was during the reign of Justinian that the centrally planned, domed church came to dominate the world of Eastern Orthodox Christianity as it does to this day.

In churches such as San Vitale, faith is called upon to predominate over reason, the structure being too complex to be immediately grasped by logic. The person entering San Vitale experiences a moment of uncomprehending awe. High above floats the dome ringed with light from the eight great windows around its base, seemingly unsupported by brick or stone but miraculously suspended from heaven. The swelling niches create a continuous interplay between inner and outer octagons, but at no point can the building be seen in its entirety—mysterious corners always remain slightly beyond the range of vision. And this impression of awe and mystery is compounded by the mosaics which appear to dissolve the very substance of the walls.

Though much of San Vitale's decoration has been lost and the overall effect is compromised by later additions, the mosaics in the sanctuary have come down to us through the centuries in undiminished splendor. Here we find both the beauty of a bygone age as well a statement of its beliefs, for there is nothing arbitrary about the scenes selected

for the sanctuary or about their placement. They demonstrate the mature resolution of a concept met with as early as Dura Europos and commented on subsequently with respect to buildings such as Sant' Apollinare Nuovo, that is, the use of a decorative program to complement and enhance the function of a given space as well as to make it beautiful. Further, the decorative program at San Vitale—as earlier at Dura Europos or, for that matter, many centuries later in the Sistine Chapel—relies heavily on representational art, the relatively naturalistic depiction of plants, animals, and, above all, human beings.

The mosaics surrounding the altar of San Vitale speak to the sacrament of the eucharist celebrated there. To the left of the altar, in a lunette above triple arches, Abraham—his wife, Sarah, watching from behind him—feeds the three strangers, who occupy an altarlike table set with three small loaves, like the bread of communion, marked with the sign of the cross. On the far right side of the lunette, Abraham raises his sword to sacrifice his only son, Isaac—an innocent victim seen as a type of Christ, whose own sacrifice is reenacted in the mass. Abraham's hand is stayed by the hand of God extending from heaven, while below, the ram, which will be sacrificed in place of the boy, waits patiently.

Directly across the sanctuary, in a matching lunette, Abel offers up a lamb on one side of an altar table, while on the other Melchizedek, considered the paradigm of a priest-king, also offers sacrifice. Above, the hand of God again appears, an acknowledgment and acceptance of these sacrifices. No one familiar with the liturgy celebrated below this could see the two lunettes facing each other on either side of the altar without recalling the words spoken by the

The late eighteenth-century work that fills the dome of San Vitale and spills over into the spaces between the eight windows at its base tends to be jolting. Of course, the juxtaposition of styles from different periods does not necessarily have to be disruptive, but here the philosophies expressed by the two styles are completely at odds. The thrust of the eighteenth century is to make blatantly physical what is spiritual, while the sixth-century art of Ravenna attempts to spiritualize, to dematerialize, the physical.

227

priest during the canon of the mass as he prays to the Lord to accept the eucharistic offerings "as thou wert graciously pleased to accept the gifts of thy just servant Abel, and the sacrifice of our Patriarch Abraham, and that which thy high priest Melchizedek offered to thee, a holy sacrifice, a spotless victim."[2]

Directly above the altar, in the highest point of the vault, is a medallion, or garland, supported by four angels. In the medallion is the Lamb of God, the symbol of Christ himself as the pure, unsullied sacrificial victim, recalling the words of John the Baptist (cited by John the Evangelist), "Behold the Lamb of God, which taketh away the sin of the world," again, words that are repeated at every mass. The lamb reminds the onlooker of the sacrifice on the cross (it will be remembered that the crucifixion itself was eschewed in the Ravennate art of the period), the expiatory nature of the death of Jesus (death for our sins), and finally its promise of eternal salvation.

To either side of the lunettes are Old Testament figures, while above the apex of each lunette flying angels hold a wreath within which is a golden cross; symbolically and literally the New Testament is firmly placed upon the foundation of the Old. On either side of the tripartite arcades are the figures of the evangelists (thus occupying, in effect, the four corners of the space), accompanied by their identifying symbols. The four evangelists are the "voices" of the New Testament, "spoken" during the mass at the reading of the gospel; they pronounce the "good news" to the four corners of the world.

Beyond the area occupied by the altar, an arch leads to the apse with its half-dome. The mosaics here address the power and the might of the Church

in general and specifically the divine favor shown to San Vitale. Jerusalem and Bethlehem (the Old and New Testaments, the Jewish and gentile aspects of the Church) flank the arch while above the apex of the arch two flying angels hold a wheel with eight spokes, another way of referring to the cross. In the half-dome of the apse, a young, unbearded Christ sits in majesty atop a globe from beneath which flow the four rivers of paradise looking rather like four skeins of blue yarn. In his left hand he holds the Book of Life and in his right the crown of martyrdom which Saint Vitalis, escorted by an angel, comes forward to receive. To Christ's left, a second angel accompanies Bishop Ecclesius with his gift, a model of the Church of San Vitale, of which he was the founder.

Two large mosaic panels, each approximately nine feet high by twelve feet long, dominate the apse walls. On the visitor's right Theodora appears, accompanied by her retinue. Robed in imperial purple, elaborately bejeweled, and even accorded a nimbus (further emphasized by the scalloped niche above her head), the empress presents the chalice with the eucharistic wine (see Figure 8.3). This gesture is repeated by the magi portrayed on the hem of her gown, who offer their gifts in a similar fashion (a scene

Figure 8.3:
The Empress Theodora and Entourage: Except for the fact that she was petite, Theodora is portrayed here as she is described by contemporaries—a slender woman with large dark eyes and a somewhat sallow complexion. In this case the additional height emphasizes her impor-tance, as does her entourage, her splendid jewels, and the crown and nimbus (halo), the latter echoed by the shell above her head. But not even an empress could enter the sanctuary of a church (where this image is found), so a male attendant is shown pulling aside a curtain, presumably so that she can enter the church itself. (Photograph courtesy of Corbis-Bettmann.)

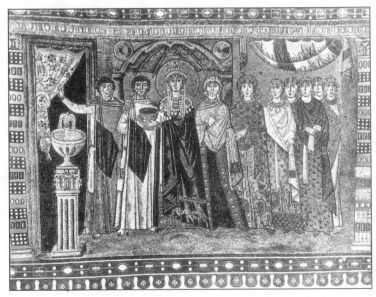

Figure 8.4:
The Emperor Justinian and Retinue: Justinian, like Constantine the Great, saw himself as the vicar of Christ on earth, the "thirteenth apostle." Counting the soldier's heads carefully, one can see the emperor amid twelve others representing the Church, the army, and the bureaucracy. Only Bishop Maximian is identified, but the figure between the bishop of Ravenna and the emperor is probably the financier Julianus Argentarius. (Photograph courtesy of Corbis-Bettmann.)

reminiscent of that depicting the magi in the lower tier of mosaics on the north side of the nave in Sant' Apollinare Nuovo). Except for her exaggerated height, the empress is portrayed as she is described by contemporaries: rather pallid with a somewhat sallow complexion, an oval face, and large dark eyes. One of the court attendants pulls aside the curtain to allow Theodora to enter, presumably into the Church of San Vitale—a tactful reminder that no woman, not even an empress, could actually have been present in the sanctuary.

On the visitor's left, but to the right of Christ in the half-dome of the apse and thus in the more favored position, Justinian presents a gold paten with the eucharistic loaves, although these are not actually shown (see Figure 8.4). He, too, has a nimbus

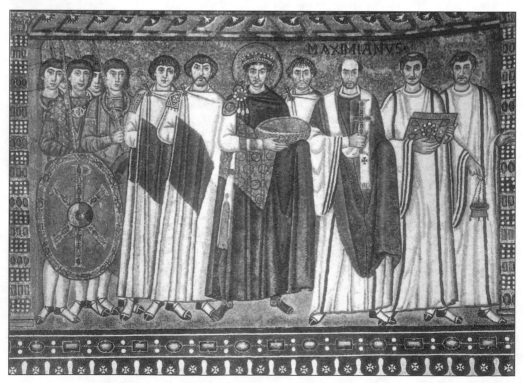

and is centered in the composition for still greater emphasis. Twelve men (one must be careful to count the tops of heads representing the soldiers) accompany the emperor, a none-too-subtle suggestion that he is the vicar of Christ on earth. Moreover, the soldiers hold a shield with the *chi-rho* monogram linking Justinian with the first Christian emperor, Constantine, while also reminding the onlooker that the emperor is the defender of the faith—and had not the armies of Justinian just recently wrested Ravenna from Arian Ostrogoths? The figure to Justinian's right (the visitor's left) is thought by some to be Belisarius, the general who helped to suppress the Nike riots and the one who was responsible for the Byzantine conquest of Ravenna.

The figure to the emperor's left is quite likely Julianus Argentarius, the great financier. But the only figure actually identified in the mosaics is Bishop Maximian—a tall, cadaverous, balding man with an egg-shaped head, brooding eyes under heavy brows, and a set mouth framed by a short beard and mustache. The old fox, dressed in his ecclesiastical garb and carrying a jeweled cross of gold, is a figure nearly as commanding as that of the emperor. To make matters still more ambiguous, the bishop's right arm appears to be behind the figure of Justinian while the lower part of Maximian's figure seems to be in front of the emperor. But there is no ambiguity to the visual statement that the emperor is supported by the three elements of his state: army, Church, and bureaucracy.

Neither Justinian nor Theodora actually attended the consecration of San Vitale in May of 547 (some will argue 548), but both were and are there in the church by virtue of their portraits—the same device

Today, the throne of
Maximian is housed
on the second floor
of the Archiepiscopal
Museum in Ravenna,
right around the
corner from the
Archiepiscopal Chapel.
A chair (or throne),
another of those
symbols that predated
Christianity and was
later absorbed into its
repertory, signifies
authority, in this case
the authority of the
bishop, particularly as
teacher of doctrine
and dispenser of
sacraments. In fact,
our word *cathedral*
comes from the Latin
word *cathedra* (in turn
from the Greek
kathedra), or chair, and
indicates not a large
and lavishly decorated
church, for a cathedral
can be of any size and
or degree of grandeur,
but the seat of a bishop.
The "throne" of
Maximian is approxi-
mately five feet tall
and two feet wide.

used by the pre-Christian Roman emperors as an
expression of their power and presence throughout
the empire. However, the message goes far beyond
that: Justinian unites in his person authority both
political (his army/the Byzantine state) and ecclesias-
tical (the clergy/the orthodox Catholic faith). The
emperor's control of the former Arian/Ostrogothic
Ravenna is a matter of imperial right (there is the
clear implication that the rest of Italy, too, will soon
be again part of the imperial fold), and the theological
position that he holds should be accepted as the true,
orthodox position. Moreover the emperor, like the
priest-king Melchizedek, offers his gifts (the paten
with the eucharistic loaves) on behalf of his people,
gifts that are presumably pleasing and acceptable to
God. In one bold stroke Justinian has expressed both
the power of Byzantium and his own philosophy of
kingship.

Ivories and the Throne of Maximian

Some of the most delicate and lovely of early Christian
art was executed in ivory but, being easily trans-
portable, has been scattered to museums throughout
Europe and the United States or lost altogether. For
example, various ivory panels that decorate another
of those Ravennate treasures—the chair, or throne, of
Maximian (the mighty bishop in the mosaics of San
Vitale)—have turned up in far-flung locations, but
fortunately all except twelve of the original thirty-
nine panels have been found and returned.[3]

The panels embellishing the throne (See Figure
8.5) show beautiful workmanship and display a rich
symbolic program, for which the bishop himself may

well have been responsible. Scholars speculate that it was made in an Eastern workshop, and we know that Maximian did visit Constantinople at the right period. The iconography stresses baptism and the eucharist, the teaching of cate-chumens and the celebration of the mass being two important occasions during which a bishop would make use of his throne as a symbol of episcopal author-ity. The five panels on the bottom of the front are especially appropriate for the former occasion. John the Baptist,

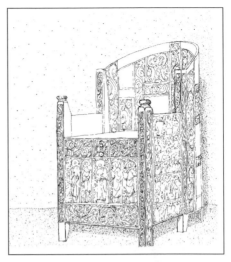

Figure 8.5:
The Throne of Maximian: A cathedral (from the Latin *cathedra* for seat, or chair) is technically the seat of the bishop. A bishop such as Maximian would have used his throne while instructing catechumens and during the celebra-tion of the eucharist, roles which are rein-forced by the symbolism of the ivory panels that embellish it. A reference to the eucharist has been noted earlier in connec-tion with the nativity scene (Figure 4.3). (Drawing inspired by the throne of Maximian, mid–sixth century, Ravenna.)

holding a disk with an image of the Agnus Dei, or Lamb of God, occupies the central panel at the bottom front of the throne. He is flanked by the four evangelists (two on either side) carrying books indica-tive of their writings, the subject matter into which the bishop was expected to initiate the catechumens prior to baptizing them as John baptized Jesus in the Jordan River.

The throne is also decorated with scenes from the childhood of Jesus (it is here that one finds the nativity scene discussed in chapter 4; see Figure 4.3), and from the life of the Old Testament Joseph, considered a type of Jesus, especially in light of incidents such as Joseph being thrown into the cistern (symbolic of the tomb) and the lamb slaugh-tered for blood to be used as proof of the boy's death. Reminders of the sacraments of baptism and the eucharist abound: the baptism of Christ, the Samaritan woman at the well (baptism), the multi-plication of the loaves and fishes (the eucharist), the cure of the blind (most probably baptism, as the baptized person is thought to be blind to the truth of

Christ prior to receiving the sacrament), the entry into Jerusalem (the prelude to the Passion, hence of eucharistic significance), and so forth. Delightful decorative elements including peacocks, deer, goats, lions, and foliage also enliven the panels.

In workmanship, symbolic content, and even decorative flourishes, the throne of Maximian is a particularly appropriate reminder of this bishop, who through subtlety (even a certain deviousness), tact, and sheer force of personality played such an important role in the religious, political, and artistic life of Ravenna.

Sant' Apollinare in Classe

The remarkable Maximian's imprint on Ravenna past and present did not end with San Vitale or with Maximian's throne. In May of 549, the bishop dedicated the Church of Sant' Apollinare in the port of Classe. This church, built to house the relics of the man believed to have brought Christianity to Ravenna and to have served as its first bishop, was begun under Bishop Ursicinus and continued under Bishop Victor, but most of the work seems to have been done under Maximian. Again Julianus Argentarius is given credit for having financed the building, the long, thin red bricks of which it is constructed still speaking clearly of his involvement.

Today, it is a thrilling sight to approach Ravenna from the south and then, swinging around toward the east, to find the Church of Sant' Apollinare standing there, as beautiful, balanced, and restful to the eye as in the sixth century, when the long, rippling green fields through which one now drives were equally

Sant' Apollinare in Classe presents yet another example of monuments which have managed to survive only by a hair's breadth. During the Second World War, rumor had it that Germans were using the bell tower of Sant' Apollinare in Classe as an observation post. The gallant Polish commander Popski (Valdimir Peniakoff) convinced Allied gunners to delay demolition of the tower (which would undoubtedly have meant demolition of the church as well) until he could send in a party to reconnoiter. The rumor about the Germans proved untrue, and Sant' Apollinare in Classe was saved.

verdant marshes and the dark sea lapped at the port of Classe. The tall bell tower, or campanile, is, of course, medieval, but it is not the only alteration to the building's facade. Originally one must have entered the basilica in the traditional manner, by way of an atrium, or courtyard, and then through the narthex, or portico (today rebuilt, with little regard for the conformation of the original). Excavation suggests that the narthex was flanked by two towers, perhaps rising to two stories, but only the left one, much altered, remains. Yet none of this has compromised the feeling of beauty and repose that have distinguished this church since its dedication.

Inside, one's first impression of the interior is equally felicitous. Here, as at the earlier San Giovanni Evangelista, is a basilica blessed with space (182 feet by 99 feet, but the *feeling* of spaciousness is far more significant than the actual dimensions) and light. Light pours in through large windows in the clerestory, aisles (one on either side of a broad central nave), and apse. The apse, rounded on the interior and polygonal on the exterior, has five windows between which stand four bishops of Ravenna: Severus (a saint), Ecclesius (the bishop under whom Justinian's rebuilding plan was begun and who offers Christ the Church of San Vitale in the mosaics of San Vitale), Ursus (the builder of the original Cathedral of Ravenna and the baptistery of the Orthodox, to which Bishop Neon later added the dome and its mosaics), and Ursicinus (the founder of Sant' Apollinare in Classe).

The nave arcade is distinguished by marble columns strikingly veined in diagonal patterns of cream and soft green, their capitals decorated with wind-blown acanthus leaves and raised on impost

blocks to counteract the tendency of perspective to flatten the look of the arches they carry. The nave wall above the arcade is decorated with medallions showing the bishops and archbishops of Ravenna, eighteenth-century work but subdued enough not to conflict with the delicate mosaics of earlier times. It is said that the side walls of this basilica were originally covered with some of the most beautiful marble panels in Italy, but these, together with marble mosaics that once carpeted the floor, are gone—the marble panels on the walls having been carried off to Rimini in the early fifteenth century. However, a few fragments of the floor mosaic can be seen in the aisles, and one has been mounted on the right wall.

Otherwise, the most striking change in the interior of Sant' Apollinare in Classe since it was dedicated by Maximian is the sanctuary, the floor of which was raised in the seventh or ninth century (opinions vary) to make room for a crypt—and not, for once, because of a change in ground level. This alteration necessitated the addition of a series of steep steps leading up to the altar. These steps effectively confine the sanctuary to the apse, whereas once it would have taken up a much more significant part of the church, thus allowing room for a more numerous clergy.

Also added since the days of Maximian are the panels on the side walls of the apse between the ring of windows and the triumphal arch. Perhaps executed in the seventh century, they recall the decorative treatment of the sanctuary of San Vitale. To the visitor's left is a substantially restored (now mostly tempera) panel depicting the Byzantine emperor Constantine IV ceremonially giving special privileges to the Church of Ravenna (later rescinded), while to

the right is a panel combining the sacrifice of Abel with those of Abraham and Melchizedek, subjects whose significance was discussed in relation to San Vitale.

The mosaics of the triumphal arch, which also postdate the dedication of the church by Maximian, are filled with what by now should be readily identifiable images. Top center is a medallion with a bust of Christ (easily recognizable with his cruciform nimbus, or halo), one hand grasping a book and the other raised in blessing. He is flanked by the winged zoomorphic symbols of the four evangelists. Below, twelve lambs, six on either side, emerge from the symbolic cities of Jerusalem and Bethlehem, the Jewish and gentile sources of the Church that will one day be reunited under the Divine Shepherd. Beneath the lambs, a fruit-bearing palm, a symbol of eternal life, fills the crevice on each side of the arch, while below the palms are the archangels Michael, to visitor's left, and Gabriel, to the right, who have been interpreted variously as the deacons who assist the priest at mass and as the angels who stood guard over the tomb. (Palm trees and angels are thought to be the work of the mid–sixth century.) On the lowest tier of the triumphal arch are busts of Saints Matthew and Luke, representing the incarnation and the Passion, respectively, but these are twelfth century and much restored.

The glory of Sant' Apollinare in Classe is the mosaic that enriches the half-dome of the apse. The dominant color is an incredibly rich moss-green to which not even the finest contemporary photography does justice. About two-thirds of the background is a sylvan setting with pines, trees, grass, flowers, shrubs, and rocks, above which is a small sliver of

gold sky striated by wisps of white clouds. In the bottom center of the half-dome stands Saint Apollinaris, arms aloft in the orant position, while twelve sheep approach him, six from either side, the flock of Apollinaris, the people of Ravenna for whom the saint intercedes.

In the upper part of the half-dome of the apse stand three more sheep, one on the left and two on the right of a jeweled gold cross set within an enormous blue, star-studded medallion hanging between earth and sky directly above the saint. In the center of the cross is the head of Christ; the *alpha* and *omega* are beside the outer edges of the cross bar. Above the cross, but still within the medallion, are the Greek letters for *Icthus* (Jesus Christ, Son of God, Savior) and below is the inscription *Salus Mundi* (Salvation of the World). Two figures, one on either side of the cross, appear in the cloud-streaked sky. These are identified by inscriptions as Moses to the right and Elijah to the left. Their presence serves as the clue to the meaning of the scene: the transfiguration on Mount Tabor in which Christ, accompanied by Moses and Elijah, revealed himself to Peter, James, and John (the three lambs) in all his glory and the voice of God (symbolized here by God's hand emerging from on high) came out of a cloud.

Another aspect of Sant' Apollinare in Classe, less exalted but still of great significance, is the large number of fine marble sarcophagi found in the basilica. This church is by no means unique in containing sarcophagi (there are, for example, some notable examples in San Vitale), but the space and light here make it particularly easy to study them. The sarcophagi of Ravenna are extremely elegant and very distinctive. Quite large, with rounded or

sometimes pitched lids, they are ornately carved, becoming a virtual compendium of all the symbols with which the reader has become familiar in the process of following the course of early Christian art: peacocks, grape vines, lambs, palm trees, the *chi-rho*, and others of the same ilk. It is well worth the effort to spend a little time in this beautiful and ancient basilica reviewing these reminders of the growth and development of Christian art, and quite appropriate, too, for in one sense this is where our present story ends and another begins.

Toward the Future

Justinian's empire, as it had been extended in the West, did not long outlive the emperor. In 568, just three years after Justinian's death, another Germanic group, the Lombards, entered Italy. They gradually conquered most of northern Italy, Ravenna itself eventually falling in the mid–eighth century. Although Constantinople stubbornly maintained a foothold in the Italian peninsula, and communications were never to cease entirely, the break between East and West was now irrevocable. Their art was similarly to follow different paths.

East or West, Christian art had firm roots in the classical tradition—that naturalistic, humanistic type of art which placed great emphasis on visual appearances. Further, although it would be much modified by contrary trends, the classical tradition continued to exist throughout the Middle Ages, and beyond, as an identifiable source of inspiration. As we have noted in connection with the nave mosaics of Sant' Apollinare Nuovo, some early Christian art had remained

Scholars have identified numerous "renascences" during the course of Byzantine art and that of medieval art in the West, times when that classical substratum (almost invisible at times, especially in the West) bubbles to the surface once again.

239

relatively close to the pure classical tradition, presenting the human body as a rounded form with weight and substance (the figures of the middle tier; see Figure 7.2), while elsewhere the body was flattened and made as abstract as it could be in an art that never entirely eschewed representation (the procession of saints in the lower tier; see Figure 7.3).

This divergence can be further illuminated by contrasting the Christ figure in the apse mosaics of the Church of Saints Cosmas and Damian (Rome, c. 520–30) and the figure of Saint Apollinaris in the apse mosaics of Sant' Apollinare in Classe. Saint Apollinaris is a flat cutout. No body appears to exist beneath the garments; the figure seems incapable of movement, frozen forever in the orant position (see Figure 8.6).

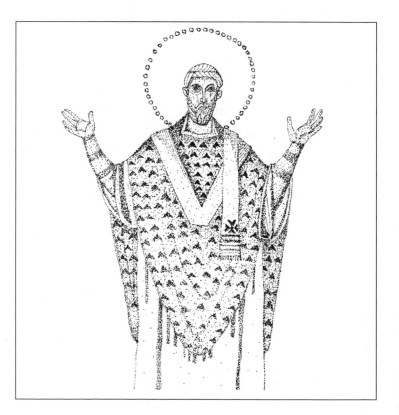

Figure 8.6:
Saint Apollinaris: Saint Apollinaris, like Saint Agnes (Figure 7.3), has a body without weight or substance. In such images Christian art has gone as far as it could go toward the spiritual without entirely eschewing representational forms.
(Drawing inspired by the mid–sixth-century apse mosaic of Sant' Apollinare in Classe, near Ravenna.)

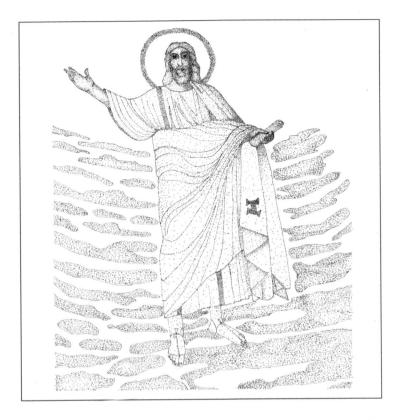

Figure 8.7:
Christ in the Clouds:
The setting may be
ethereal, but the figure
of Christ is solid and
three-dimensional, a late
reference to the classical
tradition with its regard
for the logic of appear-
ances. Though this
tradition was never to be
lost entirely, in the West
it would surface only
occasionally for many
centuries. (Drawing
inspired by the apse
mosaic, c. 520–30,
Saints Cosmas and
Damian, Rome.)

The Christ of Saints Cosmas and Damian, on the other hand, is a powerful figure existing (or at least seeming to exist) in three dimensions as he strides forth from the clouds, right hand raised in a gesture of authority, left grasping a scroll (see Figure 8.7), and originally acknowledged by the hand of God in a wreath appearing from on high. The setting (i.e., the clouds) may seem ethereal in contrast to the meadow in which Saint Apollinaris stands, but Christ himself has a vigorous reality. Below Christ, the other figures—Saints Cosmas and Damian presented by Saints Peter and Paul and accompanied by Saint Theodore Stratelates and Pope Felix IV—similarly possess bodies with weight and substance, and even the twelve sheep (six on either side) that converge on

Several Renaissance popes meddled with this mosaic. In the processes of "moderni-zation" the hand of God was cut away to allow room for a window. One of the reasons we have so much early Christian art in relatively good condition in Ravenna as in contrast to Rome is that there were no popes on hand to "up-date" the art and, as Ravenna slid from prominence with the Middle Ages, there was not the money to tempt bishops to do likewise.

the Lamb of God at the bottom of the mosaic are fat and meaty, unlike the flat animals that represent the flock of Saint Apollinaris.

Although the West would soon turn aside from the artistic values expressed by the figure of Christ at the Church of Saints Cosmas and Damian, it is instructive to note that as early Christian art came to a close, East and West were already exploring separate paths, and each was trying to find its own particular direction. However, still more important than a divergence in approach and style was, as we shall see shortly, a difference in the emerging philosophies of Christian art. Both had to respond in some way to the uncomfortable fact that no way of creating Christian art—at least so long as that art was representational—seemed to circumvent entirely satisfactorily the Old Testament prohibition against graven images.

With changing times, as the imperial power had become a positive force for Christianity and with the diminishing vigor of paganism, images gradually posed less of a threat for the Christian on both the practical and psychological levels. In fact, images had steadily become a more integral part of the practice of Christianity. From the earliest images which spoke so simply and eloquently of the Christian belief in a loving and protecting God, to an artistic program as complex as that in the sanctuary of San Vitale, Christian art had developed not just as a decorative form but as an art capable of subtle and profound expression.

And yet, for all of the momentous advances that it had made, there continued to be an uneasiness about the existence of representational Christian art. Such an art could become as near to being ethereal as the talents of the most gifted mosaicist could make

This three-dimensional, naturalistic type of representation was soon to be challenged in the West and greatly modified both by Celtic and Germanic influences and by an artistic sensibility that would call for abstraction and distortion to express intense emotions. The art of the East, too, would experience its own transitions over time.

it, but for some Christians there was still no way to reconcile it with the stern words recorded in Exodus. So, looking back, we can, on the one hand, stand in awe of the aesthetic and intellectual accomplishments of early Christian art, but on the other be discomfited by the unresolved conflict at its very heart.

This is really where one story ends and another begins. The first story—the tale of Christian art coming into being, developing an eloquent and highly sophisticated "language" with the capacity of expressing both abstract and complicated thoughts, and ultimately able to produce works of astounding beauty—is the story to which this volume is devoted. The second story, the story of the rationalization of the existence of representational Christian art—a process that would mark a still more dramatic break between East and West—must wait for another book. However, to anticipate:

The West approached the problem along practical lines. The official attitude toward images would be expressed by Pope Gregory I (d. 604), who stated that religious images were neither to be worshiped nor to be destroyed. In other words, works of art containing religious images such as those of the saints were not to be treated as physical objects possessing any special powers in themselves, but to be used solely to illustrate the Bible (or other suitable religious material), especially for the illiterate. Though such a position might fail to address philosophical objections to representational art based on the Old Testament prohibition, Gregory's pronouncement not only recognized such an art as a *fait accompli*, but also gave it an officially sanctioned role within the Church.

In the East, on the other hand, the issue was to be fought out directly and in theological terms. In defense of images it was argued that Christ, and thus other holy subjects, could be represented because Christ had assumed human form. As man, Christ could be portrayed, and to deny this was to fall into the old trap of Monophysitism, for it meant denying the humanity of Jesus. Furthermore, with the incarnation (God becoming man) a new order had come into being. The "Word had become flesh," inaugurating this new order and altering forever the basis on which the prohibition against graven images had rested. The Council of 787, accepted in the East but not the West, would place religious imagery on a level equal to the gospels, the visual being understood to be on a par with the verbal, not subservient to it. Religious images, which had been eschewed by the earliest Christians, would thus be recognized as an integral and salutary part of religious life.

Notes

1. The complex interplay of religion and politics in San Vitale can be studied in Otto G. Von Simson, *Sacred Fortress: Byzantine Art and Statescraft in Ravenna* (Princeton, N.J.: Princeton University Press, 1987; first published, 1948).

2. Ibid., p. 25. For a most interesting discussion of this aspect of the mass, see Joseph A. Jungmann, S.J., *The Mass of the Roman Rite: Its Origins and Development*, vol. 2, trans. Rev. Francis A. Brunnen (Allen, Texas: Christian Classics, 1992), pp. 226 ff.

3. To be more specific, nine plaques are missing, three of which were carved on both sides, thus leaving twelve episodes unaccounted for.

GLOSSARY

Words and phrases are defined here in the way that they are used in early Christian art. Boldface words in the definitions are defined in the glossary.

abbreviated representation: An image in which the elements are pared down to the very minimum necessary to set the scene or suggest a story. For instance, Noah floating alone in a square box, the only other figure being the approaching dove, is sufficient in early Christian art to imply the entire drama of the flood.

ambulatory: A covered passage for walking around something. For example, in churches such as Santa Costanza or San Stefano Rotondo the ambulatory transcribes a ring around the circular core of the building.

apse: A nichelike space in early Christian buildings generally (though by no means always) extending from the altar end of a church. Such an apse is usually semicircular (in Ravenna we frequently find apses semicircular on the interior but with polygonal exteriors) and covered by a **half-dome.**

arcade: A series of arches supported by columns or piers.

architrave: A lintel; in a church such as Santa Maria Maggiore it rests directly on the capitals of the columns of the **nave.**

Arians: Adherents of Arianism; a heresy. The Arians maintained that Jesus was God, but not of the same rank as God the Father. The Arians taught that Jesus was created by God the Father and thus could be considered neither of the same substance nor co-eternal with him.

atrium: An open court surrounded by **colonnades** or **arcades** in front of a church.

baldachino (or baldachin): A canopy, usually supported by columns, suspended over something of significance such as an altar or, in the case of Dura Europos, a **piscina,** or baptismal font.

barrel vault: A rounded **vault** shaped like half of a piece of pipeline or a quonset hut.

basilica: A large rectangular building entered from one of the long sides and used by the Romans for a variety of civic purposes; later a Christian church employing basically the same form but organized longitudinally with the entrance on one of the short ends and the focus on the other. (However, the tourist should note that today a church such as San Vitale in Ravenna is referred to a basilica even though it has an octagonal form.) Very early basilicas such as Old Saint Peter's (Rome, c. 313) were occidented; that is, they had the altar at the west end. Later churches were usually oriented; that is, they had the altar on the east.

bema: The **sanctuary,** or choir, in an Eastern church.

blind arches: Arches that are applied to a wall as decoration only and do not define or form part of an opening.

campanile: A bell tower.

chi-rho: The Greek letters *chi* (X) and *rho* (P) are the first two letters of *Christ* as written in Greek. When the *rho* is centered in the *chi*, the resulting image suggests the cross.

Constantine used this configuration on his military standard, the **labarum.**

clerestory: The upper part of the church building rising above the roofs of the adjoining parts and having windows; also the windows found there.

codex: A book; a manuscript in the form of pages bound together and placed between covers.

colonnade: A series of columns supporting a horizontal element such as a lintel.

cornice: A continuous, projecting, horizontal feature.

cruciform nimbus: A **nimbus** with a cross inscribed in it used to designate Christ or occasionally another member of the Trinity.

Dionysus: The god associated with the cultivation of the vine and the making of wine; also known as Bacchus. With the spread of the cult of Dionysus, the Bacchic festivals became increasingly dissolute, involving drunkenness and orgiastic excesses.

diptych: Two writing tablets hinged together like a book. Decorated diptychs were made for ceremonial purposes. For example, a new consul on taking office might give such diptychs to friends and persons of importance. These were often of ivory, the outer sides of the panels being carved with representations of the emperor, the empress, or a consul. On Christian diptychs representations of this sort were replaced by sacred images such as Christ and the Virgin. The inside of the panels were hollowed out and filled with wax in which were inscribed the names of the faithful, both living and dead, to be commemorated during mass.

dome: A **vault** the shape of half of a hollow ball.

Donatists: Caused a schism in North Africa by denying that those who had sinned after baptism could be saved.

facade: The front of a church.

fresco: Painting on plaster, either dry or wet. If the plaster is wet, the pigments become chemically bound to the plaster.

gold glass: Decorated gold leaf encased in glass and used as the bottom of a drinking vessel.

Greek cross: A cross in which all four arms are equal.

half-dome: A **vault** the shape of a quarter of a hollow ball.

impost block: A stone—usually shaped like a truncated, inverted pyramid—placed between a column capital and the point of an arch that rests on it to raise the arch sufficiently so that it will not appear flattened.

labarum: The military standard adopted by Constantine after his victory at the Milvian Bridge (312). It was composed of the chi-rho monogram—X-P in our alphabet—representing the first two letters of the name *Christ* in Greek. Beneath the monogram was the exhortation (in Latin) that in this sign one would conquer.

Latin cross: A cross in which the vertical member is longer than the horizontal member.

lunette: A semicircular surface, flat side down; in the case of the buildings surveyed here usually created where a **barrel vault** is intercepted by a vertical wall.

martyrium: A church dedicated to a martyr, usually built over his or her tomb.

mausoleum: A large tomb.

Monophysites: Adherents of Monophysitism; a heresy. The Monophysites emphasized the divine nature of Christ over his human nature.

mosaic: A technique by which patterns or pictures are created by embedding small pieces of stone or glass (**tesserae**) into a base such as concrete or plaster.

mural: A wall painting.

narrative image: An image in which the visual elements are expanded to include many figures and much action.

narthex: The porch, or vestibule, of a church.

nave: The central space of a church extending from the entrance to the **sanctuary.**

Nestorians: Adherents of Nestorianism; a heresy. The Nestorians were accused by their opponents of emphasizing the human nature of Christ over his divine nature.

nimbus: A halo; an aureole of light surrounding the head of a holy person. A square nimbus signifies that the person is still alive.

orant (also found as **orans**): A figure, either male or female, with arms raised in a "V" formation toward heaven, representing the soul of the deceased in prayer.

oratory: A chapel for private devotions.

papyrus: A plant native to Egypt used to make a paperlike writing material.

parchment: The skin of an animal prepared for writing. During the Middle Ages, parchment was prepared by specialists. For a description of this process, see Daniel V. Thompson, *The Materials and Techniques of Medieval Painting* (New York: Dover Press, 1956), pp. 24 ff.

paten: A plate used for the distribution of communion or, later, to hold water in images of the baptism of Christ. In the **dome mosaics** of the Orthodox baptistery in Ravenna, John the Baptist uses a paten with water to baptize Jesus, but this part of the scene is the work of a nineteenth-century restorer.

pendentive: A piece of masonry resembling an upside-down, concave, isosceles triangle used to bridge the gap between the corners of a square or rectangular base and a

round **dome** such as in the mausoleum of Galla Placidia, Ravenna.

personification: The treatment of an inanimate thing or idea as if it were a person. In art this entails giving the inanimate object a human form, for example, depicting the Jordan River as a man in scenes of the baptism of Christ like those in the baptistery of the Orthodox and the Arian baptistery, both Ravenna.

piscina: A pool or baptismal font often large enough to baptize an adult by immersion.

prefiguration: Something that happens before something else and suggests or announces the subsequent event. For example, in Christian thought and art the multiplication of the loaves and the fishes is seen as prefiguring the eucharist. (See **typology**.)

putto (pl. **putti**): Little cherublike figures depicted nude or very scantily clothed.

pyxis (pl. **pyxides**): A small box.

quatrefoil: A shape having four lobes like a four-leaf clover.

relief: A sculpture projecting from a background of which it is part.

roll: A rolled piece of writing; a scroll.

sanctuary: The most sacred part of a church, where the liturgy is performed and space is reserved for the clergy; also known as a choir, or in the East as a **bema**.

sarcophagus (pl. **sarcophagi**): A coffin.

scriptorium: The room in a monastery set aside for the scribes, or copyists.

sculpture in the round: Freestanding, three-dimensional sculpture.

spandrel: The roughly rectangular space left between adjacent arches.

spolia: Architectural parts, quite often columns, taken from an earlier building or monument to be used in a later one.

tempera: An egg-based paint.

tesserae (sing. **tessera**): Small pieces of stone, or more frequently in the early Christian period glass, used to make a **mosaic.** Colored glass (by the sixth century in Ravenna the mosaicist had a palate of about three hundred different colors) was baked in thin sheets that were then cut into small pieces of varying shapes and placed in wet plaster to make designs and pictures of great vibrancy. Not only did the glass reflect the light, but a skilled mosaicist could judge exactly how to place the tesserae at slightly different angles so that as the light changed there was a sense of movement like a light breeze blowing across a pond.

transept: A cross hall at the front of a church dividing the **nave** and aisles from the **sanctuary.**

triumphal arch: Great, rounded arches reminiscent of those created by Roman emperors to celebrate a military triumph; used in Christian churches to focus attention on the **sanctuary.**

tubi fittili: Small interlocking terracotta tubes that have been likened to syringes inserted into each other. These were placed in concentric circles in quick-drying cement to create lightweight domes such as that found at the baptistery of the Orthodox, Ravenna, where a **dome** of thirty-one and a half feet is supported by brick walls a mere three feet thick.

typology: Like **prefiguration,** typology rests on the belief that Old and New Testaments form parts of a unified, coordinated whole. Persons and events are seen as "types," or molds, of others. For example, Isaac, the innocent

victim, is considered the Old Testament "type" corresponding with Jesus, another innocent victim.

vault: An arched masonry ceiling or roof.

vintage feast: The grape harvest and related festivities. The vintage feast is associated with the pagan god **Dionysus,** but was also used in Christian decoration because it suggested the changing of the wine into the blood of Christ in the sacrament of the eucharist.

A GUIDE TO EARLY

CHRISTIAN SYMBOLS

Symbols are defined in terms of their use in early Christian art and more specifically in works referred to in the present book. For example, the lion is identified in terms of its role as a symbol of the evangelist Mark and as a symbol of evil (Christ treading on the lion and the adder in the entrance mosaic in the Archiepiscopal Chapel, Ravenna). However, in time the lion became associated with Christ (it was believed that lion cubs were born dead and only revived on the third day) and also became the special attribute of Saint Jerome (who is said to have removed a thorn from the paw of a lion, which then became his faithful friend). At a later date the lion appears as an attribute of other saints such as Saint Mary of Egypt, Saint Euphemia, Saint Onuphrius, and Saint Paul the Hermit.

alpha and omega: The *alpha* and the *omega* are the first and last letters of the Greek alphabet. This symbol, used verbally in Revelation 1:8 and 22:13, expresses the all-encompassing nature of the reign of God.

anchor: The anchor represents hope and steadfastness.

angels: Angels are messengers of God. Gabriel, Michael, and Raphael are mentioned by name in the canonical

books of the Bible. Seraphim, with six wings, and cherubim, with four wings, are special types of angels.

ankh: The ankh, the ancient Egyptian life sign, served the early Christians as a disguised reference to the cross.

Bethlehem: This city is associated with the gentile aspect of Christianity, for it was here that Christ manifested himself to the gentiles in the person of the magi.

chi-rho: The combination of the *chi* (X) and the *rho* (P), the first two letters of *Christ* in Greek, used by Constantine for the labarum (see Glossary). The *chi-rho* has the look of a cross, particularly if the loop at the top of the *chi* is omitted, as is often the case, and has been used as a symbol of the cross throughout Christian art.

cock: In early Christian art the cock appears as part of the Passion, symbolizing Peter's denial of Christ.

crown: In the religious games of ancient Greece, the victors received a crown of laurel. Christian saints, and still more so martyrs, were seen as winning the crown of faith (or, in Saint Paul's words, of righteousness), the symbol of their victory over the temptations and travails of this world. As Saint Paul says, "I have fought a good fight, I have finished my course, I have kept the faith: Henceforth there is laid up for me a crown of righteousness, which the Lord, the righteous judge, shall give me at that day" (1 Timothy 4:7–8). Often saints and martyrs are depicted carrying crowns symbolizing their spiritual triumph.

cruciform nimbus: A cruciform nimbus is a nimbus with a cross in it that is used to designate Christ, or sometimes the other members of the Trinity.

dove: The dove is a symbol of purity and peace. The dove brought back an olive branch to Noah in the ark to show that the flood waters had receded and God had made peace with man. The dove also represents the Holy Spirit and is often shown descending from the heavens in representations of the baptism of Christ, the only occasion on which the Holy Spirit is actually described as a dove.

dragon: The dragon symbolizes evil or the devil but is also associated with a saint such as George of Cappadocia, who slew "the dragon of disbelief" in that province.

eagle: The eagle is the attribute of the evangelist John, whose words are thought to transport the listener toward heaven.

fish: The fish already had a distinguished place in the pre-Christian world both as the "Divine Fish" worshiped in the eastern Mediterranean and, in the Jewish tradition, as the one creature to survive the flood unaided. As a Christian symbol, the fish has many layers of meaning. Jesus promised to make the apostles fishers of men. Fish, multiplied together with loaves, were seen as a prefiguration of the Last Supper and hence the eucharist. And at some point it was noted that the *icthus*, the Greek for *fish*, is an anagram for the Greek phrase "Jesus Christ, Son of God, Savior."

fruit-bearing palm: See **palm.**

Good Shepherd: A favorite in early Christian art, the Good Shepherd combines an image (the man bringing his offering to the altar) familiar in pagan art with the many references to Christ as the Good Shepherd found in the gospels, particularly that of John. By the time early Christian art was developing, the pagan image was referred to as the "Ram Bearer" and had developed connotations of philanthropy and loving care that made it a particularly appropriate symbol for Jesus.

grapes: See **vine/vintage feast.**

hand of God: The hand of God appearing from heaven signifies the power and might of God the Father and his active participation in an event.

hands, covered: Covered hands are an indication of reverence and respect.

Helios: Helios, the sun god, serves as a Christ figure in early Christian art.

Jerusalem: This city is associated with Judaism and the Jewish aspect of Christianity.

keys: Saint Peter is often shown carrying keys because Jesus gave him the keys of the kingdom of heaven.

lamb: The lamb as the sacrificial beast symbolizes Christ, who is referred to by John the Baptist as the "Lamb of God." For this reason, the lamb is the special attribute of John the Baptist. It is also the special attribute of Saint Agnes, who is accompanied by her lamb in the lower tier of nave mosaics at Sant' Apollinare Nuovo (Ravenna). Further, there is the apocalyptic Lamb of Revelation that refers to Christ's eternal victory and cosmic sovereignty. Twelve lambs may refer to the twelve apostles (Saints Cosmas and Damian, Rome), but lambs may also refer to the flock of a bishop (Sant' Apollinare in Classe, Ravenna).

lion: See **snake and lion.**

man: Man is the attribute of the evangelist Matthew, who begins his gospel with an account of the lineage of Jesus.

nimbus: The nimbus, commonly known as a halo, is a band, or aureole, of light that encircles the head of a saintly person.

Numbers: The symbolic numbers most commonly encountered in early Christian art are: one (God, unity); three (spirituality, the Trinity); four (early things: four winds, four directions, four rivers of paradise, etc.); eight (rebirth); twelve (completeness, the earthly multiplied by the spiritual, the twelve apostles).

orant (also found as **orans**): The orant represents the soul of the deceased in prayer.

Orpheus: Orpheus was a Greek demigod who played the lyre so beautifully that he charmed even the wild beasts. A shepherd who conscientiously tended his flock, Orpheus appears in early Christian art as a Christ figure.

ox and ass: In early Christian scenes of the nativity the ox (the sacrificial beast) represents the Jewish people and the ass the gentile people, the message being that the Christ

child has come for all people, Jew and gentile alike. (It has been argued that the identifications were reversed in the Late Middle Ages, but this would not change the meaning of the scene.) The ox is also the attribute of the evangelist Luke, who begins his account with the sacrifice of Zachariah.

palm: The palm, like the crown, was a classical symbol of victory taken into the Christian repertoire to express spiritual triumph. The palm also appears in Christian art as a symbol of paradise. A fruit-bearing palm denotes eternal life.

peacock: In the ancient world it was believed that the peacock's flesh was incorruptible and hence the peacock became a symbol of immortality.

philosopher: In early Christian art, the philosopher (a bearded man, chest bare or with a tunic, usually over one shoulder) often sits on a stool reading a book. He can symbolize either the person who has accepted the philosophy of Christ or Christ himself as the true philosopher.

scrolls: The scrolls are an attribute of Saint Paul. The counterpart of Peter's keys, they symbolize the laws or the rule of God. They may also be a reminder of the saint's epistles. When scrolls are found with Jesus, as at the Chapel of Sant' Aquilino (the Church of San Lorenzo Maggiore, Milan), they emphasize his role as teacher.

shell: The shell symbolizes resurrection and immortality.

snake and lion: Used as in the entrance mosaic in the Archiepiscopal Chapel (Ravenna), the snake and the lion symbolize the forces of darkness and evil (Psalm 91). The lion is also the symbol of the evangelist Saint Mark, who begins his account in the wilderness with the mission of Saint John.

star: Traditionally a star indicated the birth of a ruler, and it is used in this context on the nativity panel from the

throne of Maximian (Ravenna). Also the star is associated with the magi, who asked, "Where is he that is born King of the Jews? for we have seen his star in the east, and are come to worship him" (Matthew 2:2).

sun and moon: The sun and the moon, symbols of power in antiquity, express the cosmic significance of an event. For this reason, they are often found in depictions of the crucifixion.

victories: In the ancient world victories, or "nikes," were winged female personifications of triumph. The Christians used this form to depict angels.

vine/vintage feast: The vintage feast, though part of the Dionysian funerary cult, also had considerable religious significance for the early Christian, who knew well the metaphor of Christ as the vine and the people as the branches. Furthermore, there was the change of nature of the grapes in the process of fermentation that suggested the change of wine into the blood of Christ in the eucharist. Grapes alone also have these same connotations.

water: In Early Christian art, water is used as a symbol both of purification and of spiritual refreshment.

SUGGESTED

READING

EARLY CHRISTIAN ART AND ARCHITECTURE

Age of Spirituality: Late Antique and Early Christian Art, Third to Seventh Century.

Catalogue of the exhibition at The Metropolitan Museum of Art, November 19, 1977, through February 12, 1978. Ed. Kurt Weitzmann. New York: The Metropolitan Museum of Art, 1979.

A compendium of the work of many scholars and brilliantly edited, this book covers imperial, classical, secular, and Jewish art as well as early Christian. It is the most thorough one-volume study of early Christian art and architecture available.

Beckwith, John. *Early Christian and Byzantine Art.* New York: Penguin Books, 1970; 2nd ed. 1979.

du Bourguet, Pierre. *Early Christian Art.* Trans. Thomas Burton. New York: William Morrow & Company, 1971.

———. *Early Christian Painting.* Trans. Simon Watson Taylor. New York: Viking Press, 1966.

Both books by du Bourguet mentioned here have many beautiful color reproductions of works of early Christian art.

Gough, Michael. *The Early Christians*. New York: Frederick A. Praeger, 1966.

———. *The Origins of Christian Art*. New York: Praeger Publishers, 1973.

Grabar, André. *The Golden Age of Justinian: From the Death of Theodosius to the Rise of Islam*. Trans. Stuart Gilbert and James Emmons. New York: Odyssey Press, 1967.

A complement to the volumes by du Bourguet, this book has fine color reproductions of the works of the later period of early Christian art.

Hutter, Irmgard. *Early Christian and Byzantine Art*. New York: Universe Books, 1971.

Krautheimer, Richard. *Early Christian and Byzantine Architecture*. New York: Penguin Books, 1965.

MacDonald, William. *Early Christian and Byzantine Architecture*. New York: George Braziller, 1962.

Milburn, Robert. *Early Christian Art and Architecture*. Berkeley, Cal: University of California Press, 1988.

An extremely thorough work that gives a picture of the development of early Christian art and architecture throughout the lands touched by Christianity.

Volbach, Wolfgang Fritz. *Early Christian Art*. Trans. Christopher Ligota. New York: Harry N. Abrams, 1962.

Volbach's work is distinguished by unusually fine black and white photographs; includes a few photographs in color.

ROME (INCLUDING THE CATACOMBS), MILAN, AND RAVENNA

With the notable exception of the baptistery of Dura Europos (now reconstructed at Yale University Art Museum), most of the early Christian monuments

discussed in *The Power of Sacred Images* are (or, in the case of Old Saint Peter's, were) to be found in or near these cities. The early Christian remains in Rome, Milan, and Ravenna give an excellent picture of the development of early Christian architecture and decoration and have the advantage of being easily accessible to the traveler.

Bovini, Giuseppe. *Ravenna.* Trans. Robert Erich Wolf. New York: Harry N. Abrams, 1971.

> The visitor to Ravenna will find books by Bovini in most church/museum gift shops. They are well illustrated and make fine guides/souvenirs. Also, Bovini has been better served by his translators than Riccardo Ricci, *Ravenna: A Guide to the Knowledge of the City* (Ravenna: Sirri-Ravenna, 1987). For example, in the English edition of the latter's work the "chair" or "throne" of Maximian is referred to as a "desk." Such errors make the Ricci text (in translation) confusing and even misleading.

Krautheimer, Richard. *Rome: Profile of a City, 312–1308.* Princeton, N.J.: Princeton University Press, 1980; 2nd ed. with corrections, 1983.

———. *Three Christian Capitals: Topography and Politics.* Berkeley, Cal: University of California Press, 1982.

Stevenson, J. *The Catacombs: Rediscovered Monuments of Early Christianity.* London: Thames and Hudson, 1977.

> This is only one of many works dealing with the catacombs, but makes quite a good beginning for the general reader. It covers the construction and history of the Roman catacombs as well as the art and has a section on catacombs elsewhere in the Mediterranean area.

Von Simson, Otto G. *Sacred Fortress: Byzantine Art and Statescraft in Ravenna.* Princeton, N.J.: Princeton University Press, 1987; first published 1948.

Von Simson's work, certainly a classic in its field, discusses the politics, religious controversy (the former being inextricably bound up with the latter), and personalities behind some of the major works of art and architecture in sixth-century Ravenna.

ICONOGRAPHY AND SYMBOLISM

Ferguson, George. *Signs and Symbols in Christian Art.* New York: Oxford University Press, 1961; first published 1954.

Although Ferguson's book is basically oriented toward the art of the Renaissance, a number of the symbols will already be familiar to readers of the present work. Many museum gift shops carry this book in paperback, and it makes a handy, portable reference guide.

Grabar, André. *Christian Iconography: A Study of Its Origins.* The A.W. Mellon Lectures in the Fine Arts, 1961; The National Gallery of Art, Washington, D.C.; Princeton, N.J.: Princeton University Press, 1968.

This excellent and scholarly work explores in depth the beginnings of the Christian symbolic language, its relationship to other symbolic languages of the time, visual formulations tried and then abandoned, and the growing eloquence of the Christian artistic language.

Schiller, Gertrud. *Iconography of Christian Art*, vols. 1 and 2. Trans. Janet Seligman. Greenwich, Conn.: New York Graphic Society, 1971. Translated from the 2nd German edition, 1969.

Schiller's remarkable work of scholarship provides a helpful guide to the symbolic meaning underlying representations of Christ's life and Passion.

CHRISTIANS AND CHRISTIANITY IN THE LATE ANTIQUE WORLD

Brown, Peter. *The World of Late Antiquity, AD 150–750.* London: Thames and Hudson, 1971.

Peter Brown is a renowned scholar who has done much to make his period, the Late Antique world, accessible to the general reading public. His biography *Augustine of Hippo* (Berkeley, Cal.: University of California Press, 1967) is a classic, and more recently his *Power and Persuasion in Late Antiquity: Toward a Christian Empire* (Madison, Wis.: University of Wisconsin Press, 1992) adds greatly to our knowledge of the Late Antique period.

Grant, Robert M. *Augustus to Constantine: The Rise and Triumph of Christianity in the Roman World.* New York: Harper & Row, 1990; first published 1970.

Wilken, Robert L. *The Christians as the Romans Saw Them.* New Haven, Conn.: Yale University Press, 1984.

An illuminating collection of primary source material bound together by commentary, Wilken's work offers a good look at what various elements of the Roman Empire really thought about each other.

PERSONALITIES

Duckett, Eleanor Shipley. *Medieval Portraits from East and West.* Ann Arbor, Mich.: University of Michigan Press, 1972.

Grant, Michael. *Constantine the Great: The Man and His Times.* New York: Charles Scribner's Sons, 1994.

Oost, Stewart Irvin. *Galla Placidia Augusta.* Chicago: University of Chicago Press, 1968.

Procopius. *Secret History.* Trans. Richard Attwater. New York: Dorset Press, 1992.

There are many editions of so-called *Secret History* by Procopius, the sixth-century historian and gossip. The works of Procopius are available to the English reader through the Loeb Classical Library, and excerpts from Procopius and other sources of the time can be found in C. D. Gordon's *The Age of Attila: Fifth-Century Byzantium and the Barbarians* (Ann Arbor, Mich.: University of Michigan Press, 1960).

Smith, John Holland. *Constantine the Great.* New York: Charles Scribner's Sons, 1971.

SPECIALIZED STUDIES

Burns, Thomas S. *A History of the Ostrogoths.* Indianapolis, Ind.: Indiana University Press, 1984.

Holum, Kenneth G. *Theodosian Empresses: Women and Imperial Dominion in Late Antiquity.* Berkeley and Los Angeles: University of California Press, 1982.

Johnson, Mark J. "Toward a History of Theoderic's Building Program." *Dumbarton Oaks Papers* 42, 1988.

Malbon, Elizabeth Struthers. *The Iconography of the Sarcophagus of Junius Bassus.* Princeton, N.J.: Princeton University Press, 1990.

Onians, John. *Bearers of Meaning: The Classical Orders in Antiquity, the Middle Ages, and the Renaissance.* Princeton, N.J.: Princeton University Press, 1988.

This fascinating and well-illustrated work explores in a very readable fashion the meaning for the selection of one order, say the Ionic—as opposed to another— for people during the periods covered.

Spain, Suzanne. "'The Promised Blessing': The Iconography of the Mosaics of S. Maria Maggiore." *The Art Bulletin,* vol. lxi (December 1979), pp. 518–40.

INDEX [1]

[1] References are to the text only.

ABOUT THE AUTHOR

ELIZABETH BRUENING LEWIS has a B.A. from Vassar College, an M.A. from Arizona State University, and a Ph.D. from Georgetown University in Medieval History with a specialization in symbolism in Christian art. She has taught Logic at Phoenix College, Humanities at Arizona State University, and is presently an adjunct faculty member at the Frank Lloyd Wright School of Architecture, Scottsdale, Arizona. Dr. Lewis has lectured widely, and has conducted public seminars in the art and culture of various periods (Early Christian, Medieval, Renaissance, Modern) at the Scottsdale Center for the Arts and the Phoenix Art Museum. Although she has published numerous academic articles including the entry on Early Christian and Byzantine Religious Iconography for *The Dictionary of Art* (recently released by MacMillan Publishers, Ltd., London), her primary interest has always been in writing for the general public. Besides being actively involved with art, including traveling to see the works she discusses, Dr. Lewis and her husband are deeply committed to addressing environmental problems confronting the southwest, and their favorite activities include hiking the mountains and canyons of Arizona. They have two grown children.

ABOUT THE ILLUSTRATOR

STEVEN G. HELFFRICH brings an extensive background in both art and architecture to his work for this book. He has a B.A. in Architecture from Cal-Poly, San Luis Obispo, California, and has been responsible for master planning, schematic, and design development for projects (commercial, institutional, and residential) throughout the Phoenix, Arizona, area. He has also studied at École des Beaux-Arts in Fountainbleau, France. Steven Helffrich has participated in numerous art exhibitions and competitions. His long-term goal is to integrate the disciplines of art, sculpture, architecture, and landscape design with science and technology in order to create a more harmonious interplay between man and his environment.